iMovie User Guide

2024

The Ultimate Guide to Mastering the Latest Tools, Techniques and Tricks for Video Production from Beginners to Experts

Morgan Skye

Table of Contents

IMOVIE 2024 ... 1

CHAPTER 1 .. 2

IMOVIE'S OVERVIEW ... 2

 BECOMING FAMILIARIZED WITH THE IMOVIE PROGRAM ... 2
 OBJECTIVES AND CAPABILITIES .. 2
 WHO THIS IS MEANT FOR .. 3
 METHODS FOR USING THE USER INTERFACE ... 4
 CUSTOMIZATION OPTIONS .. 5
 PROJECT CONFIGURATION AND PREFERENCES .. 6
 Launching a Novel Initiative .. 6
 Changing the Project's Parameters ... 6
 Configuring choices .. 6
 Organizing Backup and Storage ... 6
 Creating Projects .. 7
 ASSIGNMENTS .. 7

CHAPTER 2 .. 8

GETTING STARTED WITH IMOVIE ... 8

 IMOVIE CONFIGURATION .. 8
 NAVIGATE THROUGH YOUR PHOTO LIBRARY WITH IMOVIE ON A MAC 9
 THE METHODS USED FOR THE INSTALLATION ... 10
 Mac Configuration .. 10
 Installing iOS ... 10
 Additional Remarks .. 10
 DEVICE COMPATIBILITY ... 10
 macOS ... 11
 iOS ... 11
 Additional Remarks .. 11
 CREATING A NEW PROJECT ... 12
 RECORDING INTO IMOVIE DIRECTLY ... 12
 HOW TO LAUNCH A FRESH IMOVIE PROJECT ON A MAC ... 13
 IMOVIE PROJECT TEMPLATES .. 14
 Movie Trailer Templates ... 14
 Theme templates .. 14
 Basic Templates .. 14
 Educational Templates ... 14
 Customized Templates ... 14
 IMPORTING MEDIA FILES ... 15
 OPEN MAC IMOVIE AND IMPORT FILES FROM FILE-BASED CAMERAS 16
 USE MAC IMOVIE TO IMPORT VIDEO FROM TAPE-BASED CAMERAS. 19
 ABOUT THE SUPPORTED MEDIA FORMATS .. 20
 The Videos Formats .. 20

- *The Audio Formats* .. 20
- *The Picture Formats* .. 21
- *Specific Added Remarks* ... 21
- ASSIGNMENTS .. 21

CHAPTER 3 .. 22

IMOVIE MEDIA ORGANIZATION .. 22

- METHODS FOR LIBRARY ORGANIZATION ... 22
 - *Organizing Folders* ... 22
 - *Naming Files Conventions* ... 22
 - *About Tags and Keywords* ... 22
 - *About Color Ratings and Labels* ... 22
 - *The Astute Assortments* .. 22
 - *The Regular Maintenance* ... 23
 - *About Storage and Backup* ... 23
- UNDERSTANDING TAGS AND METADATA ... 23
 - *About Metadata* ... 23
 - *About tags* .. 23
- THE TOP TECHNIQUES .. 24
- UNDERSTANDING MEDIA SORTING AND FILTERING .. 24
 - *Creating Events and Changing Their Names* ... 25
 - *Move or copy clips between events* ... 26
 - *Copying the Clips* .. 27
 - *Merge or split Events* .. 27
 - *Deleting Videos and Events* .. 28
- ASSIGNMENTS .. 28

CHAPTER 4 .. 29

UNDERSTANDING FUNDAMENTAL EDITING .. 29

- THE CLIPS TRIMMING ... 29
 - *Utilizing the clip trimmer, add or remove frames* ... 29
- ADJUSTING THE START AND END POINTS AND MAKE SPLIT ADJUSTMENTS USING THE PRECISION EDITOR. 30
 - *Make use of the shortcut menu to eliminate extraneous frames* 32
- ABOUT THE SPLIT TECHNIQUES ... 32
 - *Repositioning the timeline's clips* .. 33
 - *Splitting a video clip* .. 33
- FINE-TUNING A CLIP'S LENGTH AND SPEED .. 33
 - *Changing Acceleration* .. 33
 - *Processes of Building Your Own Speed Ramps* .. 33
 - *The reversed Playback* .. 34
- SPLITTING VIDEOS BY USING IMOVIE ON YOUR MAC .. 34
- SPLITTING IN IMOVIE 2024: DIFFERENT STRATEGIES ... 36
- THE PRECISION EDITOR USAGE .. 36

Procedures for Precision Editor Usage 38
MODIFYING EDITS 39
 Editing photos in the Movie mode 39
 Applying Ken Burns' effect to visual animations 40
ASSIGNMENTS 41

CHAPTER 5 42

TRANSITIONS AND EFFECTS INCORPORATED 42

EXPLORING TRANSITIONS 42
DIFFERENT TYPES OF TRANSITIONS 42
 The Transitional Effects usage 43
TECHNIQUES FOR TRANSITION 45
THE FILTERS AND EFFECTS USAGE 45
 Assignments 48

CHAPTER 6 49

DELVING INTO THE USAGE OF TITLES AND TEXT 49

ADDITION OF TEXT AND TITLES USING IMOVIE 49
THE AVAILABLE OPTIONS FOR TEXT FORMATTING 50
ABOUT TEXT ANIMATION EFFECTS 50
ADDITION OF TYPEWRITER EFFECT TITLES USING IMOVIE 51
THE MOVIE TEXT EFFECTS APPLICATION 52
 How to Include Text Effects in a Mac iMovie 52
 Stage 1: launch iMovie and create a new project 52
 Stage 2: Include any media 53
 Stage 3: Add dialogue to the film 53
 Stage 4: Inscribe a Custom Text 53
THE COLORS, ANIMATIONS, AND FONT STYLES MODIFICATIONS 54
ABOUT FONT CHOICE AND DESIGN 55
 Selecting Fonts 55
 The Font Style 55
 The Advanced Styles for Fonts 55
 Previewing the Fonts 55
ADDING BOTH SUBTITLES AND CAPTIONS 56
 Is it possible for iMovie to sync movie subtitles automatically? 56
 Can an SRT file be imported into iMovie? 56
 The suitable measures 56
CAPTIONS OR SUBTITLES CAN BE ADDED WITH AN IPHONE OR IPAD RUNNING IMOVIE 58
HOW TO EDIT AND DESIGN SUBTITLES IN IMOVIE 59
 On an iPad or iPhone, how do you modify subtitles in iMovie? 59
ASSIGNMENTS 60

CHAPTER 7 61

ADDITION OF SOUND .. 61

IMPORTING AND ORGANIZING AUDIO FILES ... 61
ABOUT THE COMPATIBLE AUDIO FILE FORMATS ... 61
ADD AUDIO FILES TO YOUR IMOVIE CREATION, SUCH AS MUSIC .. 62
Add some of your collection's tracks .. 62
Adding extra audio files ... 63
Add music or other audio files using the media browser ... 63
Drag and drop audio files into your iMovie project's timeline. 64
Should a song not be available in iMovie ... 64
Incorporating sound effects ... 64
Cutting or Expanding the Audio Clips ... 65
Modifying the Tempo of a Sound clip ... 65
CHANGING THE VOLUME AND AUDIO LEVELS .. 65
Adjust the audio level in Mac iMovie .. 65
Modifying the volume of a timeline clip ... 66
Adjust a section of the clip's loudness ... 66
Reduce the volume .. 67
INCLUDING THE BACKGROUND MUSIC AND SOUND EFFECTS ... 67
Including the soundtrack in the backdrop ... 67
Alter the background music .. 67
Use keyframes to gradually change the audio ... 68
Switch off iMovie's audio on the Mac ... 69
RECORD A VOICEOVER AND ADD IT IN IMOVIE ... 70
Step 1: Visit the website for recording voiceover .. 70
Step 2. Modify the voiceover recording parameters .. 70
Step 3. Begin and end the voiceover recording ... 71
ASSIGNMENTS ... 71

CHAPTER 8 ... 72

CONCERNING OVERLAYS AND KEYFRAMES ... 72

IMOVIE VIDEO OVERLAYS: OPTIONS ... 72
WHY IS A VIDEO OVERLAY REQUIRED? ... 72
Raising the level of audience participation ... 72
Additional background data .. 73
Enhance the branding and messaging ... 73
Receive Easy Content Updates .. 73
Create a dramatic effect .. 73
HOW TO ADD VIDEOS OVERLAY TO IMOVIE FOR ADDITIONAL FEATURES AND PICTURE-IN-PICTURE EFFECTS 73
USE CUTAWAYS TO CONCEAL JUMP CUTS .. 74
What exactly is a jump cut? .. 74
Which circumstances and techniques may you use a Jump Cut for? 74
The Jump Cut tool in iMovie: How to Use It ... 74

METHODS FOR CREATING OPACITY EFFECTS	76
Tips for adding fade transitions to overlays	77
HOW TO MAKE THE MOST OF PIP'S SWITCH TRANSITIONS AND ZOOM	77
Learn the Differences between Zoom and Swap Transitions	78
Starting off	78
Zoom Transitions usage	78
Swap Transitions addition	79
DEVELOPMENTS TO CHANGEOVERS USING PICTURE-IN-PICTURE (PIP) EFFECTS	79
ASSIGNMENTS	80

CHAPTER 9 ... 81

ENHANCE VIDEO QUALITY USING ADVANCED TECHNIQUES TO EDIT 81

USING GREEN SCREEN EFFECTS	81
How to set Up a Green Screen in iMovie	81
Create a green screen effect on Mac iMovie	83
Adjust the blue or green screen effect	85
CREATE A SPLIT-SCREEN EFFECT IN MAC IMOVIE	85
Create a split screen video	86
Modify a video split-screen	87
APPLYING ADVANCED COLOR CORRECTION AND GRADING	87
Changing the Color Balance	87
Exposure and Contrast Adjustment	87
Color Effects Addition	88
Custom Color Effects making	88
Making use of External Tools for Advanced Color Grading	88
ABOUT COLOR CORRECTION PROCEDURES	88
ASSIGNMENTS	89

CHAPTER 10 ... 90

INTEGRATION OF GRAPHICS AND PHOTOGRAPHY .. 90

ADDING PICTURES AND GRAPHICS	90
ABOUT IMAGES MANAGEMENT AND ORGANIZATION	90
USING PHOTOS TO CREATE SLIDESHOWS AND MONTAGES	91
Step 1: Prepare the Images in Photos	91
Step 2: Create a new project in iMovie	91
Step 3: Add photos, movies, and music	92
Step 4: Adjust the Pictures in the Timeline	92
Step 5: Motion a Still Picture	92
Step 6: Make Sure Your Presentation Has a Transition	93
Step 7: Add Titles and Text	94
Step 8: Add Music to the Slideshow	94
Step 9: Save and export the slide presentation	95
FOR EARLIER ITERATIONS OF MACOS	95

 First, import pictures from the iPhoto Collection .. 95
 Step 2: Improve the Slideshow Project in iMovie Utilizing Project Music 96
 Step 3: Export iMovie's Slideshow Video ... 96
 CREATE A PICTURE COLLAGE .. 97
 Transform Your Images into Digital Formats ... 97
 Launching iMovie ... 98
 Open the Photos app .. 98
 Place the Images in the Timeline .. 99
 Select the Ken Burns .. 99
 Add a Transition .. 100
 About Title inclusion ... 101
 The Fade to Black ... 101
 Don't forget to add audio ... 102
 The Last Actions .. 102
 Make time lapse and stop motion in iMovie ... 103
 Animating and Adding Motion Effects to Still Images ... 103
 ASSIGNMENTS .. 104

CHAPTER 11 .. 105

GAINING EXPERTISE IN AUDIO EDITING ... 105

 AN EXAMINATION OF NOISE REDUCTION TECHNIQUES FOR VIDEOS 105
 Choose the ideal location ... 105
 Protection from Wind and Interference ... 106
 Changing the audio levels and gain ... 106
 Appropriately formatting and editing ... 106
 Eliminate the Background Sounds ... 106
 How to lower the background noise in iMovie ... 107
 EMPLOYING AUDIO EFFECTS AND EQ MODIFIERS .. 108
 Employing Audio Effects .. 108
 The Adjustments of EQ .. 109
 MAINTAINING SYNC BETWEEN AUDIO AND VIDEO CLIPS ... 109
 Part 1: Common Issues with iMovie Sound Out of Tune .. 109
 Part 2: Four Easy Steps for Audio and Video Synchronization in iMovie 110
 ASSIGNMENTS .. 112

CHAPTER 12 .. 113

PROJECT SHARING AND EXPORTING .. 113

 EXPORTING PROJECTS IN DIFFERENT FORMATS AND RESOLUTIONS 113
 Use iMovie to email a Mac movie, trailer, or clip ... 113
 SHARE YOUR IMOVIE WORK ON SOCIAL MEDIA WITH A MAC 114
 Get your movie ready to be uploaded to popular video-sharing platforms 114
 Export a picture from iMovie on the Mac ... 115
 Save a video, trailer, or clip to your computer using iMovie on a Mac 116

 Personalization of Export Parameters.. 117
 Aspects of Resolution and Quality to Consider .. 118
 How to Proceed with AirDrop Sharing .. 119
 Export or share your iMovie work using an iPhone or iPad 120
 Send your video attachment as an email or text message 120
 Transfer your video to an alternative device .. 120
 Upload your film to the internet ... 121
 You can share or export your Mac iMovie project .. 121
 Send a movie email ... 121
 Add the video to your collection of photos .. 122
 Upload your film to the internet ... 122
 Assignments .. 122

CHAPTER 13 .. 123

EXPLORING THE WORLD OF CLOUD CO-EDITING ... 123

 Setting Up iCloud to Allow Cooperative Editing ... 123
 Creating an Account on iCloud .. 123
 The Greatest Methods for Collaborative Editing in iMovie 124
 How to collaborate via channels of communication .. 125
 How collaborative projects are distributed .. 126
 Comprehending Team Projects in iMovie .. 126
 Getting things started ... 126
 The incorporation of collaborators .. 127
 Collaborating in Real Time ... 127
 Project Export and Sharing ... 127
 Collaborative Editing: The Best Methods ... 128
 Assignments .. 128

CHAPTER 14 .. 129

ADDING CAPTIONS AND ILLUSTRATIONS TO THE KEYNOTE ... 129

 Using Keynote to generate original titles .. 129
 Exporting Keynote titles .. 132
 Regarding Images and Transparency .. 133
 Importing Keynote files into iMovie .. 133
 Animated title creation with Keynote ... 135
 Keynote animated title export ... 136
 Transparent video exporting .. 137
 Creating multi-stage animations with Build Order .. 138
 About animations creations ... 140
 Importing, exporting, and changing multi-stage animations 143
 Keynote route animation generation .. 144
 Using animations for Magic Moves ... 148
 Customized overlay-based transitions .. 150

- *Using Magic Move to make transitions simple* .. 150
- *Multiple stage import and export of Magic Move animations* .. 151
- *Deadly basic animation with dynamic backgrounds* .. 152
- ASSIGNMENTS ... 154

CHAPTER 15 .. 155

THE MOST COMMONLY ASKED QUESTIONS AND TROUBLESHOOTING TECHNIQUES 155

ADDING MEDIA FILES .. 155
- *Issue: iMovie won't seem to accept media files* .. 155
- *iMovie randomly freezes or crashes while operating* .. 155
- *Issues with Audio Synchronization: The audio and video stop synchronizing after a change.* 155
- *Exporting issue: I'm having issues trying to save the project from iMovie* 156
- *Your video file is incompatible with iMovie* ... 156
- *Transcoding the video that iMovie won't accept is the solution* 157
- *The videos don't play properly* .. 157
- *The technique of "reminding" iMovie of the project clips was effective* 158
- *When Audio and visuals become disconnected* ... 158
- *Solution: Adjust the audio clip's speed* .. 159
- *Approaches for Improving Performance* .. 160

FREQUENTLY ASKED QUESTIONS .. 161
- *An iMovie: what is it?* ... 161
- *Is iMovie free to use?* ... 161
- *Is Windows or Android compatible with iMovie?* .. 161
- *What kind of system is required for iMovie?* ... 161
- *How can I load videos into iMovie?* .. 161
- *Is audio editing possible with iMovie?* ... 161
- *Is it possible to add text and titles to my videos using iMovie?* 161
- *How can I export or share the edited videos that I created in iMovie?* 162
- *Does iMovie support extensions and plugins from third parties?* 162
- *Is iMovie capable of professional film editing?* .. 162
- *How do I add music to my iMovie project?* .. 162
- *Can I edit videos that I made with my iPhone or iPad using iMovie on my Mac?* 162
- *Which are the basic iMovie editing techniques?* ... 162
- *How can I create a picture-in-picture effect with iMovie?* .. 163
- *Can I create slow-motion or fast-motion effects in iMovie?* ... 163
- *How can I remove the background from a video clip in iMovie?* 163
- *Can I use iMovie to create videos on YouTube or social media?* 163
- *How can I use iMovie to edit my videos with filters and other visual effects?* 163
- *Can I collaborate with people on an iMovie project?* .. 163
- *How can I use iMovie to make my videos narrated or have voiceovers?* 164
- *Is it feasible to import and edit video from external cameras or camcorders into iMovie?* 164
- *How can I create titles and credits for my videos in iMovie?* .. 164
- *Can I add closed captions or subtitles to my videos using iMovie?* 164

How can I create a slideshow with music in iMovie?	164
Assignments	164

CHAPTER 16 .. 165

ANALYZING IMOVIE THIRD-PARTY EXTENSIONS AND PLUG-INS 165

The Best 10 Plugins & Add-ons for iMovie: Installation Tips 165
- ASCII art ... 165
- Large and Audacious ... 165
- The BKMS All Images ... 165
- BKMS Copy & Curl ... 165
- Crops & Zooms ... 166
- Effects of Titles ... 166
- DeDigitalEffects #1 ... 166
- DeDigitalEffects #2 ... 166
- Gree Three Slick ... 167
- iBubble ... 167

An overview of the marketplace for plugins ... 167
The Indicators for Using External Tools to Increase Your Editing Capabilities 168
- Options Criteria for External Tools .. 169

Methods for Workflow Integration ... 170
Summary in general ... 170

INDEX ... 172

iMovie 2024

CHAPTER 1
IMOVIE'S OVERVIEW

Becoming familiarized with the iMovie program

Apple produced a user-friendly movie editing program called iMovie. It works perfectly for editing on both iOS and macOS devices because it is compatible with both of them. A wide range of media file formats, such as pictures, audio files, and video clips, are supported by iMovie. These can be accessed straight from the device or through the library on your iOS device. After they're in, drag and drop them onto the timeline to begin editing your video. iMovie's editing features make it easy to chop, connect, and rearrange footage. You may add effects and filters to your movies, make transitions between segments, change the volume and tempo of the sound. You may now add text and titles to your movies using iMovie. A range of styles and layouts are available for adding background, starting scenes, and captions. You may use iMovie to add sound effects, background music, and voiceovers to your movies. You can also lower background noise and change the volume to enhance the sound. Upon completion of your film's editing, iMovie presents you with several sharing options. You can save your movie in many file formats, which you can then use to share it on social media, post it to video hosting services, and burn it onto a DVD. Regardless of your level of editing experience, iMovie's user-friendly interface and powerful editing tools can help you realize your creative ambitions.

Objectives and Capabilities

With the help of iMovie, users can produce videos that look polished and professional. It's a flexible video editing tool. It is appropriate for a broad spectrum of users, including novice editors as well as more seasoned authors.

Here are some of its main responsibilities and what they include: The purpose of iMovie is to facilitate video editing for those with limited editing experience. **Its primary objective is to empower users to create outstanding videos for a variety of applications, including:**

1. **Personal Projects:** iMovie is frequently used for home video editing, making memories with family, and recording private occasions like weddings, birthdays, and vacations.
2. **Educational Goals:** iMovie can be used by instructors and students to make tutorials, films, and presentations with educational themes. In the classroom, it's a useful tool for visual communication and storytelling.
3. **Content Creation:** To create interesting movies for their audience, content creators—such as vloggers, YouTubers, and social media influencers—use iMovie. It has tools for enhancing video footage with text overlays, transitions, and effects.

4. **Professional Projects:** Although iMovie might not have the most sophisticated features of editing software designed for professionals, it can still be utilized for professional projects that are smaller in scope, like short films, commercials, and promotional videos.

Features: iMovie has a number of features that let users efficiently edit, improve, and distribute their videos. **Among its principal abilities are:**

1. **Easy to Use layout:** Even for users without a lot of training or experience, iMovie's user-friendly layout makes it simple to navigate and carry out simple editing activities.
2. **Media Import:** From the device's library or straight from their iOS device, users can import a variety of media assets, such as audio files, video clips, and picture files.
3. **Editing Tools:** You may divide, resize, and rearrange video clips on the timeline using the editing tools in iMovie. To improve their films, users can add transitions between clips, change the audio's speed and level, and add effects and filters.
4. **Titles and Text:** iMovie offers a range of themes and styles that users may use to add titles, captions, and text overlays to their videos.
5. **Audio Editing:** iMovie users can incorporate voiceovers, sound effects, and background music into their videos. It also provides options for lowering background noise and modifying audio levels.
6. **Sharing Options:** After editing is finished, users can export their videos in a number of formats that can be burned to a DVD, shared on social media, or uploaded to websites that host videos.

Who This Is Meant For

a. **Novices and Casual Users:** Those who are new to video editing and are inexperienced with the program will find iMovie very intriguing. Even those without much technical experience may easily create professional-looking videos for personal usage, such as family get-togethers, trips, and special occasions, thanks to its user-friendly interface and intuitive features.
b. **Teachers and Students:** iMovie is frequently used by teachers and students for educational projects such multimedia productions, films, and presentations. It is the perfect tool for adding video content to lesson plans and classroom activities because of its accessibility and simplicity.
c. **Content Creators and Social Media Influencers:** iMovie serves content creators that have to make interesting movies for their followers, such as vloggers, YouTubers, and social media influencers. With the help of its extensive editing capabilities, multimedia producers may add text overlays, effects, and transitions to their work to improve its visual appeal and shareability.
d. **Small Businesses and NGOs:** iMovie can be an affordable option for small businesses and NGOs with limited funding to create fundraising campaigns, commercials, and promotional movies. Organizations who need to produce professional-looking movies without spending a lot of money on editing software

or paying specialized personnel can use it because of its ease of use and adaptability.
e. **Aspiring Filmmakers and Independent Artists:** Although iMovie might not have the sophisticated functionality found in professional editing software, it can still be a useful resource for individuals pursuing independent filmmaking and art. It enables users to try out different storytelling strategies, edit music videos and short films, and present their original works to a larger audience.

Methods for Using the User Interface

If you don't have a project open already, the top of the screen shows the three main areas of iMovie:

a. **Media:** This is the location of your files. You can have distinct libraries for various media kinds.
b. The list of all the projects you've updated is called Projects. It can be useful to replicate a project here and make different changes if needed. You will be prompted to select between a Movie and a Trailer project when you begin a new project. Select the film project.
c. **Theater:** In the theater, you can view movies that you have shared or saved. Here, you can also create a new film or video.

iMovie frequently opens with the last project you worked on. Go to File > New Movie to create a project if you haven't previously. After that, iMovie will take you to your new movie's project window. iMovie is divided into three sections in this project view.

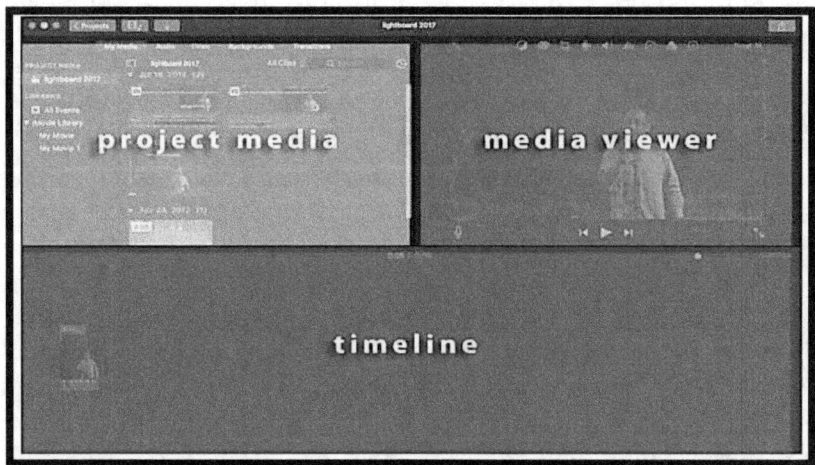

- **Project Media:** On the left side of your screen are the files for the project. You may quickly examine your iPhoto collection, tracks from GarageBand and your iTunes

library, and any additional material by doing this. iMovie creates a library for your files called this. Here you will also discover transitions, backdrops, and titles.
- **Viewer of Media:** The media can be seen in the project media area on the right, or in your stream. The media player has a number of color and sound correction options. In addition to many other helpful adjustments, you can crop an image, apply the Ken Burns effect to a media clip, and change the colors.
- **Timeline:** You can adjust the sound and video clips in the timeline of your edited material, located at the bottom.

Customization Options

iMovie offers a wide range of editing tools to assist you enhance your images, such as:

- **Themes:** iMovie has a vast array of pre-made themes that include cohesive titles, transitions, and musical selections. Choosing a theme that complements the tone or aesthetic of your video is an additional choice.
- **Titles:** You can add titles to your videos to set up parts, offer context, or introduce new scenes. iMovie allows you to customize it with a variety of title designs, fonts, and animations.
- **Transitions:** To ensure a seamless transition from one clip to the next, there are numerous options available. Transitions can be altered in duration and design to match the pacing of your movies.
- **Effects and filters:** iMovie has a number of effects and filters that you can apply to improve the appearance of your film. You may achieve the desired look by adjusting the strength of the filters.
- **Soundtracks:** Utilize iMovie's collection of royalty-free music and sound effects to enhance your videos. They can contribute to the intrigue of your films. Your own music and sound files can also be added.
- **Split Screen:** You may create split-screen effects and utilize them to display several images or movies simultaneously. In iMovie, you can adjust the dimensions and design of every screen.
- **Speed controls:** Utilizing the speed controls, you can alter the speed of your video clips to create effects such as slow motion or fast motion. You may also flip clips to create artistic effects.
- **Color Correction:** Make changes to your video's brightness, contrast, saturation, and white balance using iMovie's color correction features. Moreover, color settings can be used to quickly make adjustments.
- One effect in iMovie that you may utilize is the green screen. Another name for it is "Chroma key." You can use this effect to change the background of a clip to a new image or video.
- **Advanced Editing Tools:** iMovie provides you with sophisticated editing tools that provide you greater control over your film, such as audio adjustments, picture-in-picture effects, and precise cutting.

- **Sharing Options:** After your movie has been edited and created, you have the option to burn it to a DVD, share it straight on social media, or export it to a variety of file kinds.

Project Configuration and Preferences

iMovie's project options and preferences allow you to change the video project's resolution, frame rate, aspect ratio, and audio characteristics. **Below is a summary of the project settings and preferences in iMovie:**

Launching a Novel Initiative

When you begin a new project in iMovie, you will be prompted to choose a project theme or template. Themes provide pre-made layouts, transitions, and titles to give your work a cohesive look. You can also choose the aspect ratio (16:9 widescreen or 4:3 standards) and resolution for your project (HD 720p, Full HD 1080p, or 4K).

Changing the Project's Parameters

After creating a new project, you can click on the project settings icon (gear icon) in the toolbar to access its settings, or you can select "File" > "Project Properties" from the menu bar. You can change a lot of things in the project options, like aspect ratio, resolution, frame rate, and backdrop color. To fix shaky video clips or balance the color of your movie, you can also enable automatic content identification.

Configuring choices

With iMovie's settings, you can customize the application's behavior and settings to your preferences. To access preferences, click "iMovie" in the menu bar and select "Preferences." Preferences contain options for sharing settings, timeline behavior, and project backup, and audio and video import. Keyboard shortcuts, audio output, video quality, and new project default parameters can all be altered.

Organizing Backup and Storage

iMovie also has options for controlling backup and storage configurations, which you can use to ensure the security of your work and optimize disk space consumption. You can specify an external storage device or the internal hard drive as the location where iMovie Library files are stored. You can also enable or stop automatic project backups, as well as choose the location and frequency of backups. By adjusting the project settings and parameters, you may tailor your iMovie editing environment to your own needs and workflow. Whether you're editing from beginning or changing the way the program acts, these settings help you make the most of your editing process and quickly produce high-quality videos.

Creating Projects

- **Open iMovie:** To begin a new project, open iMovie on your Mac or iOS device. On a Mac, iMovie is located in Launchpad or the Applications folder. iMovie may be accessed from the home screen on iOS devices.
- **Start a New Initiative:** To begin a new project in iMovie, select "Create New" or "New Project". Select the relevant option according to your iMovie version and device. For your project, decide on the resolution (HD 720p, Full HD 1080p, or 4K) and aspect ratio (16:9 widescreen or 4:3 standard). If you'd like, you can also select a project theme or template.
- **Import Media:** Once your project is built, you can import media assets (video clips, images, and audio) into your project. You can drag and drop files from your device's library, iCloud Drive, or external storage, or you can click the "Import Media" button. By connecting your camera or iOS device to your computer and choosing the import option, you can easily import media straight from these devices.
- **Set up the Media:** Once the media files are imported, arrange them on the timeline according to the order you want them to appear in the finished product. Clips can be trimmed to change their length or rearranged by dragging and dropping them. To add titles and text overlays, apply effects, add transitions between clips, and change the audio levels, use the timeline.
- **Edit and Enhance:** To improve your video production, make use of iMovie's editing tools and features. To get the desired appearance and feel, trim clips, create transitions, use filters and effects, and change the audio and color levels. With iMovie's pre-built themes and styles, you can also add credits, titles, and captions to your film.
- **Preview and Complete:** Check that everything appears and sounds as you have intended when you preview your project. Watch the entire video to make sure there are no mistakes or discrepancies. Complete any last-minute rewrites or tweaks before submitting your work.
- **Share and Export:** It's time to export and distribute your completed video creation to others. Select the preferred export format (file, YouTube, Vimeo, etc.) by clicking the "Share" button. To export your video project to social media, video-sharing services, or the storage on your smartphone, simply follow the on-screen directions.

Assignments

1. What do you understand by iMovie?
2. What are some Objectives and Abilities of iMovie?
3. Create a new project

CHAPTER 2
GETTING STARTED WITH IMOVIE

iMovie Configuration

When you initially launch iMovie, it opens in the Projects view. Choose File > New > Movie from the resulting window to start making a movie.

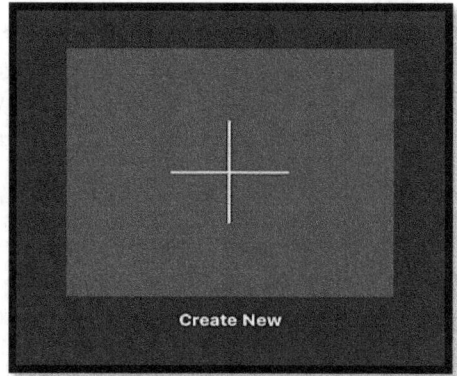

Not long after you launch a new video project, you can add both still and motion pictures to your picture library by using the libraries list on the sidebar.

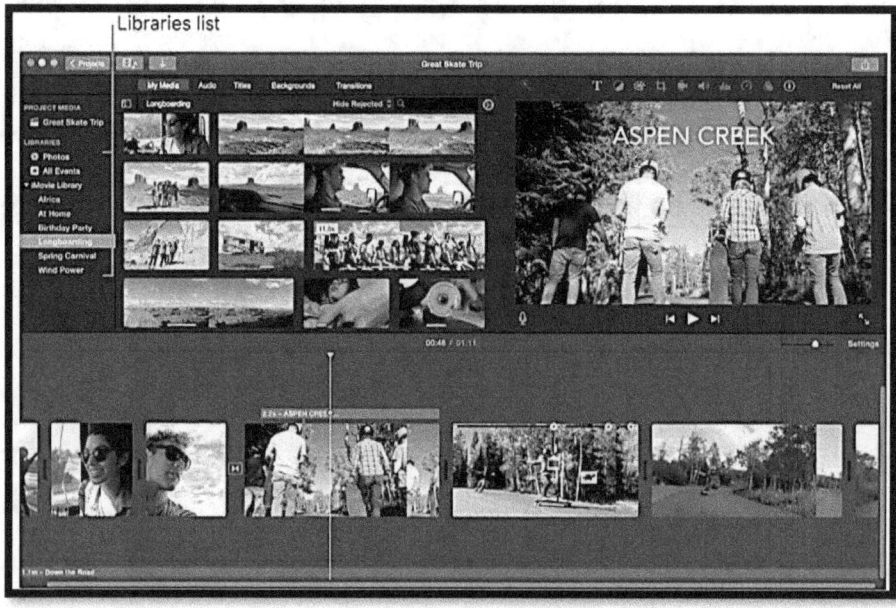

Click the material button in the menu to access your material without starting a new project.

Navigate through your photo library with iMovie on a Mac

All of the photos and videos stored in your Aperture, iPhoto, and Photos libraries are instantly accessible to and usable by the iMovie application. Please be advised that Aperture and iPhoto are not supported on Mac OS X versions higher than macOS Mojave 10.14. You can move your portfolio to Photos if your photos are kept in an Aperture or iPhoto library.

The following are the steps to follow:

- Locate your photo library when you launch the iMovie application on your Mac. Select it from the shown list of libraries.
- To select a content area, click the pop-up menu located at the top of the window. Next, navigate through the thumbnails of the images and videos that are included in that section.
- To see a sample of the picture or video clip you want to utilize, select it in the player.
- **Select a choice from the following list:**
 - To add an image or video clip, drag it onto the timeline in-between clips or between a clip and a transition. You won't have any issues adding it thanks to this.
 - As you drag, a blue box will appear in the timeline. Where the image or video clip will appear in the stream will be indicated by this box.
 - Drag the image or video into the timeline and place it over the clip to replace it.

As you move the clip over the timeline, it will acquire a white border around it. When you release the mouse button, a menu will show up. From that option, select Replace. The shorter clip in the loop is replaced by the image or clip.

The methods used for the Installation

Mac Configuration

a. **Through the Mac App Store**
 - On your Mac, open the Mac App Store.
 - Type "iMovie" into the search field in the upper-right corner and hit Enter.
 - Select the iMovie application from the list of results.
 - To start the download and installation procedure, click the "Get" or "Download" button next to iMovie.
 - After the installation is finished, iMovie is located in your Mac's Applications folder.

b. **Pre-Setup**
 - iMovie may be pre-installed on certain Macs as part of the iLife or iWork suite. In this instance, Launchpad or the Applications folder contains iMovie.

Installing iOS

a. **Through the App Store:**
 - From the home screen of your iOS device, unlock it and access the App Store.
 - Press the search icon located at the lower part of the screen, then input "iMovie" into the search field.
 - In the search results, tap on the iMovie app.
 - Download and install iMovie on your device by tapping the "Get" button.
 - After the installation is finished, iMovie appears on your home screen.

b. **Pre-Setup**
 - iMovie might be pre-installed on some more recent iOS gadgets. In this instance, iMovie is located on your home screen.

Additional Remarks

- iMovie is available for free on all new iOS and Mac devices. You might be asked to buy iMovie from the App Store, though, if you're using an outdated device or need to reinstall it for any other reason.
- Verify if your device satisfies the system requirements to use iMovie. Verify compatibility with the macOS version you are using. Make sure the iOS version on your device is compatible with it.

Device Compatibility

The devices that iMovie is compatible with vary depending on the OS. Below is a list of devices that iMovie is compatible with on macOS and iOS:

macOS

iMovie works with Mac systems running macOS. However, the version of iMovie that is accessible may vary depending on the specific version of macOS that is installed on your Mac.

The following are the general rules of compatibility:

a. **macOS Catalina and later:** iMovie is compatible with macOS Catalina (10.15) and later versions, and it may be purchased via the Mac App Store.
b. **Older macOS versions:** If your macOS version is older than the one you're using, you might be able to use an older version of iMovie that works with it. For information about compatibility, visit Apple's website or the Mac App Store.

iOS

iOS devices, such as iPhones and iPads, may use iMovie. The iOS version that is installed on your smartphone, however, might affect the particular version of iMovie that is available.

The general compatibility rules are as follows:

a. **iOS version:** iOS devices running iOS 13 and later versions are compatible with iMovie.
b. This covers iPod Touch, iPad, and iPhone models.
c. **Device compatibility:** A variety of iOS devices, including some older models and newer ones, are compatible with iMovie. However, the hardware capabilities of the device may affect the performance and features that are offered.

Additional Remarks

Verify that your device satisfies the system requirements in order to use iMovie. This involves having enough RAM, storage, and computing capacity to complete activities related to video editing efficiently.

If you're not sure if your device is compatible with iMovie, you may find out more about compatibility by visiting Apple's website or looking through the App Store listing for iMovie on your device.

Creating a New Project

a. Click the "+" symbol located in the Projects gallery. Press Done to bring up the Home screen, and then select Projects to continue editing the movie.
b. Choose a movie. The Moments screen displays all of the images and videos from a specific day or event and is a compilation of media from your Photos app photo library.
 - You may also select Trailer and create a trailer using your movies and pictures by selecting one of the pre-made themes.
c. Press and hold the thumbnail to view the image or video at a higher resolution.
d. To add an image or video clip to your movie, either tap it, or select a scene by tapping it. Every item that has been selected has a checkbox next to it. Proceed to step 6 if you wish to avoid adding images from your library.
e. To view other picture, video, and clip files, hit Media and then select another region.
f. Press "Make Movie." A new project will start. These are the videos or images that you have chosen to stream. If you didn't add any, the stream has no images or videos.

You can always add images and videos to the movie after you've finished making it. iMovie for your iPhone or iPad knows what size movie to create based on the greatest clip in your project. You can share a 4K video clip that you've included in your project to get ideas.

Recording into iMovie directly

You can add any image or video captured with your iPad or iPhone to an iMovie project:

a. Open your project in iMovie and drag the playhead to the location where you wish to add the image or video. The white line that resembles a cross is the playhead.
b. To access the "Camera" button on your iPhone, first hold down the "+" button and then push it. Locate and tap the Camera button on your iPad.

c. Use the camera's buttons to adjust the flash and quality before hitting the Record button.
 d. When you're finished creating a video, click the "Stop" button. If you snapped a photo, proceed to the following action.
 e. Select "Use Photo" or "Use Video" to include the image or video in the projects list.

Alternatively, you can hit "Retake" to retake the image or video. Where the playhead was when you first opened the iMovie timeline is the new clip.

How to launch a fresh iMovie project on a Mac

 a. When you're finished editing a movie, click the Projects option on the menu. In the Projects box, click "Create New." This is what will launch the browser for Projects.
 b. Choose a movie. The browser, viewer, and schedule are visible as soon as your new project launches.
 - If you click on Trailer, you can utilize the pre-installed themes to create a trailer using your pictures and videos.
 c. When your project is ready, add images and video clips from the photos app collection or clips from events from the Libraries list. You can also include media from external sources, such as images, videos, and other kinds of media:
 - Import data from iPad or iPhone
 - Import data from record-keeping cameras onto flash drives or other file-based storage devices.
 - Bring in files from your Mac.
 - Record video with your Mac straight into iMovie

Click the iMovie window and drag clips into the project's timeline to begin creating your movie. You may also drag clips into the timeline using the Mac's Finder or Desktop.

iMovie Project Templates

You may easily and quickly create professional-looking videos with pre-designed layouts, transitions, titles, and effects with iMovie's many project templates.

Here's a summary of a few well-liked iMovie project templates:

Movie Trailer Templates

iMovie offers a wide range of movie trailer templates that are modeled by popular movie genres, including action, comedy, drama, and adventure. Pre-made scenes with areas for titles, credits, and video clips are included with every trailer template; you can change the content to fit your story. To give your work a polished and dramatic appearance, trailer templates come pre-loaded with sound effects, music, and dramatic transitions.

Theme templates

For a range of occasions, such as weddings, birthdays, vacations, and holidays, iMovie offers theme templates with themed titles, backdrops, and transitions. Theme templates offer a consistent visual style and tone for your video production, making it easier to create themed videos for special occasions or events.

Basic Templates

iMovie has basic project templates with simple layouts and design features for creating typical video projects, like home movies, vlogs, slideshows, and presentations. Basic templates offer a great deal of versatility and customization, so feel free to add your own media assets, titles, and effects to make your project truly unique.

Educational Templates

You may create tutorials, educational films, presentations, and school projects with iMovie's educational templates. Educational templates may include interactive elements, notes, and text overlays to enhance learning and engagement.

Customized Templates

In addition to pre-made project templates, iMovie allows you to create your own with unique layouts, styles, and design elements. When you can store your personalized projects as templates for subsequent use, it's easy to duplicate the same look and feel for comparable projects in the future.

Importing Media Files

You can choose to upload photos and videos that you took using your iPhone, iPad, or iPod touch.

a. Make sure the gadget is turned on before connecting it to your Mac using the included USB connection.
b. Click the Import button in the toolbar to bring up the Import window after you've launched iMovie on your Mac.

Click the Media button after navigating to the menu. Next, select the Import button to include files. If you are unable to locate the Import button, click the Media button.

Close the window immediately if Images, Photos, or any other photo app opens.

a. Locate your device in the "Cameras" pane on the side after clicking the "Import" box. The Import box displays the images and video clips that are stored on your device as samples.
b. **You have two options:** either move the cursor over a video clip and drag it left or right, or move the mouse over the Import window's top preview and press the Play button.

You can make use of both of these features while watching. You may navigate to the previous or next clip by clicking the Previous or Next button. Alternatively, you can advance or rewind the movie by clicking and holding the Previous or Next button.

c. To instruct the computer where to store the imported material, select one of the following options:
 - Select an already-completed event by clicking the "Import to" pop-up menu at the top of the Import window.

Create a new event: From the "Import to" menu, select New Event, give it a name, and press the OK button to create a new event.

d. Choose one of the following options:
 - Click the "Import All" option to import every clip.
 - Import chosen clips: To import selected clips, command-click on each clip you wish to include, and then pick Import chosen (the button's name will change from "Import" to "Import chosen").

Your videos will be displayed in the event once the Import box has been closed. When adding clips, a progress bar may appear in the upper right corner of the window. Depending on how lengthy each clip is and how many you are importing, different folks will see this.

Although the import procedure is ongoing, you are free to continue working in iMovie.

e. The device needs to be unplugged as soon as your media is added.

Open Mac iMovie and import files from file-based cameras

File-based cameras and devices have the ability to take and store pictures and videos on flash drives or hard disk drives (HDDs). USB cords are typically used to connect file-based

webcams and other devices to your computer. You can take the memory card out of some file-based cameras and put it into your Mac instead of the camera itself.

 a. **You may select from the following options:**
 - Please make sure your device is turned on before connecting it to your Mac using the included connection.

Make sure the camera is in PC Connect mode before using it. This transfer option may go by a different name on your device. Your camera may enter "connect" mode as soon as you connect it to your Mac. The paperwork that came with your instruments may contain any further information you require. Keep in mind that the DVD Player app can start straight immediately if you connect a DVD camera to your Mac. You should just shut down the DVD player in this situation.

 - If your device utilizes an SD card, you will need to remove the card out of the device and put it in an external card reader or the card slot on your Mac, if your Mac has one.

The iMovie software on your Mac contains an Import button in the menu that you may click to launch the Import window. Click the Media button after navigating to the menu. Next, select the Import button to include files. If you are unable to locate the Import button, click the Media button.

Close the window immediately if Images, Photos, or any other photo app opens.
 b. Locate your device under Cameras on the sidebar of the Import box.
The Import box displays the images and video clips that are stored on your device as samples. You may get a preview of the selected item at the very top of the Import box. Remember that if you wish to display only images or videos, you must select an option from the menu that appears in the upper right corner of the Import window.
 c. Moving the pointer on a video clip and dragging it left and right will play a preview.
Alternatively, you can click the Play button while dragging the pointer over the preview at the top of the Import window. You may navigate to the previous or next clip by clicking the Previous or Next button. Alternatively, you can advance or rewind the movie by clicking and holding the Previous or Next button.

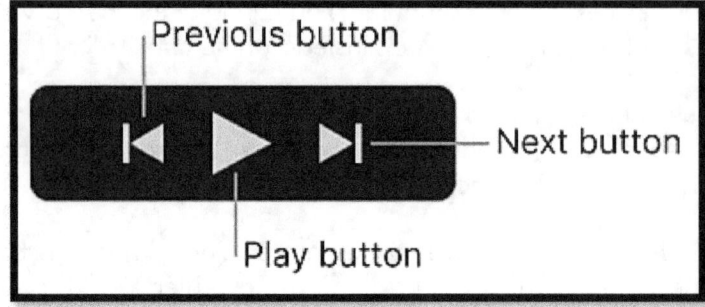

d. One of the following actions is required in order to select the location for the imported files:
 - To select an existing event, click the "Import to" pop-up option located at the top of the Import window.

To create a new event, select New Event from the menu that appears at the top of the Import window, and then click OK. After that, select "Import to" and give the newly created event a name.

e. Select a task from the following list:
 - **Bring In All:** Click this option to import every clip.
 - **Import chosen clips:** To import selected clips, command-click on each clip you wish to include, and then pick Import chosen (the button's name will change from "Import" to "Import chosen").

Your videos will be displayed in the event once the Import box has been closed. When adding clips, a progress bar may appear in the upper right corner of the window. Depending on how lengthy each clip is and how many you are importing, different folks will see this. Although the import procedure is ongoing, you are free to continue working in iMovie.

f. As soon as the media is added, the device has to be disconnected.

Use Mac iMovie to import video from tape-based cameras.

You can play the video that you have imported from tape-based cameras if you adjust the settings in the Import box. You can choose which clips to include by doing this. Video that can be imported from tape includes direct video (DVCAM and DVCPRO) and high-definition video (HDV).
 a. You can use the cord that came with the tape-based camera to connect it to your Mac.

You need to tweak the camera's settings in order for iMovie to work with it. There is a Thunderbolt port on your Mac even though it does not have a FireWire port. To create a FireWire link, you can use an Apple Thunderbolt to FireWire Adapter or an Apple Thunderbolt Display that contains a FireWire port. We'll go into more detail about each choice below. When importing from a tape-based camera, it is advisable to use the same camera that was used to record the video.
 b. Select the VTR or VCR mode from the screen after turning on the camera.

On your camera, this setting may go by a different name. Please refer to the handbook that comes with your camera for more details.
 c. To open the Import window in iMovie on a Mac, click the Import button in the menu.

Click the Media button after navigating to the menu. Next, select the Import button to include files. If you are unable to locate the Import button, click the Media button.

Close the window immediately if Images, Photos, or any other photo app opens.

 d. Locate and click on the tape-based camera you wish to add from the menu when the Import window opens. When you open the Import window, the image currently on the tape will be displayed.
 e. To view a sample of the video, you must move the cursor over the preview at the top of the Import window and then click the Play button.

You may navigate to the previous or next clip by clicking the Previous or Next button. Alternatively, you can advance or rewind the movie by clicking and holding the Previous or Next button.

- **To specify the location for the receiving files' storage, select one of the following options:**
 - Select an existing event by clicking the "Import to" pop-up option located at the top of the Import window.
 - Make a new event: select "New Event" from the menu at the top of the Import window, then click "OK." After that, click the "Import to" button and give the new event a name.
- Simply click the Import button after locating the location on the tape where you wish to start the import procedure. You may watch the video as it is being brought into iMovie as tape video is imported into the program in real-time.
- Click the Stop Import option once the segment of the video that you wish to import has finished. Until the tape runs out, iMovie will continue to load if you do not click the Stop Import box. You can relocate the tape to a new location where you want to begin importing the movie using the playback settings. Next, press the Import icon. This allows you to load another section of the file.
- Once the loading process is complete, click "Dismiss" to end the Import window.

About the Supported Media Formats

The Videos Formats

 a. **File Types:** Common video file types including MP4, MOV, M4V, AVI, and others are supported by iMovie.
 b. **Codecs:** It also supports a number of different video codecs, such as Motion JPEG, MPEG-4, HEVC (H.265), and H.264.
 c. **Resolutions:** Videos can be edited in standard definition (SD), high definition (HD), and 4K Ultra HD using iMovie.

The Audio Formats

 a. **File Types:** MP3, AAC, WAV, AIFF, M4A, and other audio file formats are supported by iMovie.

b. **Codecs:** These formats, including AAC, MP3, PCM, and others, can support audio codecs that are frequently utilized by them.
 c. **Bitrates and Sample Rates:** iMovie ensures compatibility with a broad range of audio sources by supporting several bitrates and sample rates for audio files.

The Picture Formats

 a. **File Types:** JPEG, PNG, TIFF, BMP, and GIF are among the common picture file types that iMovie supports.
 b. It has the ability to import photographs in two different resolutions: regular resolution and high resolution.
 c. **Aspect Ratios:** Images with varying aspect ratios can be handled by iMovie and used in your movie creations without distortion.

Specific Added Remarks

- Even though iMovie is compatible with a large number of media formats, it's a good idea to check the requirements and suggestions unique to your project to be sure everything works as it should.
- You might need to use third-party conversion tools or software to convert some media files to a compatible format if you have any problems importing or editing them in iMovie.
- When dealing with large or high-quality media files in iMovie, keep in aware that using media files with greater resolutions, bitrates, or sophisticated codecs may take more processing power and storage space.

Assignments

1. Explain the iMovie configurations
2. Use iMovie on Mac to import files from your photo library
3. Discuss some of the iMovie Project Templates
4. What are the procedures for iMovie installation

CHAPTER 3
iMOVIE MEDIA ORGANIZATION

Methods for Library Organization

Organizing Folders

a. Make a sensible folder structure in iMovie to organize your media files. You may, for instance, create folders for certain tasks, occasions, customers, or themes.
b. Give your folder names something that will help others quickly and easily recognize what's within. Think of arranging folders according to project kind, alphabetically, or chronologically.

Naming Files Conventions

a. Create a standardized file name scheme for your media files to facilitate fast and precise identification.
b. Make sure your file names contain pertinent details like the project name, date, location, and scene number. Later on, it will be simpler to look for particular files thanks to this.

About Tags and Keywords

a. Provide keywords and tags to your media files in iMovie to improve search and file management.
b. Make use of evocative terms that accurately convey the meaning, concept, or setting of every media file. This will make it easier for you to sort and filter your library.

About Color Ratings and Labels

a. Sort and rank your media files according to their status, quality, or importance by using color labels and ratings.
b. To indicate whether a file is essential, in progress, complete, or archived, assign different colors or ratings. This will assist you in concentrating on the most important files as you edit.

The Astute Assortments

a. Use iMovie's smart collection function to intelligently arrange your media files according to preset standards.

b. Create smart collections to organize files according to metadata attributes such as rating, date, file type, or keyword. You'll save time and effort by not having to manually organize and filter your library.

The Regular Maintenance

Plan routine maintenance sessions to go over and tidy up your iMovie media library. You can update file metadata, archive or remove unnecessary or duplicate files, and optimize folder structures to maintain your library neat and orderly.

About Storage and Backup

a. Make sure you have a solid backup strategy in place to guard against data loss in your media library.
b. To protect your media assets and projects, periodically backup your iMovie collection to network drives, external storage devices, or cloud storage services.

Understanding Tags and Metadata

To effectively organize and manage your media library in iMovie, metadata and labeling are essential. **Here's how to make efficient use of tagging and metadata:**

About Metadata

- **Automatic Metadata:** iMovie automatically gathers metadata (e.g., file name, creation date, duration, and size) from your media files.
- **Manual Metadata:** To add more context or details, you may also manually add metadata to your media files. Details like the venue, the event, the description, or the keywords might be included in this.
- **Editing Metadata:** To modify metadata in iMovie, choose a media file in the browser, and then click on the "Info" option. Here, you may examine and modify metadata fields such as title, description, keywords, and more.
- **Search and Filtering:** You can effectively search and filter your media library thanks to metadata. Utilize titles, keywords, or other metadata fields in iMovie to find particular media files fast.

About tags

- **Keyword Tags:** By adding descriptive tags to your media files, you may efficiently classify and arrange them. Themes, places, occasions, persons, and any other pertinent characteristics can all be represented by tags.
- **Adding Tags:** In iMovie, select the media file in the browser, and then click the "Keywords" button to add tags to it. For the chosen media file, you can modify, remove, or add keyword tags here.

- **Smart Collections:** Using predefined criteria, such as keywords, you can create dynamic collections of media files with iMovie's smart collection feature. For convenience and organization, set up smart collections to automatically group files with particular tags or keywords.
- **Filtering by Tags:** To focus on particular content and reduce search results, you can use iMovie's tag and keyword-based media library filter. Apply filters or use the search bar to see only media files that have specific tags.

The Top Techniques

a. **Consistency:** To guarantee uniformity and clarity throughout your media library, adopt a consistent approach to metadata and tagging. To keep things organized, use naming conventions, tagging procedures, and standardized keywords.
b. **Relevance:** Select metadata attributes and tags that make sense for your workflow and projects. Concentrate on gathering important details that will facilitate media file retrieval and searchability.
c. **Regular Maintenance:** To ensure that the metadata and labeling in your iMovie collection are correct and current, examine and update them on a regular basis. Take remove any unnecessary or out-of-date tags, and add new ones as necessary to represent additions or modifications to your media library.

Understanding Media Sorting and Filtering

If you upload video to your library in iMovie, it will organize your clips into events according to the time and date they were taken. Events, which act similarly to files, are where your clips are maintained. At first, events are grouped by time, but you can arrange clips in any way you choose. The clips that go with an event will show up in the browser if you pick it from the Libraries list.

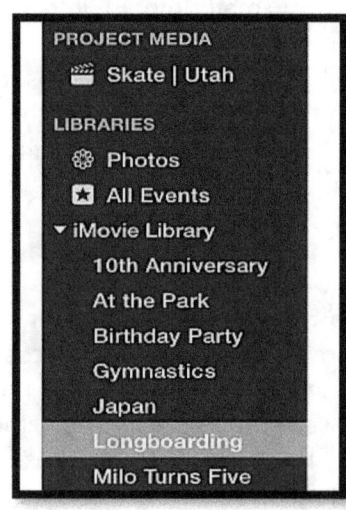

To view the libraries list, click the Libraries List button located at the top of the window if it is not present. You can change the order of the events in the Libraries list.

In the iMovie app on your Mac, perform any of these:
 a. **Sort events by name:** Go to View > Sort Events By > Name.
 b. **Sort events from newest to oldest:** In View, go to Sort Events By and choose "Newest to Oldest."

When you arrange events by date, events from the same library are grouped by year.

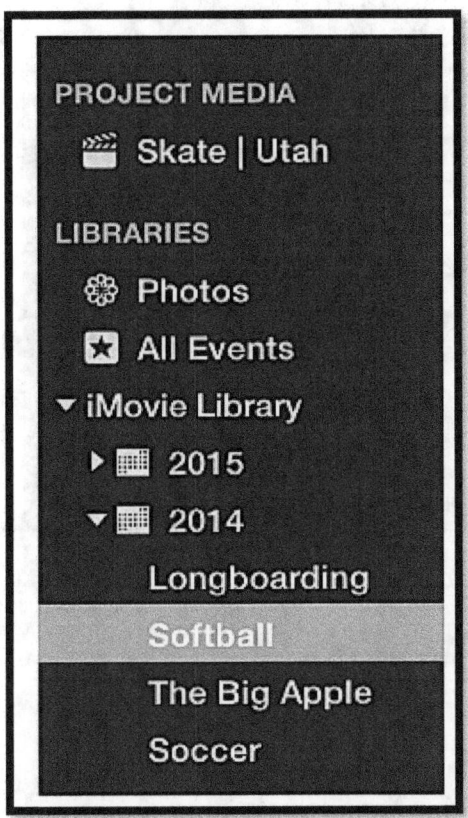

Sort events from oldest to newest: Go to View, click Sort Events By, and then choose Oldest to Newest.

Creating Events and Changing Their Names

 a. Launch the iMovie application on your Mac, and then select the library from the list in order to add an event.
 b. Choose "New Event" from the menu. • The name of the newly created event is underlined when it appears in the Libraries list.
 c. Enter a new name for the event to modify its name.

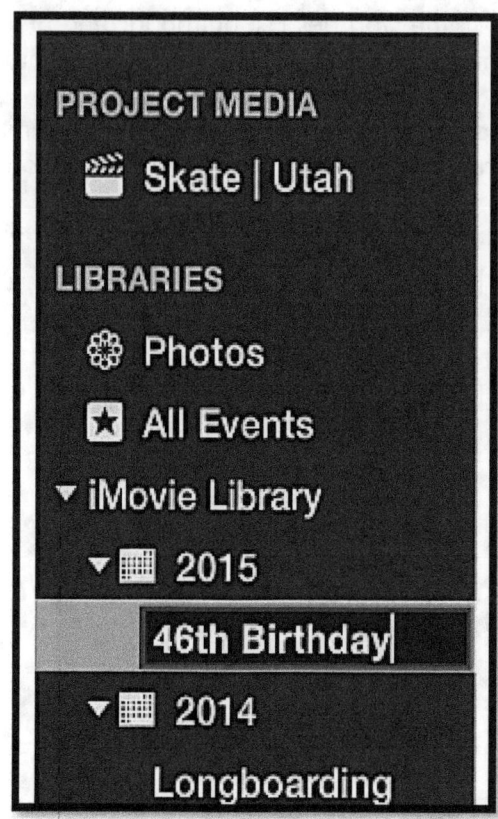

Pick out the event you wish to alter the name of in the Libraries list, hit Return, and type the new name.

Move or copy clips between events

- On a Mac, the iMovie application contains a library list. Select an event whose clips you wish to relocate or duplicate.
- Look through and choose the clips you wish to relocate or duplicate.

Hint: Click on the clips while holding down the Command key to select them. You can also drag a selection rectangle around the clips to select them all at once.

- **Select an action from the following list:**
 o Move clips between events: Drag the clips you've picked from one event to the next.
 o Transfer videos in between events. To move clips from one event to another, hold down the Option key and drag them.

Drag the clips from the browser to the selected project in the sidebar to copy them to an event.

Copying the Clips

a. A clip can be copied so that you can experiment with different adjustments or effects without affecting the original. Locate the event that contains the clip you wish to duplicate in the iMovie software on your Mac.
b. To duplicate a clip, double-click on it. If you select a portion of the clip, you can copy the entire thing.

Note: Click on the clips while holding down the Command key to select them. You can also drag a selection rectangle around the clips to select them all at once.

c. Select Duplicate Movie under Edit.

Merge or split Events

If two events in the Libraries list have footage that is highly similar to one another, you can combine them. A single event can also be split up into many events.

Use the following options in the Mac's iMovie app:

a. **Merge events:** Select one from the Libraries list and drag it to the other event to combine them. Additionally, you can choose which events to merge by selecting File > Merge Events.
b. **Divide a single event:** To divide an event, create the additional events you require, then transfer clips from the original event to the additional ones.

Deleting Videos and Events

To make room for something else, you can delete any event clips that you don't need and cancel the event itself. Note: You must remove previous events to create space for new ones. Removing clips from an event doesn't increase the amount of space used.

　　a. **Choose from the following actions in the Mac's iMovie app:**
- Choose the event you want to remove from the Libraries list.
- Look through the Libraries list for the event whose clips you wish to remove. After that, remove the video from that occasion. Next, use the browser to locate the clips you wish to delete.

Click on different clips in the same library that you want to select while holding down the Command key. You may also drag a selection box around the clips to select every one of them.

　　b. Click the File menu and choose "Move to Trash".

A notification informing you to remove the file from the project first will appear if you attempt to delete one that is currently being utilized in it.

Reminder: If you choose a clip and click "Delete," it will appear as "rejected."

Assignments

1. What are the Techniques for Organizing Libraries?
2. Explain tagging and metadata
3. Explain Sorting and Filtering

CHAPTER 4
UNDERSTANDING FUNDAMENTAL EDITING

The clips trimming

If you want to change a clip's length in your movie, you can change its start, end, or the length of a chosen range. Trimming comprises modifying the start and end positions in addition to the clip lengths.

Drag the clip around the timeline to adjust its length.

- You may quickly go to the start or finish of a clip in the timeline that you want to lengthen or shorten using the iMovie program on your Mac.
- **Select one of the following:**
 - ➤ Pull the edge away from the center of the clip to extend it. You must have the portions of a clip that aren't in use on hand in order to lengthen it.
 - ➤ Pull the edge in the direction of the center to shorten the clip.

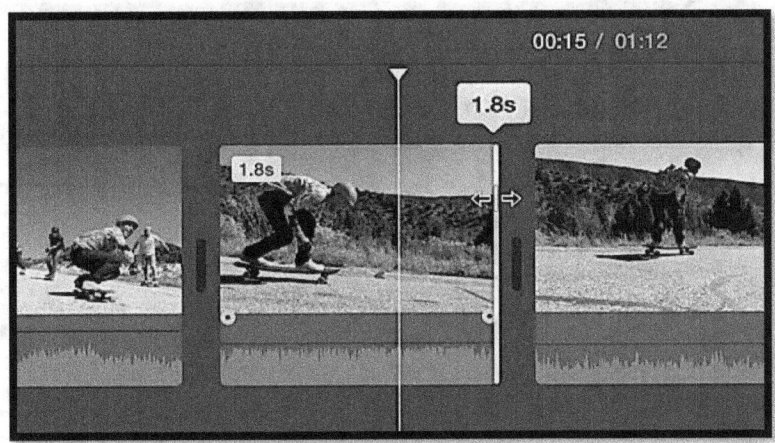

Utilizing the clip trimmer, add or remove frames

The clip cutter can be used to add or remove frames from a clip. You now have more authority over its contents. Additionally, you may monitor how much of your clip is being used.

a. Simply select the clip you wish to edit from the timeline in the Mac version of the iMovie program to trim it.
b. To access the Clip Trimmer, select Show Clip Trimmer from the Window menu. There's a clip cutter visible above the timeline.

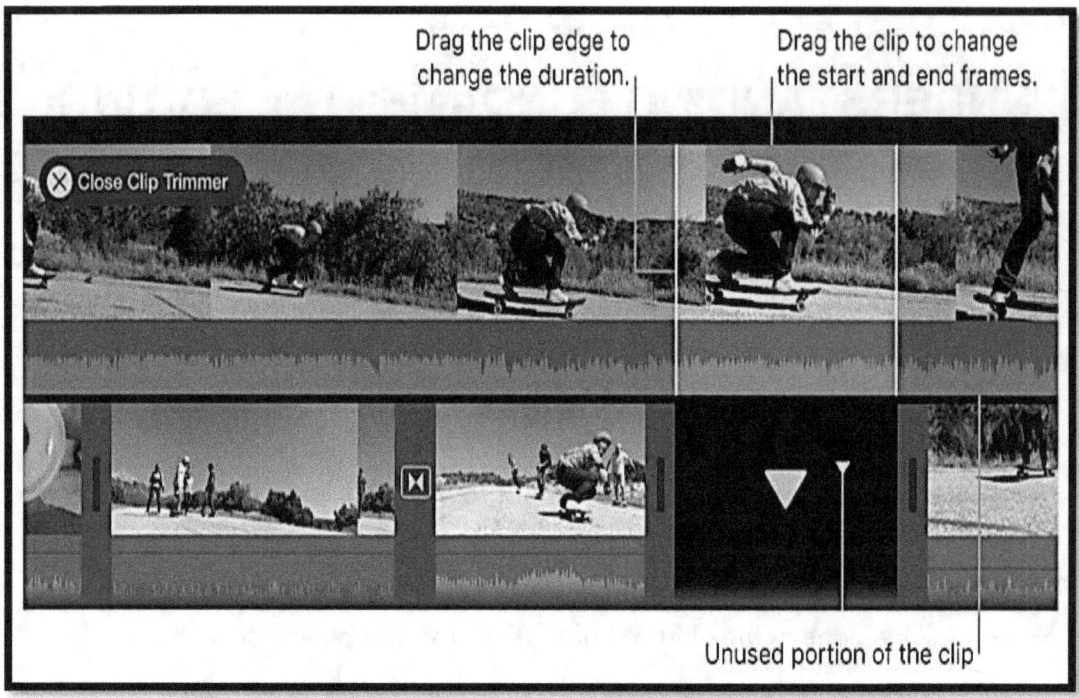

c. **Select one of the following:**
 - Simply slide the edge away from the center to extend the clip.
 - Pull the edge in the direction of the center to shorten the clip.
 - Make sure the clip remains the same length, but move it left or right from the center to alter the beginning and finishing frames.
d. Press "Return" to close the clip cutter.

Adjusting the start and end points and make split adjustments using the precision editor.

You have the ability to modify the length of your clips as well as the intervals between them using the precision editor. The precision editor allows you to add audio to a clip such that it plays for the entire duration of the video. This is helpful if you want the sound from one clip to play over another or if you want one clip to begin playing before the next. When you transition between clips, the audio and video may start or stop at different times. This is known as a split edit.

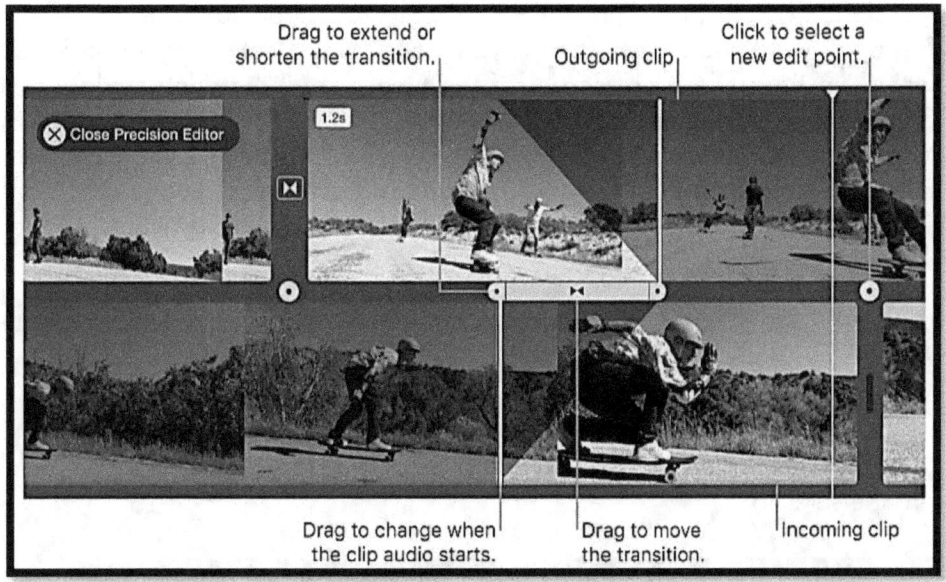

a. **Launch the iMovie application on your Mac and take these actions:**
 ➢ Double-click the timeline's edge of the clip.
 ➢ To launch the Precision Editor, click the edge of a clip in the timeline. Select Window > Show Precision Editor after that.

You can see a better view of the clips that are coming in and going out thanks to the precision editor. The edit point in the precision editor is shown by a vertical black line. This is the point at which the clip entering changes the clip leaving. The clip that is playing right now and the clips that came before it are displayed at the top of the precision editor. The next video clip and the ones that come after it are displayed below. The portions of the clips that aren't being used and can be edited away are indicated by the fading patches on either side of the edit line. To assist you in determining where to cut, you can quickly skim over these areas. When a transition is linked to the selected edit point, you can quickly determine how long it lasts by looking for vertical lines and a transition bar with handles.

b. To adjust the length of the clips, drag them or move the edit line in the center of the precision editor.
c. **One of the following actions can be taken to alter a transition:**
 ➢ To shorten the transition, you can adjust the outgoing transition handle to the left and the entering transition handle to the right.
 ➢ Adjust the transition handles' positions to prolong the transition.
d. Simply place your finger on the blue waveform of the clip that is leaving or entering and drag it to the desired location to adjust the audio edit point. Remember that in order to move an audio edit point; you must enable the Show

Waveforms option in the timeline. To ensure that your audio and video clips are displayed with audio waveforms, you can do the following actions: Click on Settings in the upper right corner of the timeline. All that's left to do is select the "Show Waveforms" checkbox.

e. When you are done modifying the clips, edit spots, or transition handles, press "Return" to end the precision editor. To modify the edit point in the precision editor, simply click on any of the dots located on the boundary between the departing and entering clips.

Make use of the shortcut menu to eliminate extraneous frames

a. To select a range of frames to preserve from a clip in the timeline, drag the cursor over it while holding down the R key in the iMovie software on your Mac.
b. Right-click on the clip and select "Trim Selection" from the menu that displays to trim the selection.

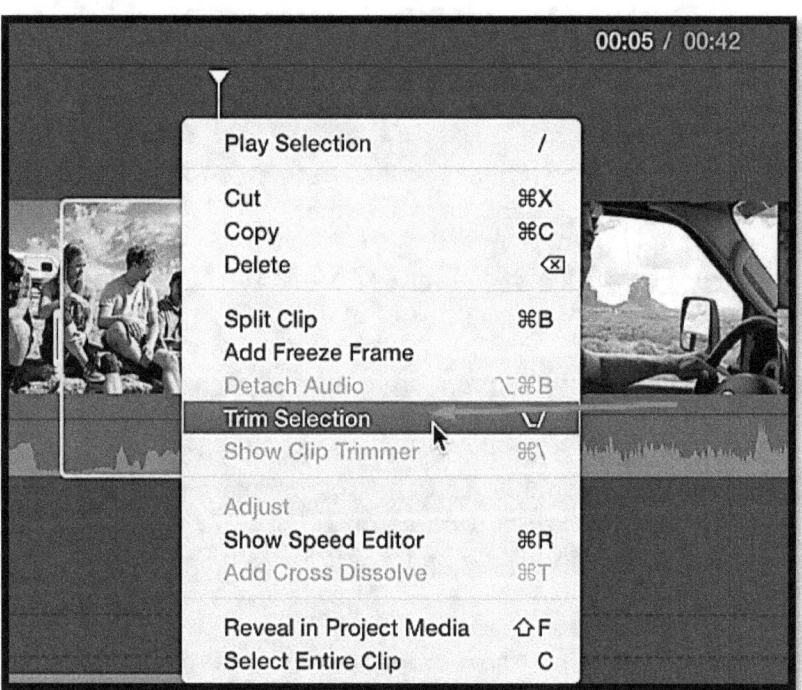

The clip is trimmed to fit between the selected lines.

About the Split Techniques

The clips in the timeline can be moved and divided into separate sections.

Repositioning the timeline's clips

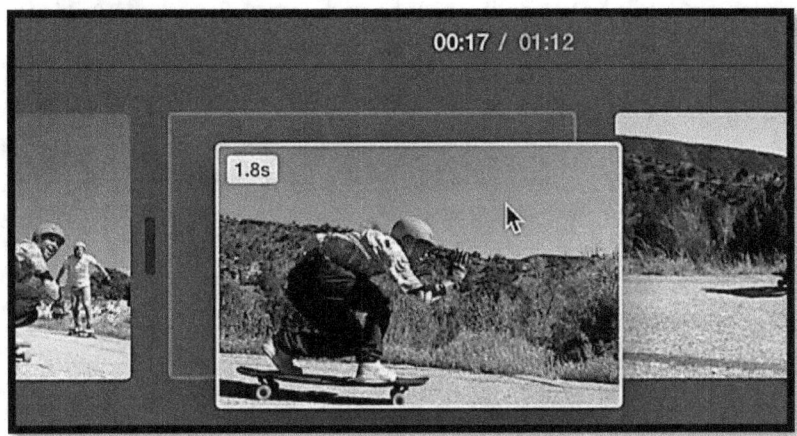

All you have to do to rearrange clips in the timeline is select them within the Mac's iMovie application and drag them to the new location. The timeline uses blue lines to indicate the locations of the clips.

Splitting a video clip

a. To divide a clip, simply choose it from the timeline of the Mac version of the iMovie software.
b. Position the playhead where you wish to divide the video.
c. Select Split Clip after selecting Change.

Fine-tuning a clip's length and speed

Changing Acceleration

a. Select a video and adjust its speed by clicking on it in the timeline.
b. Press the speed adjustment button, resembling a speedometer, located above the monitor.
c. There'll be a speed bar present. Slide the scale to the left to slow down the motion. Move it to the right to speed up the motion.
d. You can witness the real-time variations in speed by replaying the clip in the browser.

Processes of Building Your Own Speed Ramps

a. A speed ramp effect, in which the clip's speed gradually varies over time, can be created with keyframes.
b. Move the playhead to the desired starting point of the speed change.

c. Select the desired clip speed by pressing the "speed adjustment" button.
d. Choose a point on the track where you want the speed shift to stop, then adjust it once more. The shift between the two speed settings will be seamless for you when you use iMovie.

The reversed Playback

a. In iMovie, you can also play backwards clips. Locate the video on the timeline and select it. Next, to alter the playback, click the reverse playback button (represented by the double arrow icon) above the viewer.
b. As previously indicated, the reversed clip's speed can be altered by pressing the speed adjustment button.

Splitting videos by using iMovie on your Mac

a. You must access the app in order to start. You will need to download and install iMovie if you do not already have the program on your Mac. All you need to do is launch iMovie on your computer after the setup is complete.
b. Show off your video. When the "Create New" button on the app's home screen is clicked, the Movie and Trailer options appear. Select the Movie option to trim your video. All you need to do to add your video is click the Import icon located on the screen's left side.

c. Drag the video to add it to the Timeline. After posting the video, grab hold of it and move it over to the Timeline. Directly beneath the main screen is the Timeline.

d. Cut the video short. Select the video to remove from your Timeline. Next, to see the trimming arrows, drag the mouse to the start or finish of your movie. After that, snip your video by relocating the start and end places.
e. **Putting your video online:** To save the selected segment of the video, click the Export option located in the top right corner of the screen. Next, select Export File by clicking on the button that appears. Click the Next button to continue after that. After naming your file, select "Save" from the menu that appears.

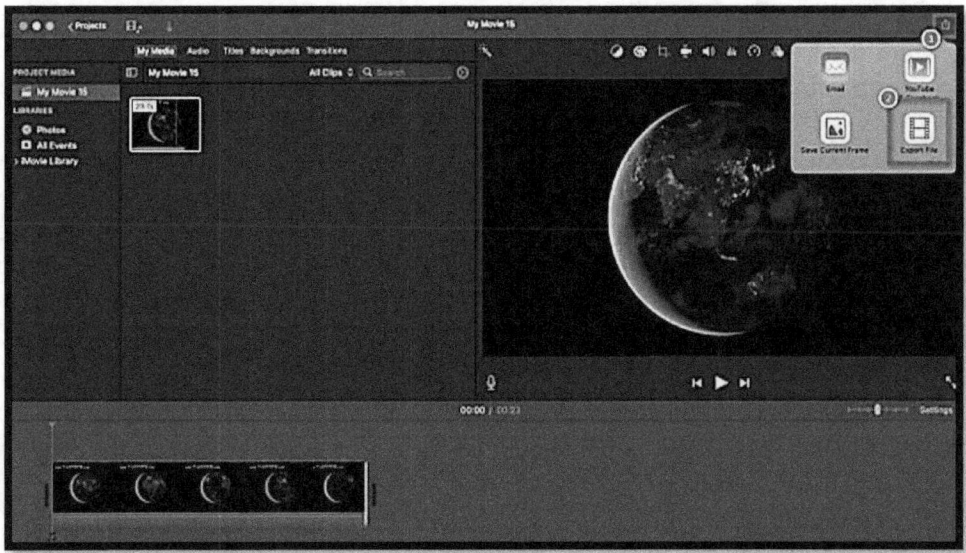

Splitting in iMovie 2024: different strategies

You can split videos with iMovie 2024 in a number of ways that make the process of making videos much more enjoyable.

Here are a few popular techniques:

a. The most common method of splitting is called a standard split. Position the playhead at the desired split point in the video. Next, select the clip by simply clicking on it. Simply hit the Command+B (Macintosh) or Ctrl+B (Windows) keys to split the video at the playhead.
b. **Blade Tool:** With the Blade Tool, you may precisely trim a clip to the desired length. Simply click on the clip and choose the blade tool from the toolbar to split it at the desired location. This is an excellent method for precise editing!
c. **Precision Editor:** The precision editor in iMovie allows you to precisely alter split points. For the precision editor to open, simply double-click on a clip. Dragging the split points left or right is a simple technique to adjust them. You can now seamlessly switch between video thanks to this.
d. **Audio and Video Splitting:** Occasionally, you might need to divide a clip's audio and video components apart. To accomplish this, select the clip and then select "Detach Audio" from the Modify menu. You can remove each audio and video track separately.
e. **Splitting Videos in the Timeline:** The same options are available as when splitting videos in the viewer when splitting videos in the timeline. While the clip is still selected, move the playhead to the desired location and hit Command+B (Mac) or Ctrl+B (Windows) to divide it.
f. **Splitting Clips during Playback:** You can divide a clip at a certain moment in time by using the "Split Clip at Playhead" command. To split the clip at the current playhead point, press Command+Shift+S (Mac) or Ctrl+Shift+S (Windows) while the video is playing.

The Precision Editor usage

Similar to the Clip Trimmer, few people consider the Precision Editor to be a necessary tool for learning how to use iMovie and create movies. If you've ever struggled to achieve the ideal transition between two clips, it's worth your time to investigate the Precision Editor. The Clip Trimmer makes it simple to determine the start and stop points of a clip, and the Precision editor allows you to consider in detail how a Transition effect may alter the way clips transition between one another. This can be incredibly useful when you're finishing off a clip because it allows you to cleanly remove any unnecessary video segments, among other edit concerns. The purpose of the Precision Editor is to improve the transitions between your clips. To open the Precision Editor, double-click on any clip's edge, selecting the edge, or select Show Precision Editor from the Window menu. Two

clips that have been trimmed and positioned per the request are displayed in the image below, along with a transition effect (indicated by the green arrow) in between.

Note that the pointer, indicated by the red arrow, is now two sideways pointing arrows instead of the standard arrow. I can double-click to open the Precision Editor because we are on the edge of the clip.

The opening of the Precision Editor has made a change to my history:

Despite its intimidating appearance, the Precision Editor provides helpful information that will enable you to make better changes. The outgoing clip has been superimposed upon the incoming footage. This image differs from the previous one, where the change was made on the left. To precisely adapt our transition, the Precision Editor attempts to display all of the raw video in both segments. You may also adjust the duration of the transition effect by clicking on any of the black dots on the gray box's edges. The fact that the right dot is nearly at the destination of the red line is useful. With the Precision editor, you can simply adjust the duration and location of the transition by seeing exactly how your clip will seem when played back.

Procedures for Precision Editor Usage

Certain aspects of a transition are displayed in the Precision Editor but not on the timetable. The timeline's style is altered by the Precision Editor, which at first glance may seem unsettling. It's a terrific tool, though, once you get used to it.

Here are a few useful applications for it:

 a. When you click on a transition indicator on the timeline, two arrows show up beneath it.
 b. Press and hold the two button keys to launch the Precision Editor.
 c. Use two fingers to poke out the timeline and zoom in on it to get a closer look at the Precision Editor.
 d. Click the question mark to open the Help menu. The tooltips for these menu options can instruct you on how to utilize the numerous handles in the Precision Editor as well as other things:

Since the Precision Editor has a lot of customization possibilities, let's look at what it can do:

 a. A slender yellow line indicates the space occupied by the transition. The middle mark, which resembles two squares facing each other, can be moved left or right by holding down and dragging it:
 ➢ Both clips begin before the other when the transition is moved to the left.
 ➢ After the transition is shifted to the right, both clips begin later.
 b. There are some grayed-out and darker sections in the video strip for the clip. These segments display the portions of the clip that are not in use. These lines continue for the entire picture because photographs don't have a fixed length.
 c. The transition can be adjusted using various handles. The location of the transition on one of the clips can be altered by adjusting one of the big yellow handles.

Why would you want to use the ProEditor because of this? This approach is nice since it simplifies the process of shifting an entire transition to a new period. To achieve this, you

must repeatedly adjust the trim handles in the timeline for the clips that come before and after the transition. You can use segments of videos without cutting them in half by moving the transition button but not the handles. Working with music is also a terrific experience using the Precision Editor. If you employ a cross-dissolve or any other lengthy transition, the sounds from both clips will play simultaneously. They are going to scrape and squeal.

There are many available methods to avoid this:

a. To move a yellow handle or the transition icon, click and drag it to the right. If you are unable to move the entire transition, select a handle to move. As the duration between the two clips increases, there will be fewer instances of the noises clashing.
b. If there is sound during the transition, you can use the thick blue handle to either reduce or enhance it. One blue handle will play when the other stops if you move them both such they are vertically aligned, preventing the sounds from blending together:

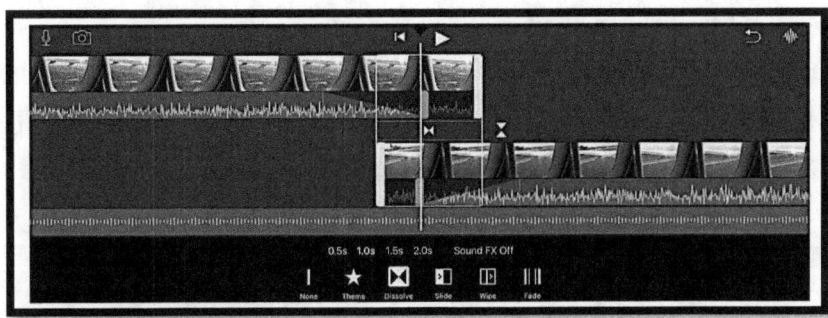

c. The audio has altered during the transition, as shown by the arrow symbols pointing in from the ends of each clip when you tap on the timeline to exit the Precision Editor.

You are now more adept at closely editing sound files. Let's discuss how to make your project's audio better overall.

Modifying Edits

Editing photos in the Movie mode

Choose Movie from the Start New Project bar at the bottom of the Projects screen. Pictures and videos are handled much differently in the Movie mode in terms of order. Fewer opportunities for editing and picture manipulation on the timeline. The playhead can only appear at the start or end of a picture. An image will move to the left or right edge of the

clip when you tap on it. This clarifies why splitting shots in Movie mode is not feasible. The only thing you can do is stop them. Additionally, the Viewer handles photos differently than it does movies. This is because of how they are positioned and shaped inside the video frame.

Applying Ken Burns' effect to visual animations

Sometimes when you add something to the timeline in iMovie, the full scene doesn't appear on screen. If you use an iPad or take a face photo, this could happen. This is what you see because the screen ratios of the image and video are different. This represents the length to height of the frame. If this ratio is different from what the viewer sees, the image won't fit the screen. The picture fills the frame entirely, either because it is too big or too tall. A lot of the photos are very huge. iMovie corrects this by zooming in and then enlarging the image to fill the screen. When this is enabled, a little section of the image takes up the full screen. This is what's referred to as "crop to fill." iMovie will automatically add motion to the image to make sure you can see as much of it as possible. We call the animation technique you saw in Magic Movie the "Ken Burns effect." Comics by Ken Burns are in Magic Movie but not editable or reversible in Movie mode.

That's simple:

a. Click on an image by swiping down. The effect's parameters will appear in the lower left corner.

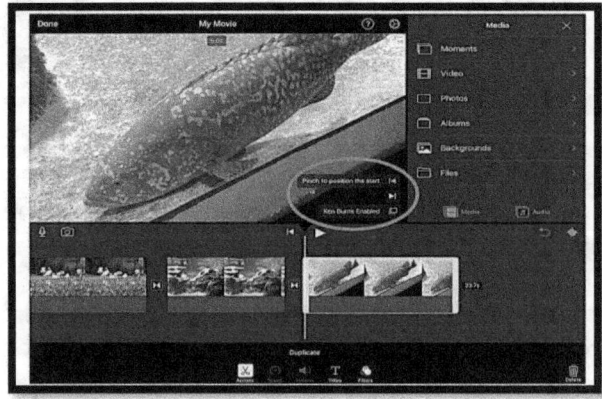

b. The blue screen indicates which iMovie menu or option is currently selected. It is also evident from where the playhead is placed where you are adjusting the start or finish of the animation. The Viewer has an option named "Pinch to position the start."
c. **Pinching the Viewer at the beginning of the clip will cause the animation to begin at a different location. Here are some things you can do:**
 ➢ To enlarge, spread your fingers apart.

- You can pinch your fingers together to make the image larger.
- Use one finger to drag the frame to move it.

d. When you move the frame and the edges turn dark, the picture is almost finished. The image will be bounced back by iMovie so that the entire frame is filled.

e. Tap the second skip button, which resembles a triangle with a line running up and down it, if you like where the animation begins. The end point is up to you. If you pinch to place the end, it will turn blue to indicate that it has been selected.

f. Press the play button at the top of the timeline and move the playhead back to the beginning after you're satisfied with the beginning and conclusion of the video. In the Viewer, you specify where the frame starts and ends. Between them, the frame should transition fluidly.

g. The Ken Burns effect on your video can be disabled with this low-level option, which reads "Ken Burns Enabled." Ken Burns will appear to be off in the Viewer.

Ken Burns can be turned off, but the image will still be cropped to suit the screen. When you place the picture on top of something else, the entire image is visible. To make a clip in the project look higher on the timeline, you "overlay" it on top of another clip. After that, the image will be displayed with a black border around it. If you wish to alter the appearance of layers, take your time. Additionally, keep in mind that you are unable to control the beginning or end of the film while using the Ken Burns effect. The animation will continue till the end of the video. It will begin immediately. It is not possible to pause an animation in the middle of a picture. If you can manage that, it will appear much less strange and more typical.

Assignments

1. Explain the process of Trimming the clips
2. Use the precision editor to create split edits and fine-tune the start and stop places.
3. Explain the Split Techniques
4. Discuss how to utilize Ken Burns effect in picture animations

CHAPTER 5
TRANSITIONS AND EFFECTS INCORPORATED
Exploring Transitions

a. **Open iMovie:** On your Mac or iOS device, open iMovie.
b. **Create or Open Project:** If you wish to add transitions to an existing project, open it or start a new one.
c. **Import Media:** Click the "Import Media" option and choose the files from your computer or device to import the photographs and video clips you wish to utilize in your project.
d. **Add Media to Timeline:** To add media to the timeline at the bottom of the iMovie interface, drag & drop your files from the "Media" browser. Put them in the order that you would like them to appear in the film.
e. **Choose Transitions:** Above the timeline, select the "Transitions" option. Many transition options, including dissolve, slide, wipe, fade, and others, are available in iMovie. Look over the possible transitions and select your favorite.
f. **Apply Transitions:** Drag the desired transition and drop it onto the timeline's edge where two clips meet to apply it between them. In the viewer window, a preview of the transition will appear.
g. **Modify Transition Duration:** iMovie automatically sets transitions to last one second. On the other hand, you may change the length of the transition by clicking on it in the timeline and moving its boundaries.
h. **Preview and Adjust:** Check the appearance of your project after adding transitions by previewing it. You can always go back and make changes or adjustments to the transitions if you're not happy.
i. **Save and Export:** After your video and transitions are to your satisfaction, it's time to save and export it. To save your project, pick "Save" from the "File" menu. Select "File" > "Share" > "File" to export your movie in the format and quality of your choice.
j. **Play Around and Have Fun:** Don't be scared to play around with various effects and transitions to see which look works best for your project. iMovie provides a variety of artistic tools to help you improve your videos.

Different Types of Transitions

A range of transition styles are available in iMovie to assist you improve the flow and aesthetic appeal of your videos. **The following are a few of the most popular transition styles seen in iMovie:**
 a. **Dissolve:** In this transition, one clip is progressively faded out and the next is simultaneously faded in. It facilitates an easy transition between scenes.

b. **Fade to Black/White:** Before moving on to the next clip, these transitions can fade the video to black or white. They are frequently employed to signify a shift in place or the passage of time.
c. **Slide:** To expose the next clip underneath, the slide transition shifts one clip either horizontally, vertically, or diagonally. It gives your videos a more contemporary and energetic look.
d. **Wipe:** To expose the following clip, wipe transitions employ a geometric shape (such a line, circle, or square). The new clip is revealed when the form advances across the screen, erasing the previous one.
e. **Push:** Push transitions cause one clip to disappear from the screen while also bringing the following clip into view from the other side. It produces an eye-catching look that highlights the transition.
f. **Cross Zoom:** This technique allows you to zoom into or out of the incoming clip and into or out of the departing clip at the same time. It produces an engaging and dynamic change of scenery.
g. **Cross Dissolve:** Cross dissolve is a transition effect that, like dissolve, progressively fades one clip out and simultaneously fades in the next. It's a tasteful and timeless change that fits in nicely with a lot of different settings.
h. **Ken Burns:** This technique dynamically adds movement and zooms to still photos, unlike a standard transition. The Ken Burns effect can be used to photographs to add motion that feels like it belongs in the movie.
i. **Map:** To simulate a voyage or change of position, the map alternately zooms out from one area and into another.
j. **Flash:** Before moving on to the next clip, Flash temporarily turns white. They breathe new life and excitement into your videos, making them ideal for dramatic or action-packed scenes.

The Transitional Effects usage

- In order to "create a project," click and hold the + symbol.
- Select the movie selection by tapping the window that appears.
- Click "Create movie" in iMovie and select the video you wish to use as a transition.
- Select an option by clicking on the video that appears beneath the timeline.
- Click the "split" button next to a clip to apply a transition effect.
- You may access the transition options in iMovie by tapping on the white line that separates the split clips.

- Choose the desired transition effect. iMovie has the following transition options: fade, slide, wipe, blur, and theme.
- Use the time limit option below to adjust the duration of the transition effect.

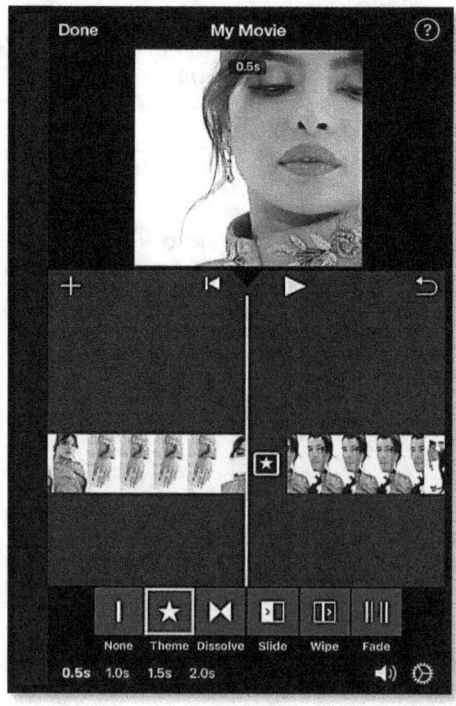

- Choose the "done" option in order to store your video.
- To save your movie to Photos, tap the arrow beneath the screen.

Techniques for Transition

a. **Match Cuts:** Use match cuts to create a seamless transition between two shots that have a lot in common. This technique can be applied by aligning segments of the incoming and departing clips, such as ensuring that an object moves in unison or maintaining the same arrangement.
b. **Sound Design:** When you transition, use sound effects or music. Your transitions will become more impactful and the viewing experience more captivating if you include sound. For example, you can apply a whoosh sound effect to highlight a fast transition or a subtle sound effect to complement a smooth fade.
c. **Motion blur:** Use motion blur effects to give your transitions a sense of motion and fluidity. Motion blur can facilitate a more seamless transition between energetic or fast-moving clips.
d. **Custom Transitions:** Create your own special transitions with layers, masks, or dynamic elements. Graphics, text overlays, or even animations can be used to create unique and creative transitions between clips.
e. **Time and Speed:** Pay attention to how your transitions are timed and accelerated to ensure that they complement the tone and beat of your video. To maintain a seamless flow and keep the viewer engaged, you may wish to adjust the duration of transitions and the timing of cuts.
f. **Transitional Effects:** Combine various transition effects to create more intricate and eye-catching transitions. You can apply a slide or push effect on top of a fade transition to give your transitions additional depth and dimension.
g. **Transitional Shots:** Employ transitional shots, such as reaction or establishing shots, to help the flow from one scene or sequence to the next. You can use transitional shots to establish connections between scenes or add background to your film.
h. **Color Grading:** Utilizing color grading techniques helps improve the visual continuity between your video's clips and give it a unified appearance. By adjusting your pictures' color temperature, contrast, and brightness, you may improve the overall appearance of your transitions.

The filters and effects usage

- In iMovie, choose the clip you wish to edit more thoroughly and drag it to the editing line.
- Select the "Filters" menu item. A list of available filters will appear.

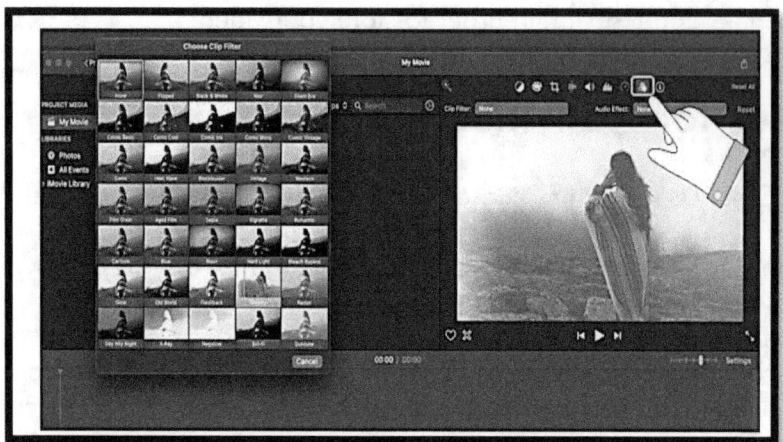

- You can drag the filter onto a clip to apply it. You can drag another filter to replace the one you don't like.

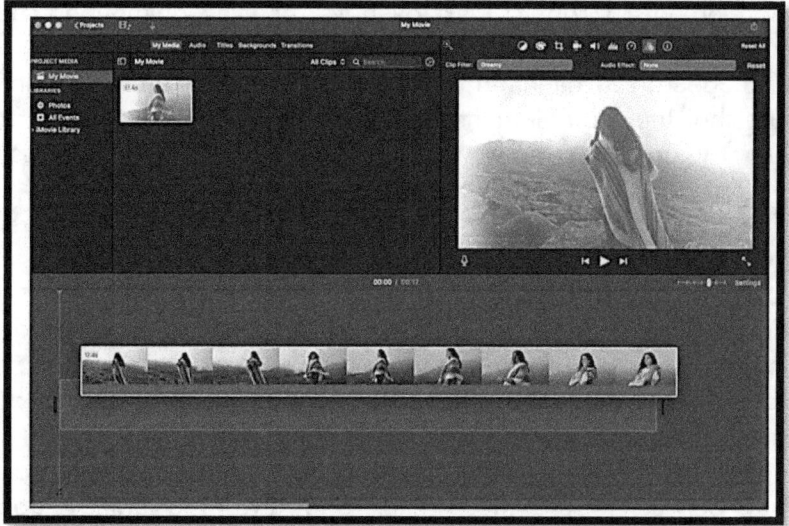

Identity theft is a common occurrence for many individuals. Sometimes revealing the faces of rape victims could also result in the public learning their true identities, which is something that should be kept private. Certain technologies blur faces and make it impossible to identify faces when images are displayed on television. These are everyday tools that people use. This hidden feature comes in very handy when you want to conceal confidential information that shouldn't be shared with the public, such as license plates, bank account information, or other similar items. Nevertheless, it's not that simple to blur faces in iMovie; we'll attempt to explain in the next part. You will need to use the picture-in-picture option to make the face less visible.

Keep on with the following actions:

- Go to iMovie > Preferences to launch the iMovie application. When you're finished, select the Show Advanced Tools option in the general settings. Next, shut down the iMovie window.

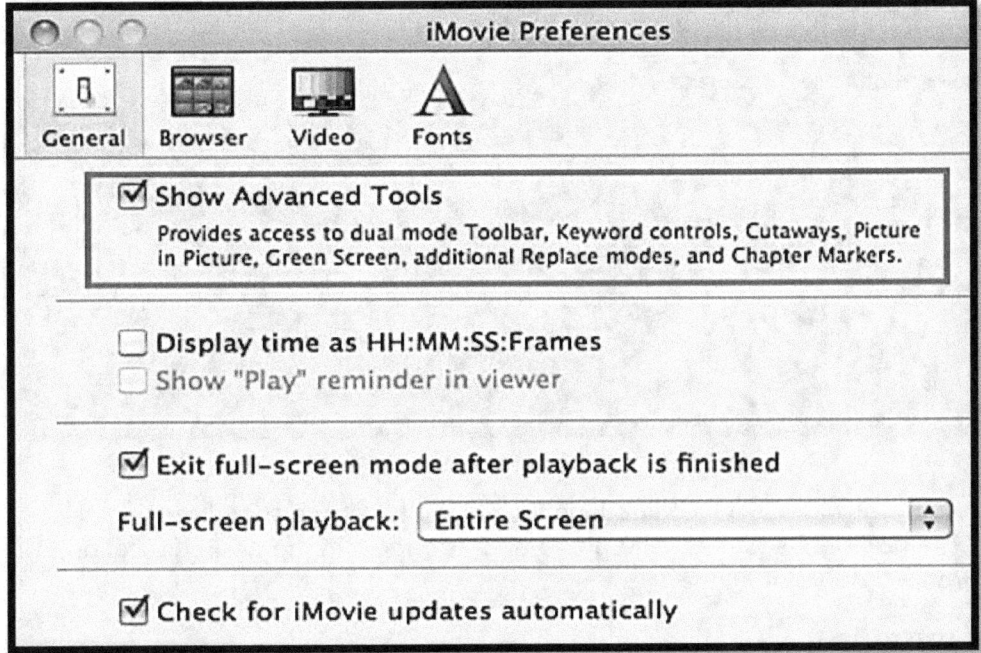

- Choosing the video clip to be displayed on the license plate is the first action in the second stage. Upon completion, iMovie will play the video clip.
- Press Shift + Command + 4 to snap a picture of the face. When you're finished, you should release the mouse button. There will be a ringing sound when the image is saved to your desktop. This will so demonstrate that the photo was taken.
- At this point, you must open it in an image editor such as Gaussian or Photoshop. The image may become hazy as a result. You are able to alter it whatever you choose. Save the image to your desktop when you're done editing it.
- Drag it over the desired iMovie clip, and then select Picture in Picture from the menu that appears. When you're done, iMovie's viewer and project window will display the blurred image as a still.

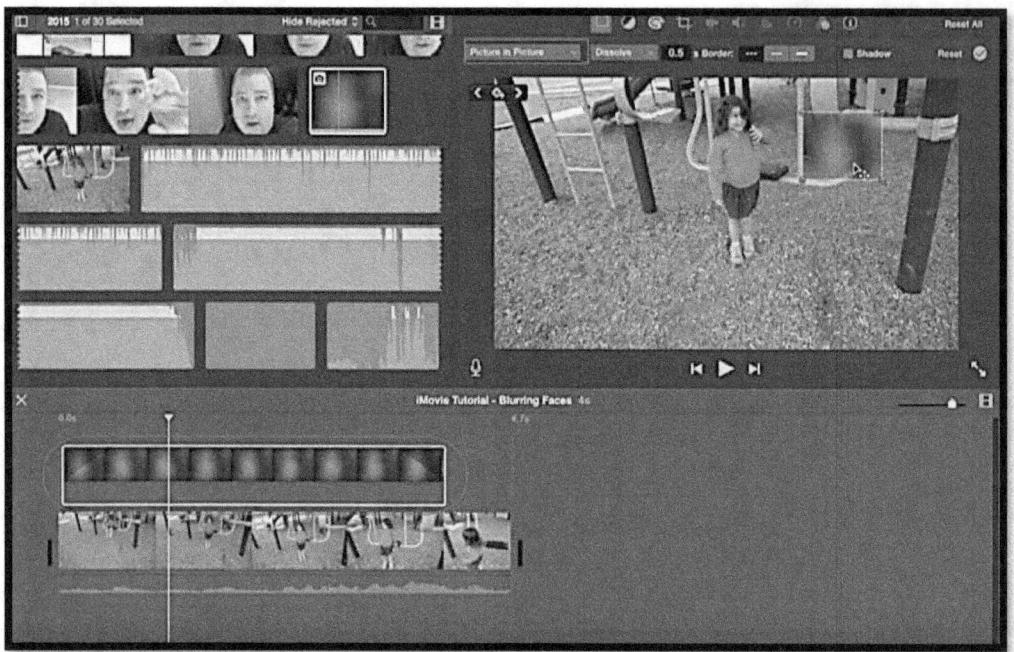

- At this point, adjust the clip's length so that it fully covers the license plate.
- The next step is to resize the photo and arrange it in the desired location inside the room.

Assignments

1. What are the types of transition?
2. Explain how to use transition effects
3. What are the methods of transition?

CHAPTER 6

DELVING INTO THE USAGE OF TITLES AND TEXT

Addition of text and titles using iMovie

Using software that allows you to add text to a presentation or video in order to create a video show or add narration to a movie requires a certain level of ability. You'll want to add text over a video on numerous occasions. It's simple to add a standard title, a lower third subtitle, or thanks to that move if you utilize iMovie on your Mac or iPhone. You are able to select one of these two options. Without a doubt, one of the greatest programs for adding text to videos is iMovie. You must drag your media files to the timeline before you can add text to your iMovie movies. Then, proceed as directed below.

- To view the list of text slides, you must click the Text button.

- Select the project-related text slide from this list. Next, drag the slide into the schedule for the project. The slide offers the choice of combining it or leaving it as a stand-alone element.

3. Double-clicking the viewing window will launch the edit mode, which you can use to alter the text. Once you have adjusted the typefaces, you can see and save your changes by clicking the "Done" button. Additionally, you can open the text editor and make edits there by double-clicking on the project timeline. You can adjust the placement and transition settings here.

The available Options for Text Formatting

a. **Font:** To style your text, iMovie comes with a number of built-in fonts that you can chose from. You can choose a typeface for your video project that goes with the overall style and concept.
b. **Font Size:** You can change the text's size to make it bigger or smaller. You can make sure your text fits the frame and is readable by using this option.
c. **Font Color:** Use the color picker to select a custom color or choose one from a preset palette for your text. To make the text stand out, utilize contrasting colors or match the text color to other aspects in your film.
d. Text alignment options include aligning it to the left, right, or center of the screen. You may place your text inside the frame precisely where you want it with this option.
e. **Bold, Italic, and Underline:** Use these text formatting options to draw attention to particular words or phrases in your writing or to add emphasis.
f. **Shadow:** To make your text stand out against the background, give it a shadow effect. To get the desired effect, you can change the shadow's hue, opacity, distance, and blur.
g. **Outline:** When your text is set against a cluttered or complicated background, use an outline effect to make it easier to see and read. The outline's color, width, and opacity can all be changed.
h. **Background:** To make your text stand out and be easier to read, add a background image behind it. To get the desired effect, you can change the blur, opacity, and color of the backdrop.
i. **Line Spacing:** To enhance readability and aesthetic appeal, adjust the distance between text lines. Line spacing can be adjusted to improve the way your text is laid out.
j. **Letter Spacing:** To fine-tune the appearance of your text, adjust the distance between individual letters. You can adjust the character spacing with this option to give your writing a more professional appearance.

About Text Animation Effects

While creating the animation with iMovie is feasible, individuals with less computer skills may find the process challenge. Given this, we are pleased to provide you with iMovie's most basic option right here. So let's begin by studying the advantages of text movement in iMovie, or any other software. Let's discuss the incredible effects that can result from

incorporating moving text into the movie clip that embodies your company. The first advantage is that it simplifies knowledge that would otherwise be difficult to understand. Then, because it looks good, moving text gives your project a more polished appearance than other projects. The iMovie text animation or other tool-made animation could also pique the viewer's curiosity. Additionally, it facilitates the dissemination of your knowledge to a larger audience than it otherwise would have.

In the next paragraphs, we will examine the steps required to animate text in iMovie using Keynote animation.

a. Firstly, you will need to download Keynote from the Mac store in order to proceed with the iMovie text animation procedure in later stages.
b. To include moving text in an iMovie movie, select the Image option when you click the Share button after selecting the project you wish to work on and moving the playhead to the desired location. It will then offer you this image as a JPEG file, which you must import into Keynote. To accomplish this, create an animation over the image (a lower-third animation in this case), remove the backdrop, and then send iMovie merely the animation as an overlay.
c. Before you erase the backdrop, make sure you haven't selected any of the things on the slide. Choose the "No Fill" tab from the Format menu.
d. To enter the Export window, select File > Export to > Movie from the menu bar. After choosing the Self-Playing option, you must click the Cancel button. The "Animate" tab, which is displayed in the image below, must be clicked in the following step. Now that you've selected the Build Border tab (see below), the Self-Playing options for the text animation are visible. Return to the File menu, select Export, and then select Custom from the resolution drop-down menu. The precise size settings that iMovie will accept can then be entered. Next, in order to save the animation with a see-through background, you must select Apple ProRes 4444. To continue using iMovie after that, navigate to the Next > Save As > Export menu.
e. Restart iMovie from Keynote and drag the newly saved video file onto the program's timeline. This will give the project you just finished another level. You may want to use the Apple Keynote Presentation package before moving text in iMovie. This follows the previous sentence. The explanation for this is that iMovie cannot produce these kinds of animations on its own. As a result, in this instance, the procedures for loading the files, configuring Keynote, and saving them are a little more involved.

Addition of Typewriter Effect Titles using iMovie

Although the typewriter effect isn't included in the collection of title animations that iMovie comes with, you can still add it to your movie using Keynote. Keynote is an excellent tool for creating slideshows with text. The text is entirely customizable to you, including the

font, size, color of the background, and hundreds of text effects. You can create complex text effects with Keynote, which you may then utilize in iMovie.

The steps are as follows:

a. Launch Keynote, and then select the Wide Themes tab. Next, pick the white blank theme from the list of options.
b. After adjusting the slide's size as needed and deleting the sample text, choose Color Fill and use the slider to alter the slide's background color to green.
c. You can type your own words by selecting the Text tool. After that, you can alter their placement, size, color, style, and other features.
d. Selecting the text is now required, and you should click the "Animate" button in the upper right corner of the screen. Select Build In and Add an Effect after that. Pick the Typewriter effect from the drop-down menu.
e. You can adjust several parameters, such the effect's direction and duration, after selecting your text and applying the Typewriter effect. Here, ensure that the build order is verified and that it begins following the completion of the transitions.
f. To see the outcome, you must see the typewriter effect. Next, export the typewriter effect by choosing the QuickTime video file format from the File menu.
g. After importing the typewriter effect you made in Keynote into iMovie, you can drag and drop it onto the timeline to position it exactly above the video clip you wish to apply the effect on. Remember that to make the text layer's backdrop see-through, you must utilize iMovie's Green/Blue Screen tool.

The Movie Text Effects Application

How to Include Text Effects in a Mac iMovie

iMovie simplifies the process, especially if you want to create something very cool or don't have many options. You may add several text themes to movies using iMovie. Every text template has a location and a motion effect. Learn how to add text to an iMovie project to add some excitement to an otherwise dull movie. However, you must first become familiar with iMovie's text effects. The Title Text is often positioned in the center of the screen. The Third Callout and Credits Text are two different types. Third, callouts are typically positioned toward the bottom of the screen, either to the left or right. When writing a new person's name, this is done. Credit texts are typically displayed in the center of the screen. What in iMovie can you put text? The name of a character at the bottom of the screen, the title at the start or finish of the film, or anything else can be added.

Stage 1: launch iMovie and create a new project

Go to iMovie and select the Projects tab to launch the Projects browser. Select Movie and Create New after that. You can also obtain a job that is still in operation if you use it frequently:

Stage 2: Include any media

Select "Import Media" to include images, audio, and videos in your project. Now, drag the newly added video onto iMovie's timeline. The window at the bottom of the screen is the timeline.

Stage 3: Add dialogue to the film

This is when it gets really crucial. Clicking Titles above the browser will open a text window. The main window of iMovie is this. You will then have a plethora of options at your disposal. You can preview the appearance of a text style by dragging your mouse over an image of it.

To add the pick, double-click it or drag it to the desired location within the video.

Stage 4: Inscribe a Custom Text

You can customize the iMovie text effect by adjusting the font style, size, color, and direction. Double-click the text box to edit it, and then enter text into it. Next, adjust the text's font, size, spacing, style, and color using the tools above the window until it is the proper size and hue.

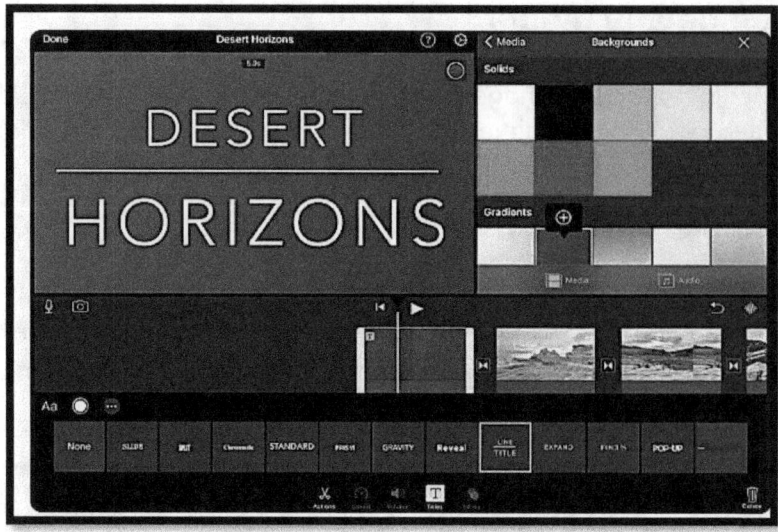

TIP: You can edit and rearrange the text to display in the correct location in your video by dragging the text layer to a new location. To adjust the duration of the text layer box, you can also shift it to the right or left.

The Colors, Animations, and Font Styles modifications

a. **Font Styles:** You can select from a variety of pre-installed fonts in iMovie for your text overlays and titles. **Take these actions to change the font style:**
 - To access the Title Inspector, double-click on the title clip within the timeline.
 - Choose a font from the choices by clicking on the "Font" dropdown menu in the Title inspector.
 - Choose the font you wish to use for your text by scrolling through the selection.

b. **Font Colors:** You can change the text's color to fit the tone and design of your film. **Here's how to alter the color of the font:**
 - To select a color for your text, click the "Color" dropdown option in the Title inspector.
 - You have the option to choose a color from the preset palette or create a custom color using the color picker.

c. **Font Size:** You can change the text's size to make it bigger or smaller. **This is how you adjust the text size:**
 - To change the font size, move the "Size" slider in the Title Inspector.
 - Drag the font size slider to the left to reduce it, or to the right to raise it.

d. **Animations:** To add movement and interest to your titles and text overlays, iMovie comes with a number of pre-made animations. **This is how you can alter the animation:**
 - To select an animation style, click the "Animation" dropdown menu in the Title inspector.

- Press the play button adjacent to the dropdown menu to see a preview of the animation.
- With the Title Inspector, you can also change the animation's direction and pace.

About Font Choice and Design

Selecting Fonts

- To access the Title Inspector, double-click on the title clip within the timeline.
- Find the "Font" dropdown menu in the Title inspector.
- Select the typeface of your choice by clicking the dropdown menu.
- Scroll down the list and select the font type that you wish to utilize for your writing.

The Font Style

- Once a font has been chosen, you can style it further to get the desired appearance.
- Use the Title inspector's "Size" slider to change the font's size. It can be made larger or smaller by sliding it to the right or left, respectively.
- In the Title inspector, use the "Color" dropdown menu to change the font color. Use the color picker to choose a custom color or pick one from the palette.
- Use the corresponding Title Inspector buttons to format your text in bold, italic, or underline.
- Use the Title Inspector to change the alignment of your text by clicking on the left, center, and right alignment icons.

The Advanced Styles for Fonts

- Some font types might have extra modification choices like stroke, shadow, and background.
- Click the "Show Advanced Options" button in the Title inspector to reveal these advanced styling choices.
- From there, you may change attributes like background color and opacity, shadow color and blur, and stroke color and width.

Previewing the Fonts

- You can preview font style changes in real time by playing back the title clip in the timeline as you make them.
- This enables you to view the font's appearance within the context of your video and make any required changes.

Adding both subtitles and captions

You cannot undervalue the importance of captions and captions as a content creator. Using these visual aids allows a greater number of people to access your content, especially those who have speech or hearing impairments. The next question is how to include them into your movies.

Is it possible for iMovie to sync movie subtitles automatically?

Subtitles for the movies that are now playing in iMovie are not generated automatically. That does not, however, mean that you should abandon the situation. Using the application's Title feature, you may create your own subtitles and have them appear over the video you're watching. This technology makes it easy to add captions or subtitles to any movie you want, even though it can be challenging at times.

Can an SRT file be imported into iMovie?

The short answer to this question is "no," since iMovie does not support the straight import of SRT files. You can still utilize the SRT file to create the subtitles in this situation. To do this, copy and paste the text from the SRT file into the application. When you choose the Title option, a text box appears where you may type your words. Copy the text and then paste it there.

The suitable measures

You may quickly comment or add subtitles to what you're watching when using iMovie on a Mac. In order to start this one, no specific knowledge is needed. If the file is long, it might be a useful way to burn some finger fatigue for a short while.

Here's what you should do to get started:

- On your Mac, iMovie must be opened. If you are unable to locate the program in the dock, you should search the Applications folder in the finder window. Double-clicking the button is required before you can utilize iMovie.
- Next, you ought to start a new job. After everything's finished, you can add the video that needs captions. To get things started, select Project first, then Create New, and lastly, Movie.

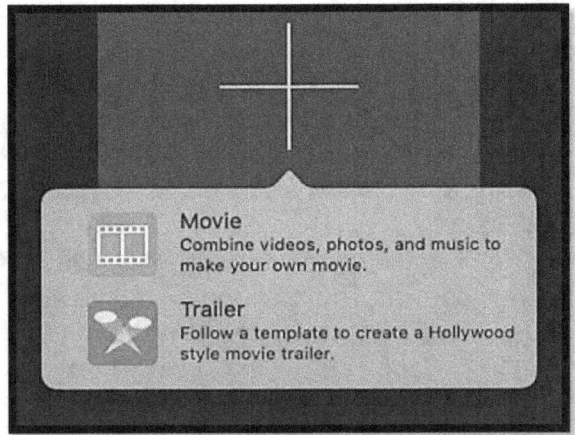

- The subtitle-equipped video must be added next. Select the clips you wish to utilize by clicking the Import Media button.
- You will see one of your videos in the upper left box. After that, on the specified date, you will have to relocate it to the location of your choice. In this case, a simple drag-and-drop technique can be used. The video file can be dragged and dropped to make it appear on the stream. The video file will include an image thumbnail.
- Adding handwritten captions is a breeze with iMovie. To get started, you must click the Titles button. After completing that process, a list of styles, including Split, Expand, Slide, and Focus, will appear. Select the option that most aligns with the image of your brand.

- Once you've selected a style, you may transfer the Title box to the timeline by dragging and dropping it there. Select when you would like the captions to start. A timestamp will be added to each text box you fill out, and it will appear above the video clip. You'll need to include a lot of subtitles with your effort. Make sure the subtitles are inserted straight into each of the Title boxes after you've added them to the timeline. If using a variety of styles aligns with the concept of your video, then go ahead and do so.
- Making your notes appear better comes next, after you've typed them down and verified that they are correct. The fact that you can edit the text in iMovie is wonderful news. To access the Title box, click on one of the boxes. You can choose from a variety of typefaces in the upper right corner of the screen, just above the video. Determine which color, shape, size, and orientation are most appropriate for your brand. The process ends when the video is stored, which is the final step. Simply select the File option at the very top of the screen. Select File once more after first selecting the Share option. Click next, give your video a name, and then click Save when a box appears.

Captions or subtitles can be added with an iPhone or iPad running iMovie

Not every person has a Mac. If all you have on your device is an iPad or iPhone, you can still annotate or add subtitles to your movie.

a. Launch iMovie. You can download this app from the App Store if it isn't already on your iOS device. The app will then launch with just a click on the icon that appears on your phone's screen. A bar with several options labeled "Start New Project" will be the first thing you see. Click on the Movie option to proceed.
b. The video that you wish to add captions to must be added to your computer. Please ensure that the video clip is saved to your iPhone or iPad. The software will direct you to the movies that are saved on your iOS device when you select the Movie option at the beginning of the procedure. Click on the one you wish to use, and then choose it by clicking the "Create Movie" button.
c. After that, click on the media in the timeline by pressing the T button at the bottom of the screen. Upon completion of that phase, a few Title styles will show up beneath the timeline. Once you've determined which best suits your needs, you should adjust the timeframe to the appropriate time.
d. While the video is playing at the top of the screen, the text will appear continuously throughout the movie. Simply select Edit after you've clicked on it. When you're finished, you can type any text you like in the box. It will show up above the video clip at the selected moment when you hit the Play button.
e. You might need to repeat the preceding procedures if you wish to add several captions to your movie. An alternative would be to select a different style for the Title.

f. On the upper left corner of the screen is the "Done" button. Click it once you're satisfied with the titles you've created. At that moment, you can save the file by clicking the Share icon at the bottom of the screen. It's also possible to share the movie with your pals via /. Using AirDrop, you can share the movie with your buddies. The video will be stored to the iOS device you are now using if you select the "Save Video" option.

How to edit and design subtitles in iMovie

Let's talk about editing subtitles now that you know how to add them in iMovie. You may modify the wording as soon as you've completed adding your comments. The directions differ slightly depending on whether you're using a Mac, iPhone, or iPad. Once you've added subtitles to your movie in Mac iMovie, you can change the text. You still have options even if you will have chosen a style at the beginning of the process.

Having said that, to give the subtitles in your video a more personal touch, adhere to these guidelines.

a. Click on the Title box that you wish to modify to get started.
b. Place your cursor over the text options located in the upper right corner of the screen.
c. Next, select the font type by clicking the dropdown menu.
d. Utilize the dropdown menu to select the letter size in the fourth step.
e. Deciding on the alignment of your comments.
f. Select Italic (I), Bold (B), or Outline (O).
g. To select the color you want for your text, click the color box.

On an iPad or iPhone, how do you modify subtitles in iMovie?

If you chose to use your iPhone or iPad instead, you can edit the video that you captured there. It is likely that the process will out to be little more difficult than you had first thought.

Once the comments have been added, you need to complete the following:

a. Click on the Title box that you wish to modify to get started.
b. To select the type style you wish to use, press the Aa button.
c. To change the text's color, click the color circle button.
d. To view additional customizable choices, click the button.
 - both lowercase and capital letters
 - Text style Shadows of the text

You can change the settings by clicking on the choices displayed above or by using the toggle button. Click "Done" to proceed after selecting the text style that best suits your needs.

Assignments

1. What are the process of using iMovie to add text and titles?
2. What are the available Options for Text Formatting?
3. What are the steps for using iMovie to Add Typewriter Effect Titles?
4. How do you add Text Effects in a Mac iMovie?
5. How can you use iMovie to edit and style subtitles?

CHAPTER 7
ADDITION OF SOUND

Importing and Organizing Audio Files

- Click the ADD MEDIA (+ Symbol) option after selecting the project you wish to work on.
- Select the AUDIO option from the menu. You will now have a choice between three options. iCloud allows you to access music, playlists, and My Music. You may select any option you desire. All it takes to play a narrative is a touch. Touch the track to download it if the sound is not on, and then touch it again to hear a sample.
- To add a score to a project, simply click the "Add Audio" button next to it. If you use iMovie, the project's soundtrack will begin at the beginning and be adjusted to match the project's duration. This will be completed over the course of the project.

About the Compatible Audio File Formats

a. Advanced Audio Coding (AAC) is a popular audio format that is renowned for its superior compression. For music and other audio files, it is frequently utilized.
b. One of the most widely used audio formats for digital audio saving and playback is MP3 (MPEG Audio Layer III). It provides high-quality audio at comparatively tiny file sizes.
c. **Waveform Audio File Format (WAV):** WAV is a high-quality, uncompressed audio format. Professional audio editing and recording are popular uses for it.
d. The uncompressed audio format known as AIFF (Audio Interchange File Format) was created by Apple. It provides high-quality audio and is frequently utilized on Mac computers for audio recording and editing.
e. **Apple Lossless:** Developed by Apple, Apple Lossless is a high-quality audio format also referred to as ALAC (Apple Lossless Audio Codec). With reduced file sizes, it offers the same audio quality as uncompressed formats like WAV and AIFF.
f. The multimedia container format MP4 (MPEG-4 Part 14) supports audio, video, and subtitles. MP4 files can have their audio tracks imported into iMovie for editing.
g. **M4A (MPEG-4 Audio):** The AAC codec is used to encode audio files with the M4A file extension. Music and other audio files are frequently stored on it, particularly those that are bought from the iTunes Store.
h. Apple created the CAF (Core Audio Format) container format for audio data. It is frequently used for professional audio applications and supports a number of audio formats.

Add audio files to your iMovie creation, such as music

You can add songs from your library by using the Music app. You can also add other music files that are kept on your PC, in iCloud Drive, or somewhere else. You may sync your iPhone, iPad, or iPod touch with music and other audio files. Tracks from your device's music library can be imported into iMovie via the Music app. Moreover, you can use it to get music files back from your computer, iCloud Drive, or any storage device.

Add some of your collection's tracks

You can sync audio files, including songs, from your Mac's music library to your device using the Music app. You can also add songs to the Music app on your phone from your library.

- Click "Add Media" next to your project in iMovie once it's open.
- Select My Music from the Audio menu. Next, select a group to view the songs within it by clicking on it.

- To hear a sample of a song, tap on it. To save the song to your phone, locate it in the Music app and, if it isn't already illuminated, hit the Download button.
- Click "Add Audio" next to a song to add it to your project. The music is edited by iMovie to match the duration of the project. It begins with the project's inception. The length of the music can be altered, just as with any other video. A project may contain more than one song. By removing the first song from the timeline and replacing it with a new one, you can alter the tone of the music in your film.

Adding extra audio files

iCloud Drive, your computer, and other locations are all viable sources for adding audio files, including M4A, MP4, MP3, WAV, and AIFF.

- The white vertical line, known as the playhead, indicates to iMovie where a file should be added to the timeline. Move the file there if it is less than a minute in length.
- Press the "Add Media" shortcut. Then select "Files" to view your files on iCloud Drive or another location.
- Click on a file to add it to your project.

Any sound file you add to your project that lasts longer than a minute is treated as a song. Shorter than one minute files will appear wherever you position the playhead. On a Mac, add music or other audio files. You can add tracks from your music collection to the iMovie for Mac Music app using the iMovie media viewer. Using the Finder, you may also add music files to your stream.

Add music or other audio files using the media browser

iMovie's media search allows you to add tracks that you've saved to your Mac's music library. You can also add sound files and music that are already in your library.

a. Navigate to the top of the window after opening the project. Click to hear. Then select Music from the Libraries list. Next, consider your choices.
b. Press the play button adjacent to a song to listen to a sample. To listen to a song on your own, select it, click on the waveform at the top of the player, and then hit the Spacebar.
c. **Drag a song you enjoy from the search gallery into the queue:**
 - Drag the file beneath the video clip until a bar appears, connecting the segments. The song or sound effects will now be added. The song will move with the video clip as you move it.

The location of the music play area is shown by the music note icon at the bottom of the timeline. You can drag tracks into your movie to add background or theme music. You can rearrange the video clips in the sequence, but the song won't change.

Choose a range from the waveform at the top of the window that has a yellow line in it. If you only want to use a portion of the music, drag that portion onto the timeline. By dragging on either side of a range choice, you may change its length.

Drag and drop audio files into your iMovie project's timeline.

To add music to your iMovie project, drag and drop M4A, MP4, MP3, WAV, and AIFF files from the Finder. An audio file can be dragged beneath a video clip to be connected to it, or tracks can be dragged to the music well to provide background music.

Should a song not be available in iMovie

Your music library's protected files are not shown in the browser and cannot be accessed. You need to either possess the rights to the music or obtain permission from the owner before using any that you downloaded from the iTunes Store for your project. Navigating to iMovie > about iMovie and selecting License Agreement will provide the iMovie software license agreement. It contains further iMovie usage instructions.

Incorporating sound effects

A sound effect that you add to the timeline is connected to the video clip that is above it. You can move the video clip and the sound effects at the same time. But this isn't the same as music, and music isn't the same as the video parts that comprise your show. To add the sound effect, move the play head (shown by the white line) to the desired point on the timeline while your project is open.

- To hear the built-in Mac sound effects, click "Add Media," followed by "Audio," and lastly "Sound Effects."

- To hear a sound effect, you must touch it. To add the sound effect, click the "Add Audio" button next to it.
- Modify the volume of the video. To achieve the ideal sound mix for your iMovie project, you can adjust the volume of various audio or video clips that incorporate sound. After incorporating audio into your project, you have the option to select one of these options.
- To adjust the loudness of an audio or video clip, choose it from the timeline, click the Volume button at the bottom of the window, and adjust the volume by dragging the slider to your desired level. A mute icon will appear on a clip in the timeline when the volume is completely reduced.

Cutting or Expanding the Audio Clips

Changing the duration of an iMovie audio clip is simple. Slide a pin through the timeline. The longer you carry the clip, the shorter it gets. When you're finished, a new lesson will appear in the upper left menu. The duration of the clip is another option. Select the clip from the timeline, and then use the context menu to select "Clip Information." The "Clip Information" tab is the one with the letter "i" over the Viewer. In the white box on the right, enter the desired amount of seconds for the time.

Modifying the Tempo of a Sound clip

You may adjust the pace and duration of an audio clip in iMovie by changing the music. Take action right now!

- **Step 1:** Select the Speed button located at the top of the Viewer. Next, enter a percentage and select a speed from the drop-down box adjacent to it. In that box, you may also adjust the speed.
- **Step 2:** From the menu that displays, select "Show Speed Editor" by performing a right-click on the video clip. A scale will then appear at the top of the clip. It can be moved to go more quickly or more slowly.

Changing the Volume and Audio Levels

Adjust the audio level in Mac iMovie

When you adjust a clip's level in iMovie, the audio waveform's shape and color are altered to visually represent your adjustments. Keep an eye out for any red or yellow peaks on the waveform. The waveform is said to be warped if there are yellow peaks, and severely distorted if there are red peaks. Reduce the volume until the curve is completely green. It is excessively loud if it is red or yellow. If the waveform has any red or yellow areas mixed in with the green, you can adjust the volume of that section.

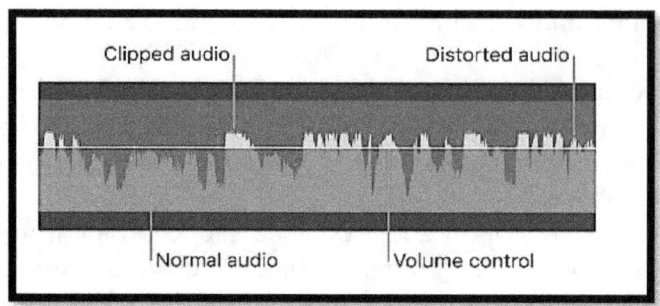

Navigate to the upper right corner of the timeline and select the Settings button to view waveforms. Next, choose the checkbox labeled "To Show Waveforms."

Modifying the volume of a timeline clip

- Select a sound or a music-accompanied video clip from the iMovie app's timeline on your Mac.
- The bottom line that travels throughout the audio spectrum is the volume setting.

As you drag, the amount is shown as a number that changes along with the level's shape to reflect your modifications.

Adjust a section of the clip's loudness

The volume of a clip can be changed just for the portion that you have chosen. The length of the black line that runs through the audio clip indicates how loud it is.

- On your Mac, select a clip from the timeline of the iMovie software, then hold down the R key. You can drag the cursor across a portion of the clip once it changes to the Range Selection pointer.
- To adjust the volume to your desired level, move the volume setting (the line that crosses the pattern) up or down.

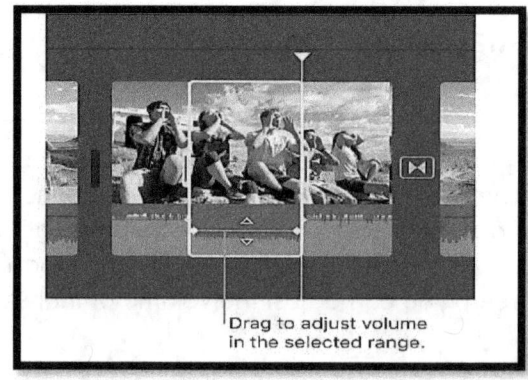

iMovie automatically adds a fade to each edge of the selection and only modifies the volume in the range selection.

- Only the range selection allows for volume changes, and iMovie automatically adds a fade to each boundary of the selection.

Reduce the volume

- Select a few sound-assisted audio or video clips from the iMovie app's timeline on your Mac.
- To view the sound settings, press and hold the sound button.

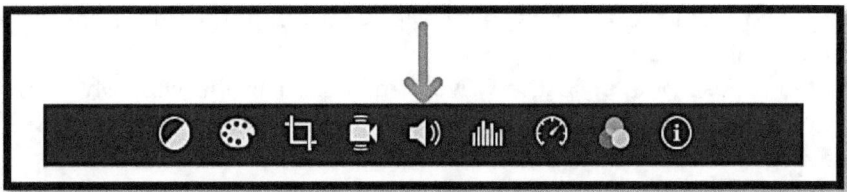

- On the "Mute" button, press.
- Press the "Mute" button once more to disable it.

Including the background music and sound effects

Including the soundtrack in the backdrop

Once you've located the right track, it's time to add it to your project. When you add a music file to your timeline, be sure it doesn't cover up any of the open video clips. You should let go of the mouse button when you see a green plus symbol (+). This creates the idea that the video's background track is being updated with new music. It will be clear that this is a background music clip because the track will appear on your timeline in green. By dragging the soundtrack to the relevant spot on the timeline, you may easily add background music to particular parts in your movie. You can then include the music after that. Holding onto the mouse button until you see the green Add (+) symbol one more time is very important. You can change the song's duration by selecting the audio clip (the edge will turn gray) and dragging the slider to make the song longer or shorter.

Alter the background music

You can change the background music's start and end times in iMovie. For instance, you might want the music to start in the middle of the song and fade out at the end. If you right-click on the music clip, a menu will appear. Choose "Show Clip Trimmer" and "Trim to PlayHead" from that menu. This lets you change how long the background music plays

for and how loud it is during that time. Fade-in and fade-out effects are optional; however they can help with the transitions between the different audio sections.

Use keyframes to gradually change the audio

With keyframes, you may progressively turn up the volume in some parts of a video and down in others. By adding keyframes—markers that you can insert at specific positions in a clip—you can change the volume at those exact periods.

The audio clip's volume in relation to other clips is shown by the black line that crosses the audio waveform.

- Select a clip from the timeline in iMovie for Mac that includes music you wish to alter during the video.
- Move the mouse pointer to the waveform section of the clip, which is the volume control (the leftmost line). This is where a keyframe should be added. The process of creating a clip begins with this.
- You must hold down the Option key while clicking the volume control to add a clip.
 Holding down the Option key will cause the pointers to approach the volume control.

The Add Keyframe pointer will be the next pointer to move. You can add as many keyframes as you like to the clip by clicking on them.

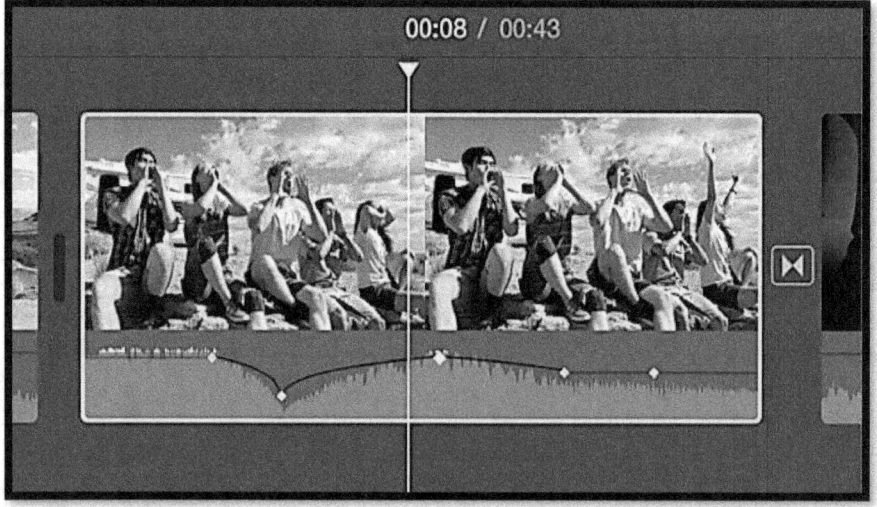

If you wish to alter the sound of your clip over time, you must include a minimum of two keyframes. This is due to the fact that level modifications take place in the interval between two keyframes.

Once two keyframes have been added, you should do one of the following:

- You can adjust the clip's loudness by dragging a keyframe in either direction.
- You can adjust the loudness of the clip between two keyframes by dragging the volume slider in either direction.
- A keyframe in the timeline cannot be deleted unless you control-click on it and select Delete Keyframe from the menu that appears.

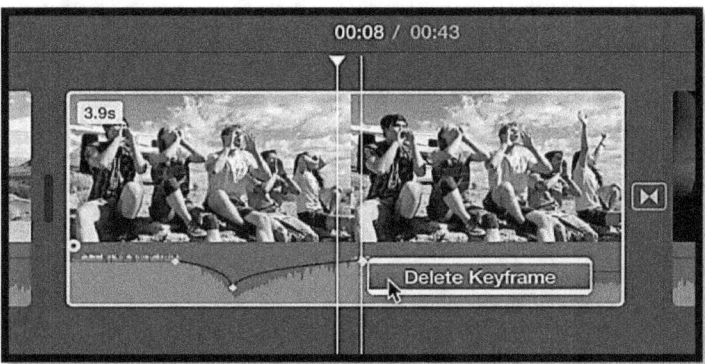

Switch off iMovie's audio on the Mac

People frequently employ fades, or sound transitions between sounds. In music, fade-outs begin loud and gradually become quieter until they reach stillness, whereas fade-ins begin quietly and gradually get louder until they reach full volume.

- Navigate the mouse pointer over a clip's background sound within the iMovie software on your Mac. This will display the clip's corresponding fading controls.
- Move the fade lever to the desired beginning or ending point in the clip to initiate or stop the fade.

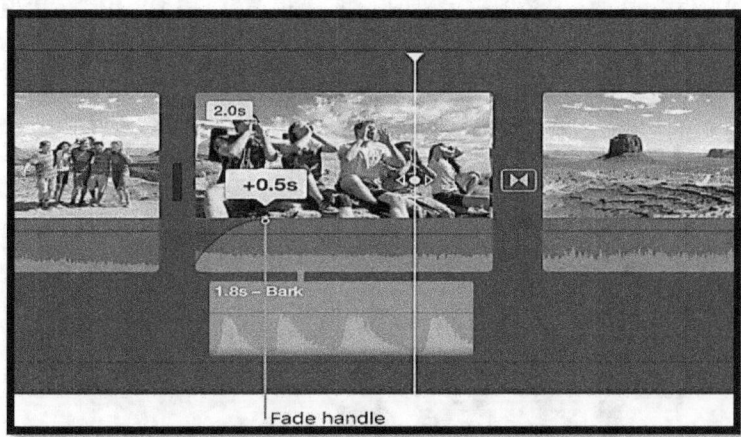

Drag the fade handle at the beginning of the clip to create a fade-in. Drag the fade handle at the conclusion of the clip to create a fade-out.

Record a voiceover and add it in iMovie

You can record sound in iMovie to enhance the scenes or say something. Why not use iMovie because you can add voice-overs to it? It's simple to add text to any area of your film and provide an explanation of a movie with iMovie. One built-in microphone or another can be used.

Step 1: Visit the website for recording voiceover

- Position the Playhead where you wish to add the voiceover on the timeline. To start recording, click the Record Voiceover icon located beneath the sample boxes.

Step 2. Modify the voiceover recording parameters

Now, before you begin, you can adjust the parameters for recording commentary:
- You can adjust the speech level and select the input source when you click the Voiceover Option button. To adjust the clip's volume, just move the level button to the right or left. That's a wise decision. iMovie will cut off the music from the clips while you record if you tick the "Mute Project" option.

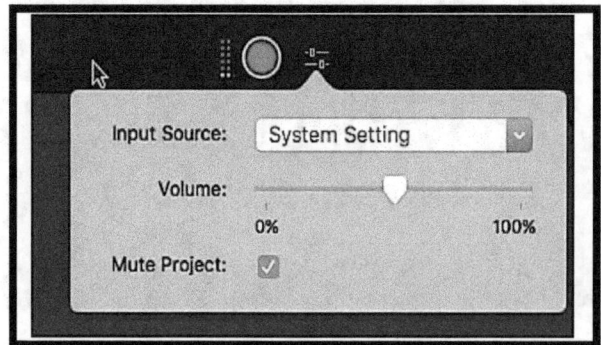

Step 3. Begin and end the voiceover recording

To create a video, click the red "Record" button. Upon completion, press the Record button one more. "Voiceover" is the name of a recently added audio clip to the timeline. When you're finished, click the "Done" button to the right of the speech recording settings.

Assignments

1. Explain the process of importing and Organizing Audio Files
2. Mention some Compatible Audio File Formats
3. Mention some viable sources for adding audio files,
4. How can you add Sound Effects and Background Music?

CHAPTER 8
CONCERNING OVERLAYS AND KEYFRAMES

iMovie Video Overlays: Options

Before delving into the process of layering films in iMovie to produce picture-in-picture effects, let's take a brief look at what's possible with video layers. There are four different layer options in iMovie.

This is only one of the many fantastic features of the application.

- **Cutaway:** This is one of the available patch options in iMovie. If you decide to upload your video using the cutaway method, the project will transition at specific points in the timeline to the footage that is positioned above the original track. Upon completion of the video layer, the project will return to the primary clip.
- **Green/Blue Screen:** If you add your video over the main clip using the Green/Blue Screen option; it will appear without any green- or blue-screen elements. The remainder of the clip will be added to the timeline on top of the primary clip after the portions that aren't green- or blue-screened are cut out.
- **Split Screen:** This layer allows you to display two movies or images side by side. This section also allows you to rearrange the clips so that they stack on top of each other.
- **Picture in Picture:** This feature allows you to add an image or video to a portion of the screen. The clip will overlay the primary clip on the timeline in a smaller window. You can utilize the "Picture in Picture" function in the timeline.

Why Is a Video Overlay Required?

For whatever reason, you should think about adding a video layer. Included in this are the following:

Raising the level of audience participation

A video overlay is made for several reasons, all with the goal of increasing user engagement with motion. Hotspots, links, and clickable buttons are examples of dynamic elements that can be added to a video overlay directly over the video. Longer viewing sessions are encouraged by providing more possibilities for viewers to investigate and interact with the movie.

Additional background data

One of the best ways to give your videos more meaning is to add a layer. Video overlays may help your viewer's better grasp the message or content you're delivering since they let you add more information like subtitles, images, or other stuff that gives your video additional meaning.

Enhance the branding and messaging

You could also need to make a video layer if you want to reinforce your brand and message. By adding text, logos, or other branded elements over the video, you can make sure that viewers understand your most important points and reinforce the brand of your company.

Receive Easy Content Updates

With video inserts, updating or changing text or image content in a video is easy and doesn't need reshooting or editing the entire thing. The following approach is useful if you want to keep your content current and relevant without having to put in a lot of work.

Create a dramatic effect

Visual effects like film grain, light leaks, and other creative filters can enhance the overall appearance of your film. It will make your video look more professional and more like a motion picture.

How to Add Videos overlay to iMovie for Additional Features and Picture-in-Picture Effects

Using a video over a video is a great idea if you want your viewers to stay interested in your film.

To add videos on top of one other in Mac iMovie, follow these steps:

- As soon as your Mac opens your iMovie project, confirm that every film has been saved and is prepared for usage.
- Drag and drop the second video into the timeline after moving the playhead to the desired location for the video overlay. The video layer will then be inserted successfully.
- Two videos should now appear on the timeline. To adjust the video overlay's settings, click on it. Next, navigate to the top of the screen's iMovie menu and select the Video Overlay Settings option.

- A list of the various overlay kinds and a little download button will appear when you select the overlay choice. Simply select the "Download" option, after which you can choose the location for the video. In addition to the picture in picture mode, you may also set up scenarios like cutaways, split-screen, green/blue screens, and more.
- Now you can alter the layer that's currently shown on your screen, if needed. When you're done editing and adding effects, you can export the iMovie video to your Mac. To accomplish this, select File from the File menu, then Share. Choose the format, quality, and resolution you wish to use to save the video after that.

Use cutaways to conceal jump cuts

What exactly is a jump cut?

Having the time elapsed displayed is an effective approach to use the Jump Cut technique. A shot that has been split up into several parts is called an abbreviated shot. The goal of most projects is to produce a seamless experience, yet by emphasizing the breaks, Jump Cuts undermine consistency. Making this choice can have a big impact on the viewer's experience if done well, but it's also very easy to get it wrong. After discussing the definition of the phrase, we shall discuss the circumstances under which and methods by which someone may employ a Jump Cut.

Which circumstances and techniques may you use a Jump Cut for?

In the following situations, including jump cuts in your video makes sense:

- You should display a variety of items, such as food, beverages, hotel, and so forth.
- It should be easy to switch between characters by using abrupt cuts if you decide to add more.
- One thing you should do is build the tension in a moment. Increasing the magnification of an object with every cut is one method to achieve this.
- Alter a picture's subject or environment to convey the passing of time.

Keyframing is a crucial technique for video editing; you should be aware that it can produce effects that are very different from what a Jump Cut can accomplish, as well as better-looking transitions. Now that we understand what a Jump Cut is and how it functions in iMovie, here's a rundown of the steps involved in creating one:

The Jump Cut tool in iMovie: How to Use It

When iMovie is launched and ready to use, you may start by following the steps below.

- To begin a new long-format project, choose Movie.

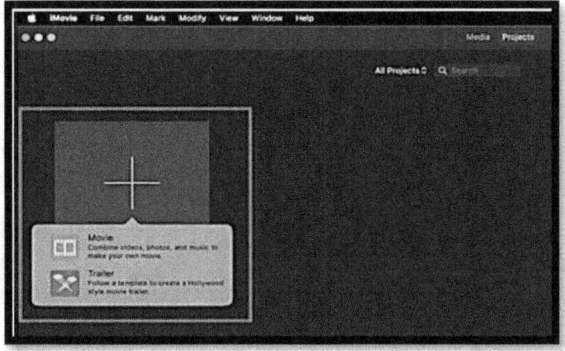

- Insert your video clip into the Timeline by bringing it in.

- You may divide a video clip by simultaneously pressing the Command and B keys. Create a second clip then, stopping the original where you want it to. It's crucial to keep in mind that the context menu can also be used to split. To turn on the Trackpad, either tap it with two fingers or perform a right-click.

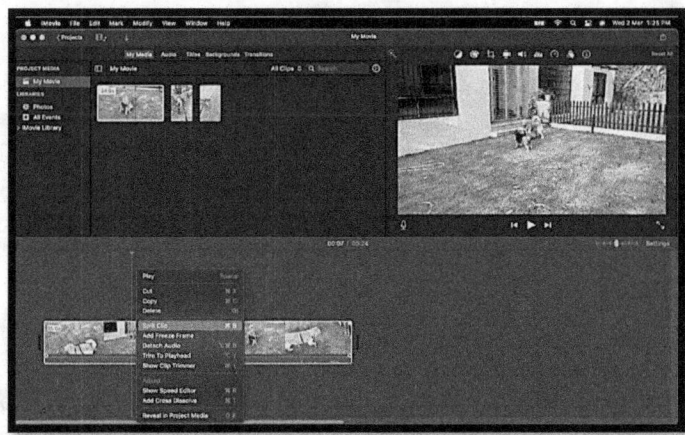

- Get rid of any unnecessary clips. This will cause a hole to appear that you may patch.

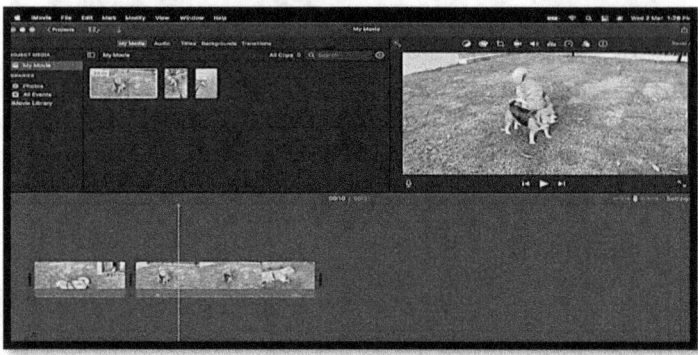

If you need to do a jump cut in your video, it's also advised that you take the music out of the clip. Finding the silent audio segments will be easier for you, which could allow you to generate a better cut with greater impact.

Methods for creating opacity effects

The techniques described below might help you add opacity effects to your videos in iMovie 2024. Your videos' visual appeal may benefit from this.

Perform the following actions:

a. To incorporate the desired video clip into your project, use iMovie. Bringing in your files requires you to do this first.
b. You can move your video clip to the desired location by dragging it into the timeline. That concludes the second phase of adding clips to the timeline.
c. To select the desired clip, click on it. You will be notified that it has been chosen with a yellow marker.
d. Click the "Adjust" option in the menu above the browser to access the Clip Adjustments. This button appears to have three levels on it. When you do so, the Adjustments pane will appear.
e. To adjust the degree of opacity of your clip, open the Adjustments box and make your selection. Determine the opaqueness scale for a given object. To make it more opaque, adjust the scale to the right; to make it less opaque, drag it to the left. This allows you to adjust the brightness. You will be able to see the outcome in real time as you make changes.
f. If you would like to make the color change gradually over time, you can use keyframes. Click the clock icon next to the scale to adjust the brightness. Keyframes will therefore be able to be see-through. Locate the point in the video where you wish the brightness to adjust. Click the "Add Keyframe" button, which

has a diamond form. Before making any adjustments to the opacity slider, position the playhead to the desired end of the opacity adjustment. When you go between keyframes in iMovie, the transition will happen seamlessly for you.

g. Once you're satisfied with the opacity effect, play your video to see how your changes appear.
h. Once you're satisfied with the results, select "Share" from the "File" menu to transfer your movie to a different device.

Tips for adding fade transitions to overlays

To make fade transitions to effects in iMovie 2024, you have to do the following:

a. Open the iMovie project where you wish to apply layer fade transitions. This implies that in order to add the transitions, you must first launch the project.
b. To apply an overlay, drag the desired overlay clip into the timeline and position it directly over the target clip.
c. After that, by clicking on the overlay clip in the timeline, you may select the overlay.
d. Double-clicking the overlay clip will bring up the Clip Choices window. You may then modify the overlay's settings from there.
e. Modify the overlay's length. Make sure the overlay clip's length matches the length of the clip it is overlaid on, if any adjustments are necessary.
f. To add a transition, make sure you click the "Transitions" button in the menu. This button has the appearance of two squares piled on top of one another.
g. Select the desired fade transition from the provided options. You can choose from a variety of settings, such as crossfade, fade to black, and others.
h. Add the transition by dragging the selected fade transition and placing it in the timeline as a transition between the clips that cross over each other.
i. Adjust the transition's length in the timeline by dragging its edges.
j. Play through your project to see how the fade transition between the clip above and the clip below appears.
k. Make any necessary adjustments to the top clip or the transition to achieve the desired look.
l. Once you are certain that the fade transitions on your layers are ready and functioning properly, save your project.

How to make the most of PiP's switch transitions and zoom

In today's fast-paced digital world, storytelling has expanded to a wide range of media due to the widespread usage of digital technologies. Video is one of the most useful tools we have. Thanks to editing programs like iMovie 2024, creating movies that appear to have been created by pros is actually simpler than it has ever been. Because of its zoom

and swap transitions with Picture-in-Picture (PiP) effects, iMovie stands out as a dynamic way to keep viewers' attention and improve your project's visual story. These are just a few of the many options available in iMovie.

Learn the Differences between Zoom and Swap Transitions

Before understanding how to use Zoom and swap transitions in iMovie 2024, you should grasp their purpose. This is due to the fact that these transitions have the power to significantly enhance your narrative.

- ➢ **Zoom Transitions:** To provide a seamless clip transition effect between two clips, zoom transitions necessitates dynamically entering or exiting a frame on either side of the transition. Your photos will have more movement and vitality if you use this method, which visually interestingly and seamlessly moves the viewer's attention from one scene to the next.
- ➢ **Swap Transitions:** In a swap transition, a clip is changed without causing the frame to break. It is simpler to create and tell a visual tale when you use this technique to combine several images or points of view.

Starting off

All you need to do to begin utilizing iMovie 2024's Zoom power and switch transitions with PiP are these simple steps:

- Your Mac should be running iMovie 2024. If you wish to add these transitions to an existing project, open it or start a new one.
- Open iMovie and import the desired video clips to begin working on your project. Make sure the clips are arranged in the final video the way you intend for them to appear.
- Simply drag and drop your clips onto the timeline to arrange them in the desired sequence. The foundation for the following steps, which involve adding transitions between zoom and swap, is set in this step.

Zoom Transitions usage

Now let's take a closer look at how to apply zoom transitions between your videos:

- Position the playhead where you wish the zoom to end. This will determine the point of changeover. It will display the precise instant at which the two clips will change.
- To view the available transition options, click the "Transitions" button above the timeline. This will cause a window with various transition effects to emerge.
- Select the Zoom Transition option from the transition menu. The "Zoom" option needs to be chosen. You can zoom in and out of iMovie, zoom diagonally, and

perform other operations for zoom level transitions. Select the one that most closely resembles the tone of your video.
- Select the desired zoom transition and then drag and drop it into the timeline's transition point between the two clips. Adding the transition effect and seamlessly zooming down from one clip to the next will be the task of iMovie.

Swap Transitions addition

Let's now discuss how to incorporate swap transitions into your project, which is the following step:

- To activate the swap effect, advance the playhead to the intersection of two clips. This is comparable to the operation of zoom transitions.
- Select the "Swap" transition from the "Transitions" menu to view the available transitions.
- iMovie offers a variety of swap transitions, including vertical, horizontal, and lateral swaps. Select the switch effect that best expresses your creative concept.
- The swap transition can be utilised by simply dragging and dropping it onto the timeline transition point situated between the two clips. You may use iMovie to create a visually appealing transition effect since it makes switching between clips easy.

Developments to Changeovers Using Picture-in-Picture (PiP) Effects

Picture-in-Picture (PiP) effects can be added to your project to enhance the transitions you have already created. PiP allows you to layer one video clip on top of another, so you can add more intricacy and depth to your transitions.

To add PiP effects with zoom and switch transitions, follow these steps:

- Select the video clip you wish to overlay another clip with to create the PiP effect.
- Use the parameters that appear on the screen to adjust the PiP clip's size and position.
- To get the desired visual impact, you can change the PiP clip's size, position, and orientation. The next step is to add a transition on the timeline between the PiP clip and the clip below it. Once the PiP clip is in place, you may add a zoom or swap transition between the two clips. This will make it simple to add the PiP effect to your transition, which will improve the flow of the story and the visuals.
- After applying the PiP effect, observe how the transition appears and make any necessary adjustments to ensure that it is consistent and seamless. To achieve the greatest effects, you can modify the PiP clip's duration, location, and timing.

Assignments

1. What are the four distinct layer options for iMovie Video Overlays?
2. Why is a Video Overlay required?
3. What do you understand by A Jump Cut?
4. How do you give overlays fade transitions?
5. Explain the PiP's zoom and switch transitions usage?
6. Discuss the differences between Swap and Zoom Transitions

CHAPTER 9
ENHANCE VIDEO QUALITY USING ADVANCED TECHNIQUES TO EDIT

Using Green Screen Effects

Using a blue or green background will allow you to easily transition between numerous captivating and exciting scenarios while creating the movie. Should you choose not to employ the green screen setting when filming, the calibre of the background editing could be compromised. When making a movie, you can see through a single-colored background, such blue or green, thanks to iMovie's green screen effect. You can set the background to any other picture, still photo, or video clip you own, if you'd like. Any object may be easily added to any shot in iMovie thanks to its green screen functionality. You are free to see the world and to act in the films that you find most entertaining. What actions are necessary to make a green screen in iMovie? Now you have to follow iMovie's instructions to add the green screen effect to your movie. When making a green screen image in iMovie, one of the most notable features is the green screen, which you might want to look into.

How to set Up a Green Screen in iMovie

Before we look at the iMovie green screen, let's talk about the features of the program. With the help of this wonderful video editing tool, you may radically alter the film by changing almost every feature to breathtaking effect. Even while iMovie's user interface isn't the most intuitive, it's not hard to learn the fundamentals of this program quickly. Besides modifying individual image segments, iMovie also includes a green screen feature. With this technique, you may add mystery and beauty to the film by making it look as though it was made with a green screen in iMovie.

To learn how to use the green screen in iMovie, refer to the list of instructions below.

- **Launch iMovie and choose File from the menu.** To send the green screen and backdrop video, select the File choice and then click the Import button. Before sending a movie to iMovie, be sure it is compatible with the software. If this does not occur, you will not be able to edit the movie in iMovie. Additionally, you can drag your movie from the "Event Browser" to the Project Library at any moment.

You can now include the backdrop video in your timeline. You can also alter, crop, and modify the backdrop image or video to suit your requirements. After clicking the "green screen" option, the video that is currently playing needs to be relocated to the timeline.

- It is important to ensure that the two films you are combining are the same duration. You should tap on the image with the green screen after accessing the timeline. You will be able to see it there with a yellow box. By opening the sample window, selecting the "Video Overlay Settings" button, and then selecting the Green/Blue Screen option, you can choose it. This will enable you to witness the

true magic. Using the Cleanup and Softness tools, you may also add more personal touches to the process to enhance the final product.

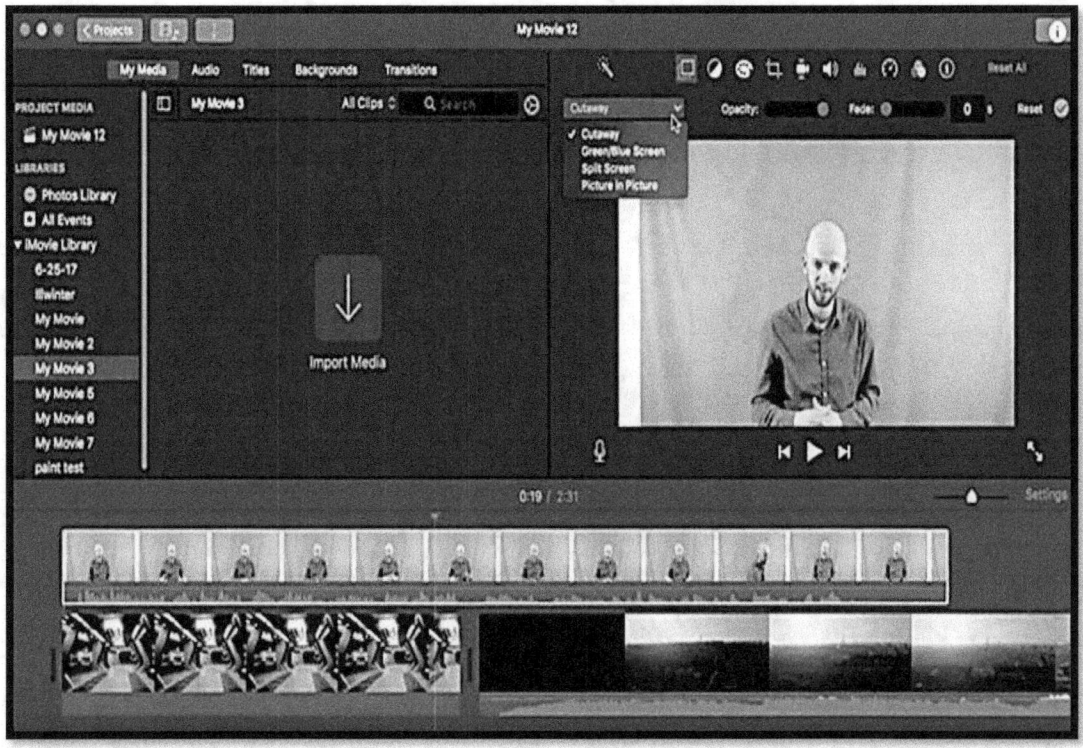

Once you've finished all of these steps, you'll be able to use iMovie's green screen in fantastic ways.

Create a green screen effect on Mac iMovie

If the topic of the video is recorded against a blue or green background, you can "cut out" and overlay another video clip. We call this kind of effect a blue-screen or green-screen effect. An illustration of this would be to record a friend moving on camera against a blue or green backdrop, and then superimpose the video on top of a movie that shows a starry sky. Because of this, your buddy would seem to be dancing in the skies. Additionally, you have the option to drag the green or blue screen clip over a background clip that is moving or has a solid color. It is recommended that you record your video against a blue background if you are wearing green or if the object in the movie is green. If your subject wears blue, you should also record them on a green background. The noises from the original clip and the clip that was played simultaneously are played when the green-screen or blue-screen clip is played. You may want to lower the level of one clip so that the sound from the other clip is more prominent.

To produce an effect, use a green or blue screen.

- Select a video, or a selection of videos, that you recorded against a blue or green screen when using iMovie on your Mac. After that, drag that clip to another project clip. Release the mouse button when you see the green "Add" icon on the screen.

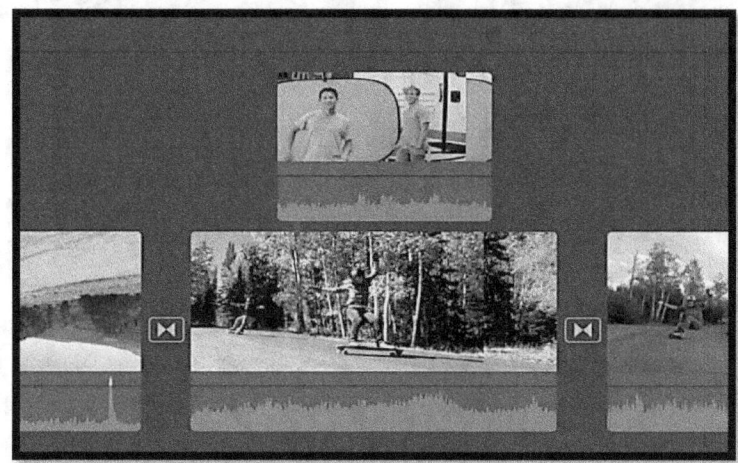

- Click the Video Overlay options button if the video overlay options are not displayed.

- Select Green/Blue Screen from the menu that appears on the left side of the screen.
- The clip that was made against the red or blue background is removed, and the clip below it is visible through the areas that are green or blue, creating a jumbled image. iMovie removes the color that is most evident on the screen where the playhead is when you select Green/Blue Screen from the pop-up option. If the frame below the playhead doesn't display the remainder of the clip correctly, you might need to shift the playhead and apply the effect once more. You can drag a green-screen or blue-screen clip to a new location within the clip or to a separate clip. To change the length, you can also drag the ends.
- Simply click the Apply button under the Green/Blue Screen settings to have the changes take effect.

Adjust the blue or green screen effect

- Select a video clip with a green or blue screen from the iMovie app's sequence on your Mac.
- Click the Video Overlay Settings option if you are unable to see the Green/Blue Screen settings.

- **Take any of these actions:**
 - Modify the provided clip's rounded edges: The included clip's edges can be made softer or harder by adjusting the Softness tool.

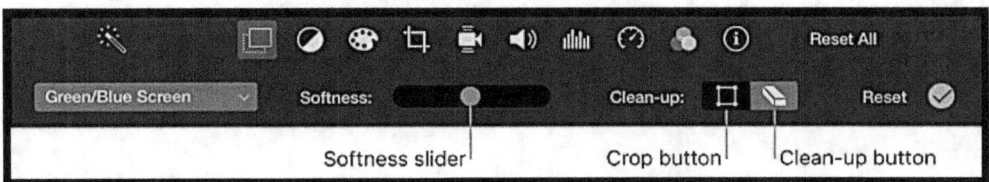

 - Isolate areas of the green-screen or blue-screen clip: To isolate the topic in the main clip, hit the Crop button and then drag the frame's edges. You can use this to isolate specific portions of the desired green-screen or blue-screen footage.
 - Clear out certain portions of the green-screen or blue-screen clip: Press the Clean-up button, and then move the cursor over any regions that you don't want to see.

iMovie examines the newly selected image when you drag to determine what needs to be adjusted. This is what happens every time you drag. Before pressing the Clean-up button, make sure the Softness setting is selected. After selecting the Clean-up button, the Background Clean-up option will be lost and will need to be selected again if you change the Softness level.

- Click the Apply button under the Green/Blue Screen settings to make the change take effect.

Create a split-screen effect in Mac iMovie

By merging two videos into one and using the split-screen effect, you can play two videos at once. The connected clip can also shift into the frame or show up at the top, bottom,

left, or right of the frame, depending on your preference. If you would like to use a slide-in transition, you can change how long it lasts.

Create a split screen video

- Select a clip or range in iMovie on your Mac that you want to play simultaneously with another clip, and then drag it over a clip in the timeline. This will enable you to play both clips simultaneously. Release the mouse button when you see the green "Add" icon on the screen.

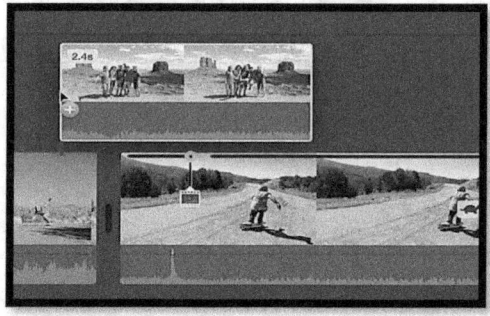

- If the video overlay settings are not displayed already, click the "Video Overlay Settings" button to view them.

- Selecting Split Screen from the option that appears on the left is the next step. The user sees the split-screen controls mode above, with cropped versions of both movies displayed inside.

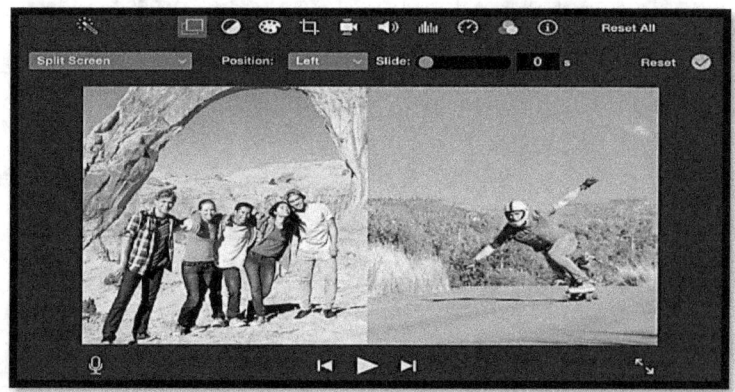

Shifting the split-screen clip in the timeline to a new clip or to a different location in the clip beneath it is one method to alter when the split-screen effect appears. To change the length, you can also drag the ends.

- To apply the adjustment, select the split-screen options and click the Apply button.

Modify a video split-screen

- Locate a split-screen clip in the timeline when you launch the iMovie application on your Mac.
- If the split-screen settings don't show up automatically, click the "Video Overlay Settings" button.
- **Select one of the following:**
 - Here's how to adjust the attached clip's position within the frame: Select a choice from the list when the Position pop-up menu appears.
 - Add a sliding transition and specify the duration of the transition: To the right, move the bar.

There won't be a transition if the transition length is set to 0.

- Select the split-screen options and click the "Apply" button to let the changes take effect.

Applying Advanced Color Correction and Grading

Changing the Color Balance

- Select the video clip by clicking on it in the timeline.
- Click the "Adjust" button (the slider icon) above the viewer to open the "Adjustments" panel.
- There are adjustments for exposure, color balance, and other aspects under the Adjustments panel.
- You can modify the red, green, and blue saturation levels in your movie by dragging the "Color Balance" sliders. This enables you to attain a particular color tone or fix any color casts.

Exposure and Contrast Adjustment

- Make brightness adjustments to your video by utilizing the "Exposure" slider located in the Adjustments menu. Its brightness can be adjusted by sliding it to the right or left, respectively.
- To change the contrast between the lightest and darkest areas of your video, use the "Contrast" slider. Your video can appear livelier by increasing contrast or softer by decreasing it.

Color Effects Addition

- iMovie comes with a number of pre-installed color effects that you may use on your video clips. These effects come in many stylistic looks, black and white, and sepia.
- Click the video clip to pick it in the timeline, and then click the "Effects" button (the magic wand icon) above the viewer to add a color effect. Select the intended outcome from the list.

Custom Color Effects making

- Although iMovie lacks a specific tool for this task, you can nevertheless accomplish some degree of personalization by mixing effects and modifications.
- To get the ideal look for your video, experiment with changing color balance, exposure, and contrast as well as applying various color effects.

Making use of External Tools for Advanced Color Grading

- You might want to think about utilizing external tools like Adobe Premiere Pro, DaVinci Resolve, or Final Cut Pro if you need more sophisticated color grading skills.
- With the help of these high-end color-grading tools, you may achieve exact control over the color and general appearance of your film.

About Color Correction procedures

a. **White Balance Adjustment:** To fix any color casts in your movie, start by altering the white balance. To sample a portion of your film that should be neutral gray or white, use the eyedropper tool in the color adjustment window of iMovie. This will help the whites look true to color and balance out any color tinting.
b. **Exposure Correction:** Make sure your movie isn't very bright or dark by adjusting the exposure. Adjust the exposure slider to make your movie appear more or less bright overall until it strikes a balance between exposure and balance.
c. **Contrast Adjustment:** Adjust the contrast to enhance your video's dynamic range. To make the shadows darker and the highlights brighter, adjust the contrast; to get a softer, more muted look, reduce it. Take care not to go overboard because too much contrast might cause the highlights and shadows to lose definition.
d. **Saturation and Vibrance:** Modify the saturation and vibrance to regulate the color intensity in your video. Color can be made more bright and saturated by increasing saturation, or they can be made more muted and desaturated by decreasing it. Vibrance can be used to enhance subdued hues without oversaturating colors that are already vivid.

e. **Color Balance:** Adjust the color balance so that all of the colors in your footage look natural and consistent. If there are any color casts or imbalances, adjust the red, green, and blue channels independently. Skin tones should be considered because they should seem realistic and natural.
f. **Focused Color Correction:** Modify particular colors or areas of your video with focused color correction tools. For instance, you may modify the hue, saturation, and brightness of certain colors with the use of color wheels or color curves. This might be very helpful if you want to enhance certain colors in your footage or correct color casts.
g. **Consistency throughout Clips:** Make sure that the color and exposure of each clip in your video are consistent. To keep your project looking consistent, use adjustment presets or copy and paste color fixes from one clip to another.
h. **Preview and Fine-Tune:** See how your color corrections appear in real time and make any necessary adjustments to give your video the desired appearance. Observe how your tweaks impact the skin tones, shadows, and highlights, among other components in the frame.

Assignments

1. Explain the applications Green Screen Effects
2. Explain the process of Generating iMovie Green Screen
3. Explain the techniques in Grading and Advanced Color Correction Usage
4. What are the Procedures for Color Correction?

CHAPTER 10
INTEGRATION OF GRAPHICS AND PHOTOGRAPHY

Adding Pictures and Graphics

a. **Open iMovie:** On your Mac, open the iMovie program.
b. **Create or Open a Project:** Depending on which project you want to import the images and graphics into, you may either create a new one or open an old one.
c. **Add Images and Graphics:**
 - **From Finder:** Images or graphics can be dropped straight into the Media Browser or your iMovie project timeline from a Finder window.
 - **Importing Images:** You can also use iMovie's Import button to import images by navigating to their location on your computer, selecting them, and importing them.
d. **Organize in Timeline:** Following import, your images and graphics will show up in the timeline at the bottom of the iMovie window or in the Media Browser. To include them in your project, drag and drop them into the timeline using the Media Browser.
e. **Modify as Needed:** The timeline's picture and graphic duration, positions, and orders can all be changed. Double-clicking a photo in the timeline will reveal the editing options.
f. **Add Transitions or Effects (Optional):** After selecting the photo, you can use the toolbar or Modify menu to select the desired choice for adding transitions between photos or adding visual effects to them.
g. After importing and editing your images and graphics, export and preview your work to make sure everything looks the way you want it. To save your project or share it with others, export it at the end.

About Images Management and Organization

- Images can be imported into iMovie from your computer's storage, as was previously explained. Many image formats, including JPEG, PNG, TIFF, BMP, and GIF, are supported by iMovie.
- **Event Library:** Based on the date of the import, iMovie automatically groups the photos into Events. A group of simultaneous imports of media files is represented by each Event.
- To better arrange your photos, manually create additional Events.
- **Keywording:** You can add keywords to your photographs in iMovie to facilitate future image searches. Using keywords, you can arrange and classify your photos according to particular topics or themes.

- **Timeline Structure:** Images added to an iMovie project are displayed in the timeline. To make your film, you can change their duration and arrange them in the desired sequence. This aids in organizing the original image files within your project, even if it has no direct impact on their arrangement.
- **Storyboard View:** iMovie has a storyboard view, which provides a visual depiction of your production. Before completing your project, you can use this view to arrange and organize your photos and video recordings.
- **Project Exporting:** After completing a project in iMovie, you can save it as a video file. Make careful to save a backup of your project file (imovieproject) and any related media files if you want to keep your photographs organized.

Using Photos to Create Slideshows and Montages

Step 1: Prepare the Images in Photos

You should use photographs to trim and edit your photographs before utilizing iMovie to make presentations. After that's finished, you should get an album and arrange the pictures in it in a method that you would like the slideshow to present them. While iMovie can produce results that are similar, Photos is a far superior option for modifying them.

Step 2: **Create a new project in iMovie**

Open iMovie first, and then select the Projects button to begin a new movie. You may make a video by combining pictures, movies, and music with iMovie. As an alternative, you can make quick and entertaining trailers that resemble Hollywood productions by using some of the pre-made themes listed below. You are able to select one of these two options.

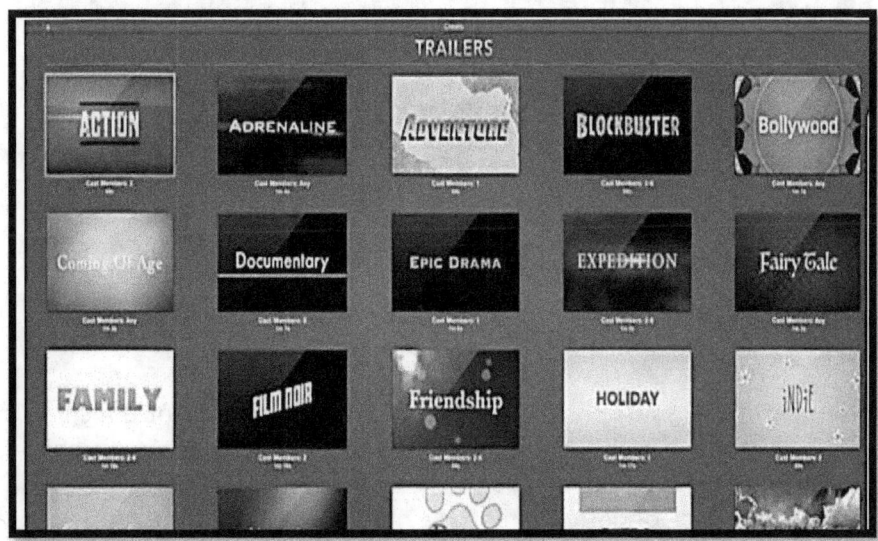

Today, since the Movie tool gives us more options and flexibility, we will use it to create a slideshow.

Step 3: Add photos, movies, and music

The first step in importing your audio, movies, and images into iMovie is to choose the Import option from the My Media menu. You can import your media collections quickly if you have arranged them all in the Photos app. To do this, select the Photos tab from the Libraries panel on the left side of the screen.

Step 4: Adjust the Pictures in the Timeline

This is the ideal time to apply the extra editing tools in the Viewer pane to add that finishing touch to your pictures. Make use of the Magic Wand tool to instantly enhance the quality of your images. In addition, it can apply effects, crop your photos, and change the color and tone. After you've finished modifying them, don't forget to save your modifications.

Step 5: Motion a Still Picture

To add motion to still photographs in a video is a visually pleasant effect. To resize the images, choose the ones you wish to resize, and then select the Cropping option from the Viewer window's top menu. The next step is to select the Ken Burns tab. You may customize the effect's start and stop times by modifying the frames that show when it begins and ends.

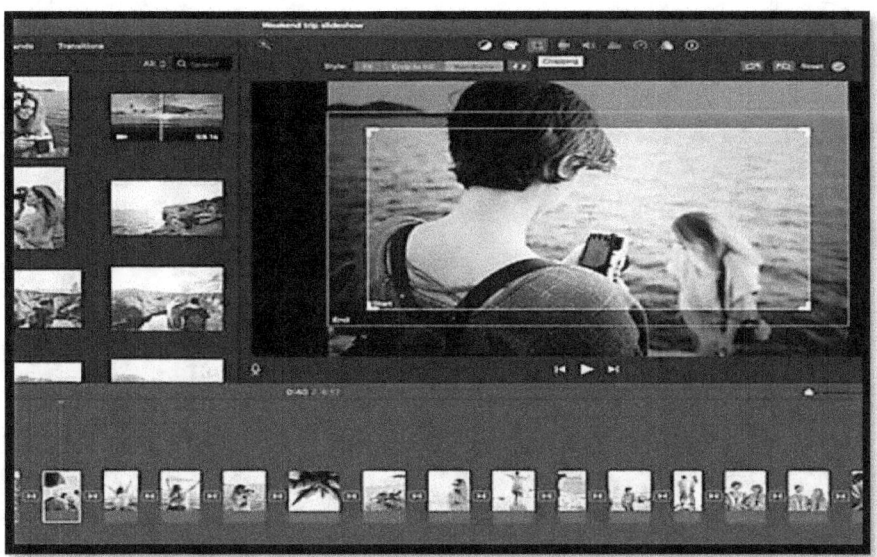

Step 6: Make Sure Your Presentation Has a Transition

One of the most crucial elements of creating a visually pleasing video is the transition. Many transition effects, including cross split, fade, and cross blur, are available in iMovie. However, using a number of various transitions one after the other will complicate the plot and break the flow. To create a transition between two photos on the timeline, drag and drop an image between them.

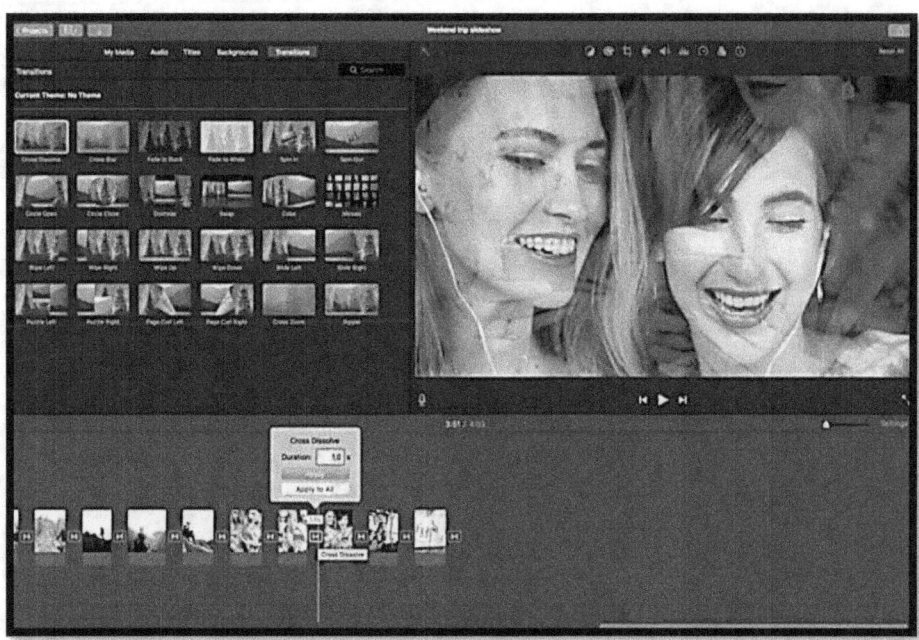

Step 7: Add Titles and Text

Using text and titles to denote the opening and ending of your video is a useful strategy. For added emotional effect, you may incorporate some famous sayings and phrases into your movie. To design a title, you can select from a number of templates. Write the words you wish to use in the timeline's sample window now that it's on the timeline. All of iMovie's text settings include motion effects, so adding text to your video won't be possible.

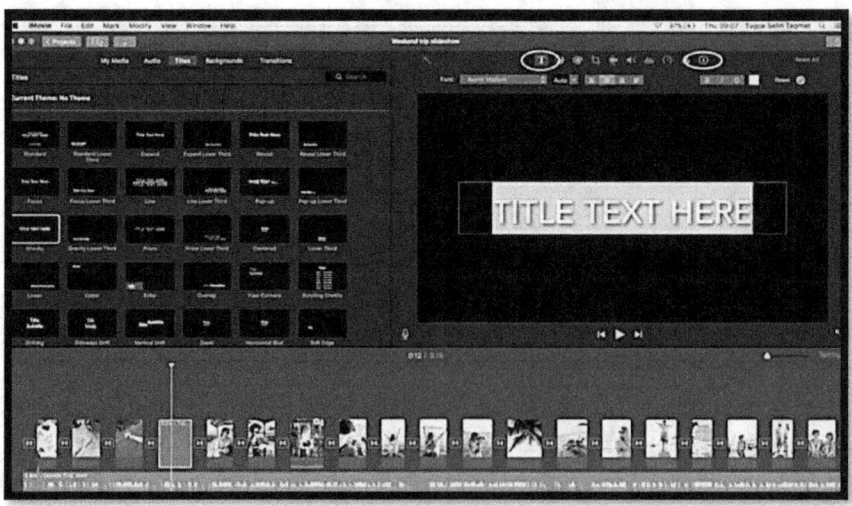

Step 8: Add Music to the Slideshow

If you would like to include music in your video, you can either use audio files that you have on your computer or you can download music tracks that are royalty-free from the internet. The official iMovie website suggests that before including music in your film production, you should purchase it from iTunes. You should adjust the music in your film to match your slideshow if it tells a story. If you want to incorporate a lot of audio tracks in your video, such as voice, background music, and sound effects, iMovie isn't the ideal option.

Step 9: Save and export the slide presentation

To ensure that everything is operating as it should, run the slideshow. Go to the File menu, pick Share, and then File to export your slideshow. You may now share the iMovie video link with your friends.

For Earlier Iterations of macOS

If your Mac is running an older version of macOS and iPhoto, the procedures below are specific to making an iMovie slideshow using an iPhoto project.

First, import pictures from the iPhoto Collection

iPhoto and iMovie have an amazing synergy. The images should be extracted from iPhoto and dropped into the iMovie project. Before importing the pictures, make sure you have one if you don't already have one using iPhoto. Drag and drag the desired movies into the schedule from the "File/Import" or "Event Library" options. After that, you can include videos. You can watch a preview of the raw slideshow by using the space bar on your computer after adding images and videos to the iMovie slideshow project. Edit the video and transitions as needed after that. Take into consideration the option to click on the settings icon after dragging the mouse over a clip or the "double arrow" button, for instance. You could alter the video's parameters, the way clips transition between one another, and the transitions themselves if you did this.

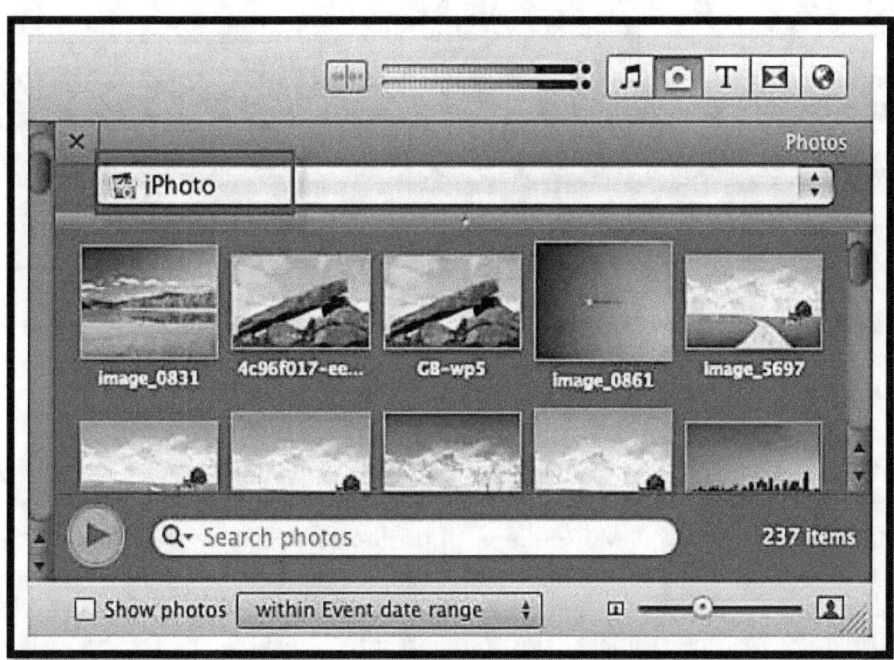

Step 2: Improve the Slideshow Project in iMovie Utilizing Project Music

The ambiance of your presentation is enhanced with music. It's simple to add thoughts to an iMovie display, just as it is to add pictures and videos. After choosing the desired audio file using the audio button located in the lower right corner of the screen, drag and drop it onto the timeline. iMovie allows you to include many music in the mix. Having said that, iMovie allows you to use only one music. It may be necessary to join the audio tracks using an external audio editor before you can add them to an iMovie video. Sound levels can be lowered and audio effects added with an equalizer.

Step 3: Export iMovie's Slideshow Video

Movie sharing is incredibly simple using iMovie. When it's convenient for you, you may use iMovie to quickly and effortlessly publish movies to websites like Facebook, Vimeo, YouTube, CNN iReport, MobileMe Gallery, and others. You may share the iMovie video through Media Browser, and other Mac apps, including iWeb, will display the slideshow. These applications consist of, for example. You should export your iMovie slideshow to iTunes, as advised. You can quickly start playing the slideshow after sharing it with your iPad, iPod, or iPhone.

Create a picture collage

Transform Your Images into Digital Formats

You should make sure that every single image you plan to use is digitally stored on your Mac before you start assembling your photomontage. If the photos were taken with a digital camera or if they have already been scanned and stored in Photos, they are ready to be utilized. Regular photo copies can be produced at home by utilizing a scanner to scan your photos and turn them into digital files.

A local photography business should be able to scan your photos if you don't own a camera or if you have a large number of them. The creation of the montage will proceed more swiftly if you make a single album in the Photos app with all of the chosen photos and name it something easy to remember, like "iMovie album." In the event that this is not the case, you may just go through your Photos folder and choose any image that you would like to use.

Launching iMovie

As an alternative, you can access the File menu at the top of the screen by pressing the Command key and the letter n on the computer. From there, select "New Movie." Select the Projects tab and click the large plus sign icon next to it when the iMovie screen appears. From the menu that appears in the box that displays, select Movie.

Open the Photos app

Navigate to the Libraries section, which is located to the left of the main work area, after selecting My Media from the screen that displays the iMovie project. Choose the "Photos" menu item. This launches the Photos library previews in iMovie. From there, you can select the images you want to use in the montage by either selecting them directly from your stored iMovie album or by searching through your Photos albums. You can view these samples by choosing the Photos Library previews option.

Place the Images in the Timeline

To pick a photo, simply click on each one separately. You can drag the photos you wish to include in the sequence at the bottom of the screen once you've chosen them. You can change the order in which the photos appear as you click and drag each one into position.

Select the Ken Burns

You can use the Ken Burns effect to make the images move. Choose the first picture, then crop it by clicking the crop button, which is located directly above the iMovie window's showing preview. Clicking this will access Ken Burns's settings. After clicking on the Start and End boxes in the viewing window, you should arrange them in two distinct locations on the image. This must be completed for each and every image. To view the effect, click the play button located below the sample window. You can make individual adjustments to each image until you are satisfied with the outcome, although it may take some time to get it perfect. On the timeline, the playhead appears as a yellow line that is straight. If you move your photomontage to the spot right before the first picture and then press the play button under the sample window, you can see how it looks.

Add a Transition

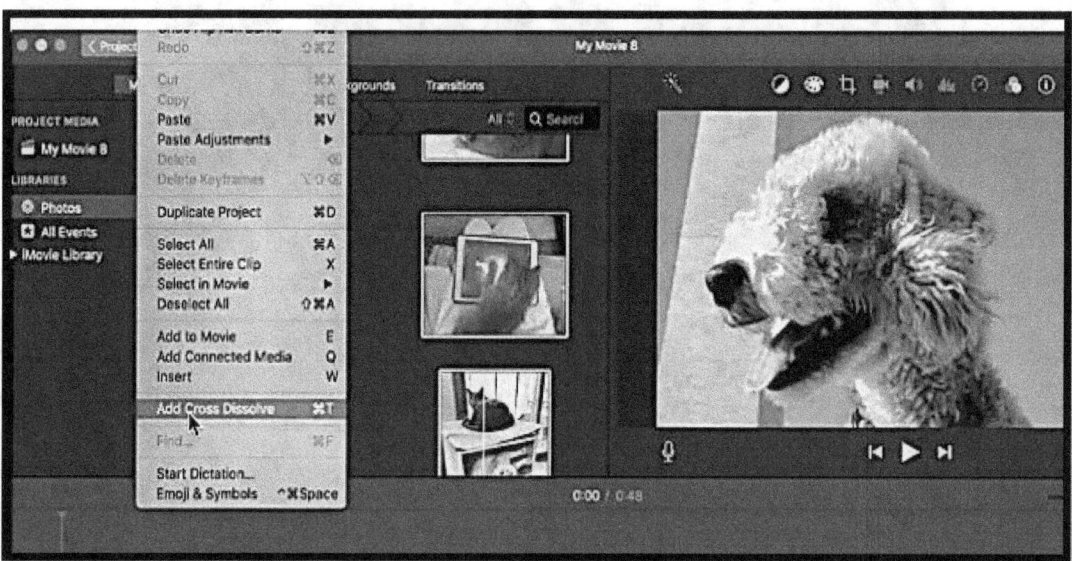

You have the option to add more effects to your photomontage if you so desire. Transition effects soften the jarring breaks between images. Although there are many different types of transitions available in iMovie, the simple Cross Dissolve transition works well with static images and doesn't draw too much attention to itself. Examine the menu bar and choose Edit. Subsequently, choose each image that appears on the timeline, and press the Add Cross Dissolve button. You may see a preview of the sample screen by clicking the play button beneath it. You can change how much time elapses before the cross starts to fade away by clicking the button that appears in between each picture and entering a new number of seconds.

About Title inclusion

Click the Titles tab near the top of the page, then browse to Content Library > Titles. You can view examples of different title styles by doing this. Once you have decided on a title style that you like, you need to drag the playhead to the desired position in the timeline. This usually happens right in the start. When you double-click the title style that you believe is the finest, the title will be placed over the text that is blank in the example window. The user can now see the title screen.

The Fade to Black

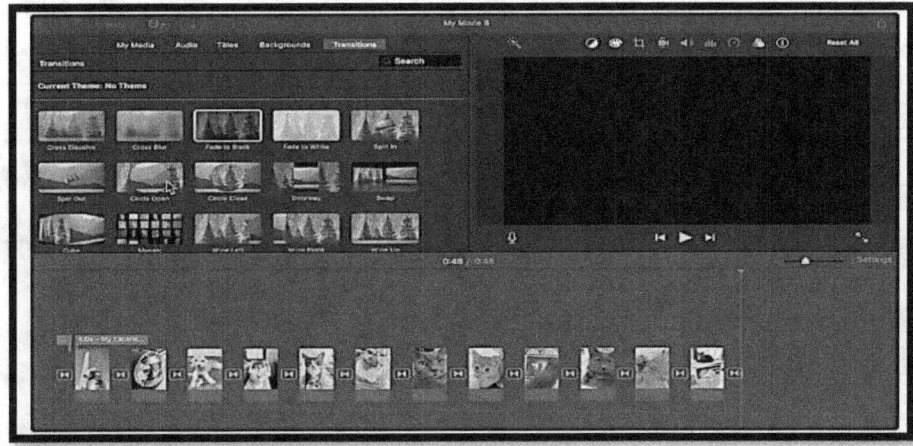

To reach the Transitions menu, you may either click on the Transitions tab or travel to Window > Content Library > Transitions. The transitions were employed to produce a fade-out, which resulted in a magnificent finish for the video. Because of this, you won't see a static last frame of video after the photos are done; instead, you'll see a blank screen. The collage will fade away if you apply this effect after the final picture, just like you did with the title: place the playhead where it needs to be, choose your transition, and then press the Fade to Black button.

Don't forget to add audio

Once the way all of the images and effects look together is to your satisfaction, add some music to the background of your photos. You can browse and select from a variety of music by clicking on the Audio tab. There's a music in the area beneath the pictures. You can click and drag it into the timeline to add it. If the audio track goes on for too long, you can pause it by scrolling to the bottom of the page, clicking on it, and then dragging it back till it ends right before the last image.

The Last Actions

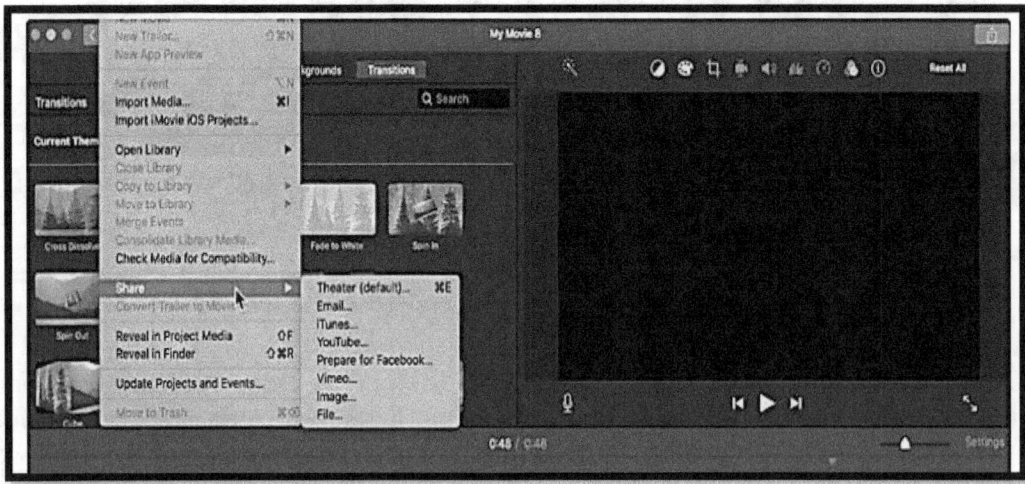

Now is the perfect time to test your photo collage. The playhead needs to be placed exactly in front of the first image on the timeline. Clicking the "Play" button beneath the

sample window will allow you to see the photomontage in full. Utilizing this will help you make sure that all of the titles, transitions, and visual effects look excellent. This is your chance to adjust anything you feel is necessary. While you work, iMovie will safeguard your creation. Just choose Share from the File menu after navigating to it. To share your photomontage right away, choose Email, iTunes, YouTube, or any other option that appears. The iMovie screen will display an area where you may enter a title for your project if you pick Projects at the top. Clicking this button will bring up the iMovie main screen.

Make time lapse and stop motion in iMovie

It could be a lot of fun to add time-lapse and stop motion effects to some of your video editing projects. On the other hand, you might believe that the task calls for pricey tools or advanced video editing software. That is not accurate! You can create slow-motion and time-lapse videos with iMovie if you know how to use it.

To create a stop-motion or time-lapse video with iMovie, you need to follow these instructions.

- Launch iMovie. Select the Properties > Timing option. It is necessary to change "Ken Burns" to "Fit in Frame" in the options. Because of this, your photos won't become in focus or out of focus when using the stop-motion effect.
- If your photos are already arranged, all you have to do to import them into iMovie is click and drag them into the application.
- You can change each clip's duration to suit your needs. Press and hold on to a photo to do this. The inspector window will then appear. One second should be the new standard instead of the present four seconds. Repeat these steps for every single still.
- This will make your stop-motion animation to move at the 10 frames per second that you are allowed to move in iMovie.
- You ought to export the movie. On the other side, you can combine multiple stop clips to build a scenario if necessary.
- You will be able to add transitions, scripting, color correction, and other aspects to your project once you have completed adding your stop-motion clip.

Animating and Adding Motion Effects to Still Images

- **Import Your Still Image:** To begin, open your iMovie project and import the still image you wish to animate. You can use the Import button or drag and drop the image into the timeline to accomplish this.
- **Modify Duration:** iMovie sets still photographs' default duration to a few seconds. By clicking on the image in the timeline and dragging its edges, you can change the duration from short to lengthy.

- **Add Animation:** Click on the image in the timeline to choose it in order to add animation to your still image. Next, select the "Clip Filter and Audio Effects" button located above the viewer window. This button resembles three overlapping circles.
- **Select an Animation:** Click the "Video Effects" tab in the Clip Filter and Audio Effects box. You can apply different animation presets to your still image by going to this section. Each animation has a preview that you may see by hovering over its thumbnail.
- **Apply the Animation:** After selecting an animation, drag it onto the timeline's still image from the Clip Filter and Audio Effects box. When the animation is applied, a green bar will show up above the picture in the timeline.
- **Change Animation Settings:** To make more changes to the animation, click the green bar that appears above the timeline image. This will launch the animation options, where you may change variables like direction, intensity, and speed.
- **Preview and fine-tune:** To see how the still image animates, preview your project after applying the animation. To get the desired effect, you can alter the duration of the image or fine-tune the animation settings.
- **Apply Extra Motion Effects (Optional):** You can manually apply motion effects to your still image in addition to the predefined animations. The "Cropping, Ken Burns & Rotation" button (which resembles a cropping tool) above the viewer window must be clicked after selecting the image in the timeline. Here, you may add motion to your still image by using zooming and panning effects.
- After you're happy with the animations and motion effects, preview your project to make sure everything appears the way you want it to. Then, finalize it. If necessary, make any last-minute changes before exporting your project.

Assignments

1. Explain the steps in importing Images and Graphics
2. Explain the steps in Images Management and Organization
3. Explain the steps in creation of photos collage
4. Discuss the means of Adding Motion Effects and Animations to Still Images

CHAPTER 11
GAINING EXPERTISE IN AUDIO EDITING

Your videos can suffer significantly from background noise. You might discover that the overall audio quality of your movies will be greatly impacted by the addition of background noise. You may significantly improve the sound that is captured on your iPhones or other iOS devices by lowering the level of noise in iMovie. A few built-in features in iMovie could assist you in resolving background noise issues in your films.

Typically, there are three choices:

- **Audio Detachment:** This method lets you take the audio track out of your video clip so you can change or edit it as you see necessary.
- **Equalizer Tool (Mac Only):** This tool lets users adjust audio frequencies and maybe cut down on unwanted background noise.
- **Muting the Audio:** Although it might not be ideal for every occasion, totally muting the audio might be a quick solution in instances where the background noise gets overbearing and there are no other audio alternatives accessible.

An Examination of Noise Reduction Techniques for Videos

The development of artificial intelligence technology has made noise reduction extraordinarily smooth. However, there are a few things that may be done to lower the recording's noise level. The several methods for removing background noise in iMovie will be covered in this section.

The following significant variables have the power to significantly affect the noise levels:

Choose the ideal location

It's important to select the right setting when recording audio or video. While it may be difficult to find a place where noise is completely absent, it is possible to try to reduce the amount of noise that is present. There is usually no noise in areas that are tranquil, have few people living there, and have lots of natural surroundings. You may set up a studio for audio or video recording with comparatively minimal work. They have noise-cancelling technology along with space and prearranged settings. Delivering music in crystal clear quality and positioning the microphone perfectly. To produce audio and video content of the highest caliber, a microphone is a necessary instrument. Sound quality is greater with an excellent microphone. Regarding microphones, both an external and an inside microphone are thought to be viable choices. Additionally, the voice quality

is impacted by the positioning and arrangement of the microphones. Moving the microphone closer to the speaker may enable it to produce a sound suitable for the speech.

Protection from Wind and Interference

Shooting outside could be difficult due to the wind noise. Not only does the audio quality decline, but sitting audience members become irritated too. Consider using a fuzzy cover or a windshield to reduce wind noise. For best results, it is advised to keep the recorder a safe distance away from any electrical equipment. By doing this, the likelihood of interference will decrease. This group may include gadgets like computers, cellphones, and other similar technologies.

Changing the audio levels and gain

When recording, it is essential to keep an eye on the volume levels in order to obtain a greater quality. Artists can use headphones (sometimes referred to as headphones) to reduce undesired background noise and change the volume of their recordings. Moreover, we advise increasing the gain to obtain the highest level of clarity. When the gain is set high, there's a chance that distortions and other noise will drastically reduce the quality of the music.

Appropriately formatting and editing

Selecting the best audio format is crucial before you begin the recording process. Excellent file formats that are frequently utilized by a large number of users are WAV and FLAC. Additionally, it is essential to choose editing software that has noise reduction integrated into its functions. Throughout the editing process, the program must to guarantee that the audio quality remains intact. These technologies also allow for audio augmentation effects that can accomplish the desired outcome.

Eliminate the Background Sounds

Users may easily create and edit videos with the great built-in software iMovie, which was designed exclusively for macOS machines. With this software, Mac users may quickly edit their films and add sound effects. With iMovie, users can effortlessly share their accomplishments on the internet or stream their work on Apple TV. Reducing background noise is one of the many sophisticated aspects of iMovie's audio and video editing capabilities. Voice clarity can be improved and the audio's equalization can be adjusted using the program's audio improvement tools. You can use iMovie's audio denoise tool to subtly remove background noise. A straightforward and rather user-friendly editing interface serves as the foundation for this feature. It can also edit a variety of audio formats, such as MP3, ACC, and others.

How to lower the background noise in iMovie

Would you be interested in learning how to get rid of background noise from movies in iMovie if you're a Mac owner?

Utilize this comprehensive, step-by-step manual to gain all the knowledge possible about noise reduction:

- To get started, open iMovie and select "Create New" from the accessible menu. After finishing it, import your media files. Then, using the drag-and-drop technique to quickly add your content to the timeline.

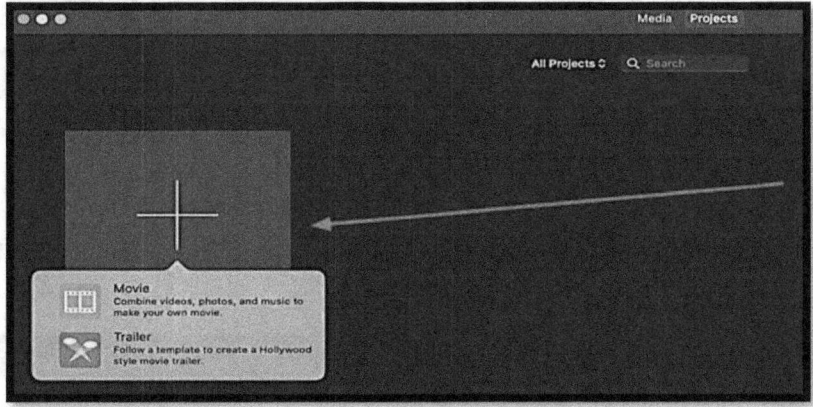

- Locate the toolbar in the top right corner of the screen and acquaint yourself with the numerous options at your disposal. To begin the editing procedure, locate and click the "Noise Reduction and Equalizer" option.

- The next step is to locate the "Reduce background noise" slider among the many options. This slider's position within the slider can be changed to vary the level of noise reduction.

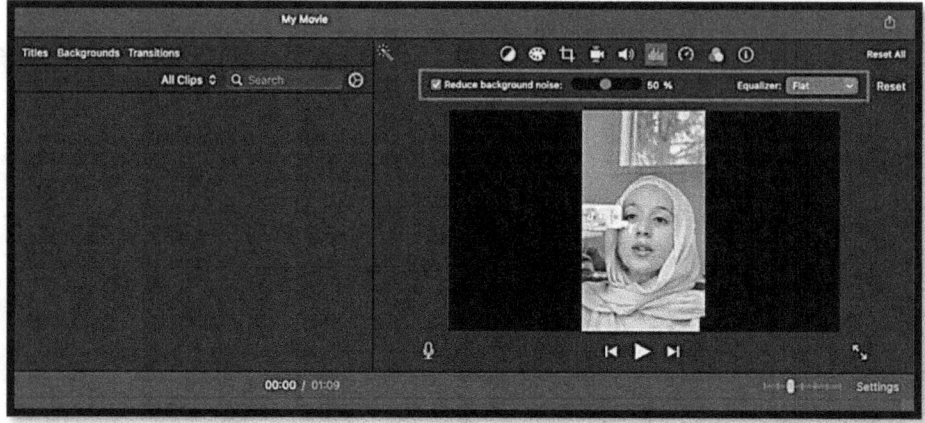

- Play your video at this point to observe what happens, and then change the volume of the sound to your preferred level. Once everything you wanted to do is done, you may choose to save your film to iMovie or export it.

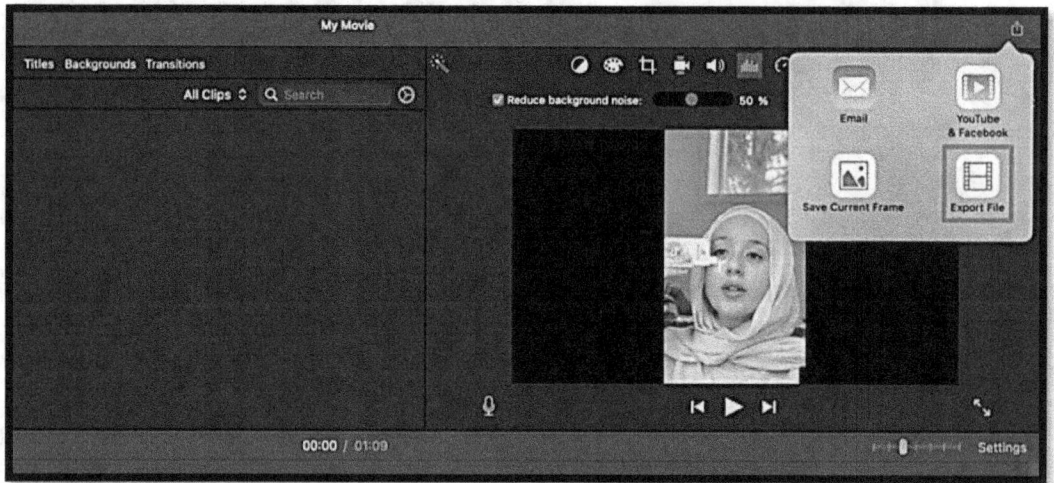

Employing Audio Effects and EQ Modifiers

Employing Audio Effects

- To add audio effects, open your iMovie project, and then select the timeline that contains your audio clip.

- Click and hold the audio clip to select it. As the video comes to an end, you'll notice that yellow handles have emerged.
- From the menu bar at the top of the screen, choose the "Audio" tab.
- You can click the "Clip Filters and Audio Effects" button (it looks like three circles that overlap each other) or select "Clip Filters and Audio Effects" from the dropdown menu.
- Select the "Audio Effects" tab from the menu when the Clip Filter and Audio Effects window opens.
- A range of audio effects will show up for you to add to your clip. "Echo," "Reverb," "Dynamics," and more settings are some of these effects. Click on the effect you want to apply to select it.
- Use the provided sliders and options to make any necessary changes to the effect parameters.
- Replay the audio clip to see a sneak peek at the effect. Any more changes that are necessary should be made.
- After you've decided the effect is what you want, click the "Apply" button to add it to the audio clip.

The Adjustments of EQ

- Select the audio clip that can be found within the timeline.
- Choose "Audio" from the top menu bar and press the button.
- Choose "Clip Filters and Audio Effects" from the drop-down menu or press the designated "Clip Filters and Audio Effects" button.
- Select the "Equalization" panel from the window that houses the Audio Effects and Clip Filter. A graphical equalization window with sliders and frequency ranges will be shown to you. By dragging the sliders, the levels of the different frequency ranges can be changed.
- After choosing a preset from the dropdown menu, you can also choose from a number of preset equalization settings, including "Bass Boost," "Treble Boost," "Vocal Enhance," and so forth.
- To hear a preview of the equalization changes, press Play on the audio clip.
- Make any more changes necessary to get the desired sound.
- Click "Apply" to apply the equalization settings to the audio clip after you've reached a point of satisfaction.

Maintaining Sync between Audio and Video Clips

Part 1: Common Issues with iMovie Sound Out of Tune

The following are typical issues with iMovie's audio being out of sync:
- Out of sync audio when making a video

I made a movie with iMovie and posted it to my social media pages. There have been several attempts to fix the issue, but the audio and video are still out of sync. You should

unplug and then rejoin, however it didn't help either! I've read that's what you ought to do. When I finally found something strange, I found that every single one of these sections implied that I could fix my problem if I split up long films into multiple pieces and then removed the audio from each one.

- **When exporting an altered movie, the audio is out of sync**

I am trying to use iMovie to edit my recorded lecture, but I am having some trouble. How can I make sure that the two will work together appropriately so that when I export them, they will play back together?

- **Transfer video from an iPhone to a Mac.**

Experiencing iMovie's audio/video sync issues. I hope that you are doing well. Editing videos on my macOS X machine is being done with the latest version of iMovie. But the iPhone's audio and video playback are not quite in sync. The file is played back at different speeds based on whether FaceTime or the primary camera is being used. They will not be in sync when you import them into Apple Final Cut Pro because there was a timing error during the recording process. Why is it essential that I understand the nature of the issue?

- **When importing camera video into iMovie, the audio is not in sync**

I'm having trouble getting the audio and video on my laptop to sync with the operating system after moving from camera tapes to the newest version of Mac OS. Movies that have been shifted start to play three or six seconds later than they did at the beginning, but the first thirty seconds or so are precisely timed! That being said, what seems to be the cause of this?

Part 2: Four Easy Steps for Audio and Video Synchronization in iMovie

You may find out more about the different ways that iMovie can be used to sync audio and video by following the instructions given below:

- Take out the audio and edit it. You can separate the audio from the video in iMovie and edit each part separately. With the help of the following steps, you should be able to perform that specific maneuver:
- To get started, launch iMovie and select the menu bar. Click the File menu now. There, you can import the video that you want to edit by clicking the Import Media icon.
- Following that choose the clip that you just inserted and then click the "Detach Audio" option to export the audio.
- The next action to take is to right-click on the audio file within the timeline and chooses "Edit." After pressing the Trim to Selection button, make any adjustments that are required based on the video.
- Click the File and Save button when you've completed editing.

- **Embed External Audio into Video with iMovie**
 - ➢ Open the video in iMovie that you want to sync with the other video.
 - ➢ Lastly, to add the audio and video files to the timeline in iMovie, drag and drop them.

- Once that is complete, click Video and then disable the Speaker option to get rid of the audio.
- Following that, put the audio file you deleted back onto the timeline and perform the appropriate actions to make sure it plays in sync with the video.

- For the purpose of saving the video, kindly click the Share button and choose Export File.

Assignments

1. Discuss three built-in options that may help you address problems with background noise in your movies.
2. Discuss How to reduce iMovie's Background Noise
3. What are the ways to carry out EQ MODIFICATIONS?

CHAPTER 12
PROJECT SHARING AND EXPORTING

Exporting Projects in Different Formats and Resolutions

Use iMovie to email a Mac movie, trailer, or clip

Using Mail, the macOS email software, you may quickly attach your movie, trailer, or clip to an email. The first time you attempt to send an email with a movie, trailer, or clip larger than the maximum suggested attachment size of 10 megabytes, you will receive a warning.

- Use a movie, trailer, or web clip that you find online as a guide within the Mac version of iMovie.
- Once you've chosen File, click the Share option and choose Email.
- **The dialog box that shows on the screen gives you the ability to do the following actions:**
 - Give the shared movie a title by clicking on the name at the top and entering a new one.
 - You can change the shared video's description by clicking on the "Description" section and then inserting new text.
 - Add tags to the movie that is shared. Enter the tag names in the designated section, separating each one with a comma.
 - Modify the shared movie's resolution. Select the resolution-related choice from the pop-up menu.
 - It is imperative to acknowledge that exporting a 4K movie or video clip in its original resolution is possible.
 - It is possible to expedite the export process by choosing the "Allow export segmentation" option. This will facilitate the export of projects with a minimum duration of three minutes and help accelerate it. iMovie utilizes the processing power of multiple media engines to handle different aspects of your video simultaneously.

Remember that in order to do export segmentation, your Mac must be running macOS Sonoma or a more recent version and equipped with one of the following: an Apple M1 Max, M1 Ultra, M2 Max, M2 Ultra, or M3 Max.

- From the menu, pick the Share option.

On the right-hand side of the toolbar, there is an indicator of progress. You can review it by clicking on the progress indicator for more details. The indicator will disappear from view as soon as the process is finished.

After the sharing process is finished, the movie will be attached to a draft email with the project title as the subject line. Furthermore, the platform displays a notice indicating that the share was successful.

Share your iMovie work on social media with a Mac

Get your movie ready to be uploaded to popular video-sharing platforms

- Use a movie, trailer, or web clip that you find online as a guide within the Mac version of iMovie.
- Navigate to the File menu, select Sharing from the drop-down menu, and then select Social Platforms.

- **The following options are available to you in the box that opens:**
 - Change the title of the shared movie by selecting it from the menu at the top and typing a new one.
 - By clicking on the "Description" section and entering new text, you can change the description of the shared video.
 - To add tags to the shared movie, click the Tags area and type the tag names, making sure to comma-separate them.
 - Modify the shared movie's resolution. Select the resolution-related choice from the pop-up menu.
 - Boost export velocity with concurrent processing. To do this, select the "Allow export segmentation" check box to expedite the exporting of projects lasting three minutes or more. iMovie will send portions of your video to multiple media engines for processing at the same time while you work on it.

- Select the menu item labeled "Next".
- The next step is to designate a location on your Mac or storage device where the output media file will be saved, after naming it. Just press the Save button. Your project's structure is perfect for spreading via different social media platforms. The progress bar indicates where you are in the process and is shown on the right side of the toolbar. You can review it by clicking on the progress indicator for more details. The indicator will disappear as soon as the treatment is finished.
- Make sure that you closely follow the instructions provided by the website or platform if you wish to upload the file using a web browser like Safari.

Export a picture from iMovie on the Mac

You can export your video as an image if you ever wanted to use a single frame from it in another program. A JPEG file is the one that is stored with the image.

Observe the guidelines provided below;

- Open iMovie on your Mac and browse the movie or video clip you want to export straight. You can use the skim option to quickly get a glimpse of the content. Once you've found the frame you wish to utilize, you should click on it.
- Select File, and then click Share, and last, select Image.
- When the dialog box pops up, you have the option to keep the default name—the title of the film, trailer, or clip—or enter a new one in the Save As field.
- After navigating to the location where you want to save the file, click the Save button. A message indicating that the sharing process was successful will show up after it is finished.

Save a video, trailer, or clip to your computer using iMovie on a Mac

You can use your video in other applications by exporting it as a file.

- Use a movie, trailer, or web clip that you find online as a guide within the Mac version of iMovie.
- Choose File, choose Share from the menu, and then choose File again.
- **The dialog box that shows on the screen gives you the ability to do the following actions:**
 - To change the title of the shared movie, simply click on the name at the top of the screen and enter a new title.
 - You can change the shared video's description by clicking on the "Description" section and then inserting new text.
 - All you have to do is click on the Tags area and enter the necessary tag names, making sure to comma-separate them, to add tags to the shared video.
 - You can choose an option by clicking on the "Format" pop-up menu to find out the output format of the shared video.
 - Throughout the procedure, you have the choice to export only audio or both video and audio.
 - Choose an option from the "Resolution" pop-up menu to change the shared movie's resolution.

Recall that a 4K video or clip can be exported in the same resolution as when it was made.
 - An option from the "Quality" pop-up menu can be chosen to change the output quality of the shared movie.

You can adjust the output quality of the movie you've shared by simply doing the following steps: select Custom from the pop-up menu that displays when you click on the Quality option, and then use the slider to set the necessary target bit rate. Every time the slider is

adjusted, an automatic update is made to the file size estimate that appears beneath the preview thumbnail.
- o Choose a compression setting: Open the Compress menu, and then pick the preset that most closely matches your requirements.
- o Boost export speed with concurrent processing: For projects lasting three minutes or more, make sure the "Allow export segmentation" option is checked to expedite the exporting process. iMovie will send portions of your video to multiple media engines for processing at the same time while you work on it.
- Select the menu item labeled "Next".
- You can choose to save the default name—the title of the film, trailer, or clip—or type a name into the Save As field in the dialog box that displays.
- Once you've browsed to the spot where you want to store the file, click the store button.

On the right-hand side of the toolbar, there is an indicator of progress. You can view it by clicking on the progress indicator to view more information. The indicator will disappear as soon as the treatment is finished. Instantly once the movie sharing process is finished, QuickTime Player will automatically start the movie. Furthermore, the platform displays a notice indicating that the share was successful.

Personalization of Export Parameters

You have to start here before you can decide whether or not to export videos from iMovie to another device. Because the options have an impact on crucial elements like compatibility and file size, they need to be carefully thought through. If you don't know how to use these settings, exporting videos from iMovie won't be easy for you. For this reason, it's crucial that you read them all in order. The ease with which these settings can be changed to meet your needs is among the most significant things you will discover.

When exporting videos from iMovie, QuickTime is the format most users choose. This is an excellent example of how to change the settings. This can be accomplished by using the "file" tab and choosing the "export" option. Next, a selection containing each type will be shown. In this case, please select "expert settings" before clicking the "export" button. There will also be a "Movie to QuickTime movie" option available from the pop-up menu. The "options" button allows you to view further settings. You won't have any trouble finding the "settings" button. Clicking it will open a video panel with settings for frame rate, compression, and other important parameters. Choose the right parameters to modify based on your preferences. Ultimately, you should choose modification options that provide you a satisfactory return in terms of file size and image clarity. There's no other way to maximize the iMovie options save from doing that. If you make any changes to the settings, your video quality may decrease and exporting will become more challenging. You will need to enter the frame size first, then the frame number, and then the frame rate to make sure that everything is consistent.

Aspects of Resolution and Quality to Consider

To make sure your audio sounds clean and professional, you must always take resolution and quality into account while working with audio in iMovie.

Here are some important things to keep in mind:

 a. **Audio Format:** MP3, AAC, AIFF, WAV, and a host of other formats are among the many audio formats that iMovie can play. Make sure the audio files you import into iMovie are in a format that works with the application before importing them.
 b. **Bitrate:** Higher bitrates usually translate into higher quality audio files, but they also result in larger file sizes. A balance between the size of the file and the audio quality should be struck when choosing the bitrate for your audio files.
 c. **Sample Rate:** During recording, the sample rate determines how many samples are taken in a single second. Because they can capture more detail and produce better sound quality, higher sample rates inevitably result in larger file sizes. By default, iMovie calculates the audio sample rate to be 44.1 kHz.
 d. **Compression:** Compression can significantly affect how good the audio sounds. To ensure that the overall clarity of your audio is maintained, it's crucial to consider the compression settings when exporting your completed video output from iMovie. Avoid using too much compression since this could cause the audio quality to deteriorate.
 e. **Recording Quality:** If you are recording audio directly into iMovie, you should use top-notch microphones and audio interfaces to record crisp, professional-quality audio. It is crucial to consider factors like background noise, space acoustics, and microphone placement in order to achieve the highest quality recording possible.
 f. **Editing without Loss:** iMovie uses a non-destructive editing technique, so no changes are made to your original audio files. Rather than changing the files

directly, changes are applied as instructions. This allows you to make changes without sacrificing the final product's quality.

g. **Export Settings:** you maintain the audio quality while exporting your completed video project using iMovie, please make sure you choose the appropriate export settings. Numerous export presets, including choices for various resolutions and quality levels, are supported by iMovie. Select a level that preserves the audio and video quality while controlling the file size.

h. **Monitoring:** It is advised to use studio monitors or headphones to evaluate the audio quality when editing with iMovie. This allows you to locate any issues, including distortion, clipping, or background noise, and then modify the audio quality as needed.

How to Proceed with AirDrop Sharing

You may utilize iMovie on iOS with AirDrop in two distinct ways. Any video file used during the project's production can be shared, either with specific video clips or a whole iMovie project (such a movie or trailer).

To submit different video clips:

- Make sure that AirDrop is enabled on both of your devices.
- Choose the video you want to share using iMovie's built-in video browser, then tap on it.
- Press the "Share" icon.
- The next step is to choose the device from which you want to receive the video clips from the list of nearby devices that have AirDrop enabled.

The video snippets will be sent out starting now. If the names of the devices don't appear, check sure that all local devices are in the Contacts app, that AirDrop is enabled for all of them, or that your AirDrop settings are set to "Everyone."

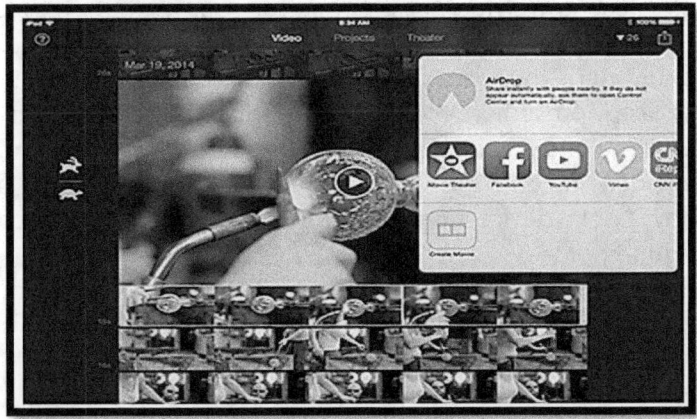

- The video clips are added to the device that was received when it notifies you that it will be receiving them. Tap "Accept."

Export or share your iMovie work using an iPhone or iPad

You can share your video via email or SMS, upload it to the internet, or move it to another device. After sharing your movie, open the saved file in iMovie and make the required adjustments to edit it. Share the movie again after you're done.

Send your video attachment as an email or text message

You can email or text someone a finished movie by using the Mail or Messages programs.

- Select the video you wish to share from the Projects list. To end the editing process for a project, select "Done" located in the upper left corner.
- Select Messages or Mail after clicking the Share button.
- Once the email or message is complete, click "Send."

You can reduce the size of the movie file if it is too large to transfer. Close and return to the email or message you are now reading if you would want the share screen to be smaller.

Transfer your video to an alternative device

You can watch the movie on a neighboring Apple TV or iPad by transferring the movie file there using AirDrop. You can save your movie to your photo collection as well. From the Projects list, choose the movie you want to share.

- **To close an editing project, click the "Done" button in the top left corner.**
 - Press the "Share" icon.
 - After selecting a style or size option for your movie, press Options and then tap Done.
 - Decide where you wish to submit your film:
- To utilize AirDrop, press "AirDrop" and then tap the user's picture at the top of the screen. AirDrop allows Apple users to exchange data with one another.
- Click "Save Video" to add the video to your gallery of photos. You can see the video on any Apple device connected to the same iCloud account if you have enabled iCloud Photos.
- You may save your movie to an external storage service, a folder on your computer, or iCloud Drive using the Files app. To accomplish this, select where to save the file by pressing Save.

Upload your film to the internet

Put your movie in the Photos library first. After that, post it online.

- Launch iMovie, then select the Projects tab. Select the project that you wish to distribute. Select "Share."
- Next to the name of the movie, click Options. There are various options available if you wish to alter the size of your movie. Movies in 1080p can be shared online.
 - Movies of lower resolutions, such as 720p HD, can be shared to the web more quickly due to their smaller sizes.
- Select "Save Video" to store the movie in your device's Photos library.
- Set your phone aside and launch a social networking app, such as YouTube or Facebook. Alternatively, you could post your video on the website of the provider.

You can share or export your Mac iMovie project

Get your video ready for emailing, storing it in your Photos collection, or sharing it online. After sharing your movie, open the saved file in iMovie and make the required adjustments to edit it. Share the movie again after you're done.

Send a movie email

You can distribute your movie to other people via the Mail app.

- Select the iMovie project you wish to send from the Projects window. If you are making modifications to a project, simply click the Share button after that. Otherwise, click "More" and select "Share Project."
- Click the Email icon.
- Click the "Share" option. If your video file is larger than the suggested 10 MB, you will notice a notification on the share screen.

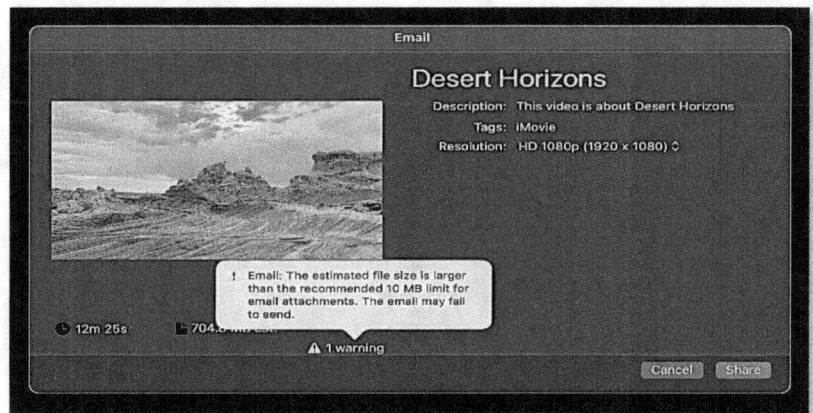

- Select Resolution from the selection that pops up. Select a quality that will result in a smaller video file because most email systems cannot handle large files.
- Click the "Share" option. You'll receive a notice from iMovie after the movie has finished being sent to email.
- Once you have completed the email, click "Send."

Add the video to your collection of photos

Save the movie as a file. After that, you have the option to keep it in iCloud Drive, add it to your collection in Photos, or save it somewhere else. You should save the movie as a file as well, in case you wish to transmit it from a different computer or service.

- Select the iMovie project you wish to send from the Projects box. Once you've done that, simply click the Share button when working on a project, then select "More" and "Share Project."
- Click "File."
- Select the dimensions of your video in the Resolution box that appears. The size of a movie is determined by its quality. Selecting a lower level reduces the amount of time needed to upload the file to the internet. If you select a higher resolution, the file will be larger, which is ideal for watching on an HDTV via Apple TV or a Mac.
- After choose where to save the video file, select "Save."
- To add the movie file to your image library, drag and drop it into the Photos app after saving it. You can see the video on any Apple device connected to the same iCloud account if you have enabled iCloud Photos.

Upload your film to the internet

Sharing movies on Facebook and YouTube is easy with iMovie's options. This arrangement also makes sharing on other websites—like Vimeo and Twitter—easy.

- Click the Share icon next to your project in iMovie after opening it.
- Visit YouTube and Facebook.
- Click Save after selecting a location to store the video file.
- Navigate to the website where you wish to share your video on the internet. Post the video file after that.

Assignments

1. Discuss the process of Exporting Projects with Various Resolutions and Formats
2. In iMovie on the Mac, carry out the exportation of an image
3. Explain the Customization of Export Settings
4. What are some crucial points to remember in Resolution and Quality Aspects
5. Explain the Procedure for AirDrop Sharing

CHAPTER 13
EXPLORING THE WORLD OF CLOUD CO-EDITING

Setting Up iCloud to Allow Cooperative Editing

It is impossible to overstate the importance of teamwork in artistic endeavors like video editing, especially in this day of digital technology. Thanks to innovations in technology such as iMovie, making visually appealing videos is now easier than ever before. Additionally, the advent of iCloud has made collaboration on projects in iMovie much more streamlined and efficient.

Creating an Account on iCloud

Before beginning the process of configuring iMovie 2024, it is important to understand how the iCloud collaboration function operates. This is finished before the process begins. You may store your iMovie projects on the cloud safely and securely with the aid of iCloud. Any device that is directly linked to such projects can also be used to view them. As a result, multiple people can now work together on the same project at the same time, regardless of where they are physically located.

Collaboration is more adaptable and user-friendly than before.

- As soon as possible, all of the devices that will be utilized for collaborative editing need to have iCloud Drive turned on. This is the procedure's initial step. To complete this process, please navigate to the System Preferences menu on your Mac or the Settings menu on your iOS device. From there, you may click on the iCloud icon to see if iCloud Drive is enabled.
- You will need to provide iCloud access for iMovie in particular in order to proceed to the next step. To use iCloud on your device, open iMovie, then go to Preferences > iCloud and tick the box next to "Enable iCloud." All of these will enable iCloud. Your projects will therefore be able to sync with each and every device linked to your iCloud account as a consequence of this.
- You can open an existing project in iMovie or start a new one now that iCloud is enabled. Once you've completed this step, iCloud will save your project right away. Once you have completed this step, you will be able to access it from any device that is signed in with the same iCloud account.
- It will be necessary for you to invite other people to participate in the project in order to cooperate on it. To begin, navigate to iMovie's toolbar and select the option that allows you to work together. After that, you will need to provide the email addresses of the people you want to send invitations to. They will receive an offer to participate in the project through iCloud, and after they accept, they will be able to access and edit the project with you.

- You and the other project participants can work on the project simultaneously and in real-time if you have enabled iCloud collaboration. All of the other users' devices will instantaneously sync with any changes made by a single user. Users will be able to collaborate easily regardless of where they are thanks to this.
- It is necessary for you to assess the changes that are being made to the project on a frequent basis and to give feedback to the people who are collaborating with you. You have the ability to directly comment on certain clips or sections of the project using iMovie's integrated commenting mechanism. This feature makes the process really simple to understand.
- Once you've made all the necessary changes, save the file to iCloud so that everyone who worked on it may access it. This will guarantee that everyone on your team can view the file. Following that, you can export the project to the file format of your choice within that platform, or you can give it to other people via email along with a link.

The Greatest Methods for Collaborative Editing in iMovie

These are a few of them:

- **Communicate Clearly:** Any endeavor involving teamwork must succeed in large part due to the ability to communicate clearly. Maintaining open channels of communication and being transparent and honest when expressing any changes or thoughts to your partners is crucial.
- **Give tasks and responsibilities:** It's critical to give tasks and responsibilities to each contributor, considering their unique areas of knowledge and abilities, in order to expedite the editing process. This will make it simpler to make sure that everyone understands their responsibilities and can collaborate effectively to achieve a common objective.
- **Periodically save and back up your work:** While iCloud offers advanced syncing and backup capabilities, it's a good idea to periodically save and back up your projects locally as well. In addition to providing an extra degree of security, this guarantees that you won't lose any of your work in the event that the connection has any problems or has any technical difficulties.
- **Respect version control:** It's important to respect version control when many people are working on the same project and to avoid accidentally overwriting each other's work. It is crucial to show respect for version control as a result. To avoid disagreements and guarantee that everyone is working on the most recent version of the project, you should make sure that your collaborators are informed of any changes or updates to the project. This will guarantee that all team members are utilizing the latest iteration of the project.

How to collaborate via channels of communication

Before diving into the technical aspects of the process, it is imperative to have a firm grasp of the reasons why collaboration is essential to the video production process. Collaborative efforts have the potential to increase output while also stimulating innovation and the production of new products. Teams that successfully combine the many skill sets and viewpoints of their members are better able to tackle challenging assignments and create richer, more interesting material. Effective communication is the primary requirement for successful teamwork. This is because it ensures that every team member has the knowledge, coordination, and authority to produce their best job. Regarding iMovie, channel integration for communication

- **Establishing the Suitable Roles and Objectives**

Clearly defined project goals must be established at the outset of the process, and each team member must be given specified responsibilities. A clear grasp of the tasks at hand promotes accountability and reduces the possibility of misunderstandings when editing, writing, or making comments. Project management software like Trello or Asana are helpful for organizing work, setting deadlines, and tracking advancement.

- **Making the Most of iMovie's Built-In Features**
 - **Notes and Explanations.** It is recommended that team members be directed to provide comments and annotations within the iMovie timeline as soon as feasible. This has made it possible to provide contextual feedback, which improves communication and lessens the need for various distinct communication platforms.
 - **Sharing and Collaboration:** With iMovie's sharing features, you may work together in real time with several individuals. The ability to access the same project simultaneously for any team member allows for seamless collaboration regardless of physical location.
- **Including Communication Channels Accessible to the Public**
 - Despite the abundance of in-app collaboration options available in iMovie, using external communication channels can improve teamwork even more:
 - **Messaging systems:** These systems act as hubs for communication, with Slack and Microsoft Teams being the main centers of activity. It is possible to have discussions about the project, share files, and provide frequent updates by setting up specific channels.
 - **Video Conferencing:** To address issues, discuss ideas, and assess project milestones, it is advised that you schedule frequent video conferences using Zoom or Google Meet. Face-to-face interactions have the ability to foster connections between team members, which can ultimately foster a sense of unity and promote cooperation.

- Developing Distinct Communication Protocols. **To speed up interactions and lower the possibility of misconceptions, the following communication guidelines should be established:**
 - **Set aside time for communication:** It's critical to set up particular hours for communication so that team members can work together uninterrupted throughout certain periods of time.
 - **Expected Levels of Response:** It is critical to set expectations for how quickly emails and messages will be answered. There need to be a predicted degree of response. Giving prompt answers helps foster a culture of accountability and responsiveness, which in turn helps keep project costs within reasonable bounds.
 - **Providing Evidence of Decisions:** By keeping track of important decisions and discussions in one place, you may ensure that you don't overlook them. This will offer proof of the choices you have made. Even if they are unable to participate in the discussion directly, everyone will still be aware of and in agreement with the circumstances. This suggests that everyone will stick by the current course of events.

How collaborative projects are distributed

iMovie 2024 has improved the efficiency and simplicity of sharing collaborative projects, allowing groups to collaborate together on creative projects without any hassles. Home movies, business presentations, and academic assignments may all be completed with iMovie because of its many features that encourage collaboration and sharing.

Comprehending Team Projects in iMovie

Several people can collaborate on the same project simultaneously in iMovie 2024 thanks to a feature called collaborative projects. This kind of functionality is very beneficial for both people working together on creative projects and remote work teams. iMovie's cloud-based storage and real-time synchronization make it possible to work together more quickly. This will guarantee that all parties involved are in agreement for the duration of the procedure.

Getting things started

To begin a project in iMovie 2024 that requires numerous individuals to collaborate, the following steps must be taken:

- On the device you are using, open iMovie.
- Select "File" from the menu, and then tick the box next to "New Project."
- Select the project template that best fits your needs, or select "Blank Project" to start the customization process from scratch.
- Name your project and decide where to keep it.

The incorporation of collaborators

It's time to look for possible company partners once your idea has been perfected. This is how it operates:

- Select the "Collaborate" button in the top-right corner of the screen after navigating to the iMovie user interface.
- Either select your colleagues' email addresses from your contact list or type in their email addresses.
- Make sure that each contributor has unique access privileges, and specify whether they can alter the content or just see it.
- To invite team members to participate in the project, use the "Send Invitation" option.

Collaborating in Real Time

You will soon have the ability to work together in real-time once your coworkers accept the invitation that was provided to them.

The following are some of the most crucial elements for group editing in iMovie 2024:

- **Real-Time Sync:** One advantage of this type of synchronization is that any changes made by one partner are instantly mirrored by the others. This makes sure that there are no interruptions to the synchronization process.
- **Comments and Annotations:** This feature makes it easier for collaborators to communicate and give feedback by allowing them to submit comments and annotations to particular clips or segments.
- **Version History:** One of iMovie's advantages is its automatic version history feature, which allows you to go back to earlier versions of your film when necessary.
- **Chat capability:** The integrated chat feature facilitates instantaneous communication among team members, augmenting their capacity to cooperate and elevate their degree of cooperation.

Project Export and Sharing

When the project you and your team have been working on is finished, it's time to present it to the larger public. **This is how it operates:**

- Move your cursor over the "Share" button, which is located in the iMovie interface's upper-right corner.
- Select the desired export format, such as a file, Vimeo, YouTube, or iCloud, and then proceed with the selection.

- Make certain changes to the export parameters, such as the resolution, frame rate, and compression settings.
- To begin generating the finished product, choose the "Export" option.

Collaborative Editing: The Best Methods

To ensure uninterrupted communication and optimal productivity, it is imperative to review the following best practices:

- Remember that one of the most important things to remember is to keep lines of communication open with your collaborators during the entire process.
- The second step in the process is to design workflow rules, which involve defining roles, responsibilities, and processes to streamline the editing process.
- It's critical to establish precise deadlines for each of the project's many milestones in order to ensure that everyone keeps on course.
- It is imperative to encourage contributors to participate and to keep an open mind when it comes to making changes in response to the helpful feedback that others have offered.
- Always remember to create a backup of your project files to ensure continuity and avoid losing any data.

Assignments

1. Carry out the Configuration of an iCloud to Enable Collaborative Editing
2. How will you Set Up an iCloud Account
3. What are The Best Methods for iMovie Collaborative Editing

CHAPTER 14
ADDING CAPTIONS AND ILLUSTRATIONS TO THE KEYNOTE

Using Keynote to generate original titles

You need to first make a different Keynote file specifically for this process before you can start coming up with original titles.

This removes the need for you to carry out the subsequent steps each time you want to come up with a project title:

- You can launch Keynote by double-clicking on its icon or by searching for it using Spotlight after pressing the Command Key and the space bar.
- Click the New Document button or use the Command Key and N to begin a new document.
- This is where you will view the selected theme.

So that we can create titles with alpha channels, we want the presentation to be as straightforward as possible. Click the Create button after selecting the Basic Black design.

- You will now see the primary picture-editing options. To alter the slide's backdrop, click on it. If this step is completed correctly, the Slide title will appear in the File sidebar on the right, as seen in the image below.

- Look for the "Current Fill" option on the page's bottom tab. This option is essential as it determines the color of the slide's back. Since there can't be any color, we'll choose "No Fill" from the drop-down menu to get an Alpha channel.
- You can click on the text boxes you don't need and then hit the backspace key to remove them. The kind of title you wish to create will determine this step. I would like remove the Author, Date, and Presentation Subtitle boxes so that I can only edit the primary title.
- Type the words you want to appear in the title by double-clicking on the Presentation Title. To select all of the text, press the Command Key and A three times.

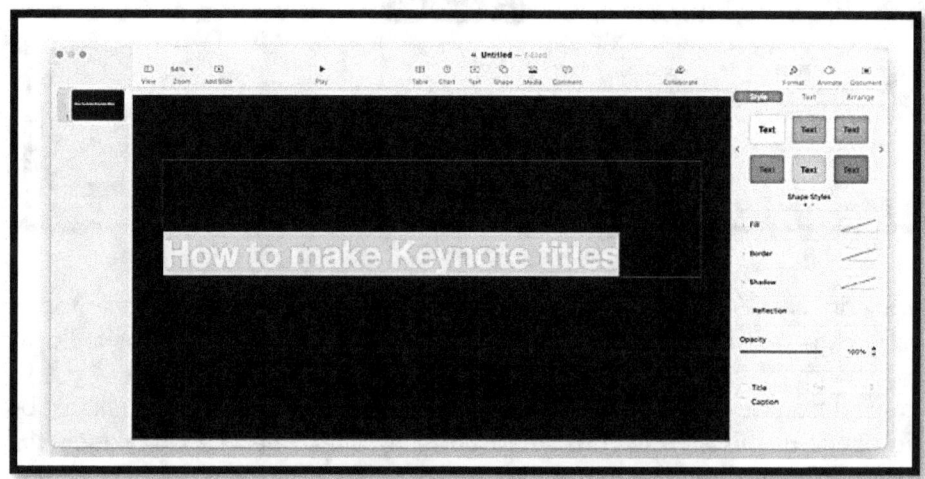

- As of right now, there should be three tabs in the Format sidebar: Style, Text, and Arrange. When you click on Text, you can adjust the text's color and size.
- You are welcome to alter the typeface however you see fit, although I would strongly advise adding a drop shadow. It will stand out from your video's background as a result. The hover menu will appear after selecting the gear button beneath the point size indicator. Select the Shadow option from there. You may create a drop shadow in this manner.

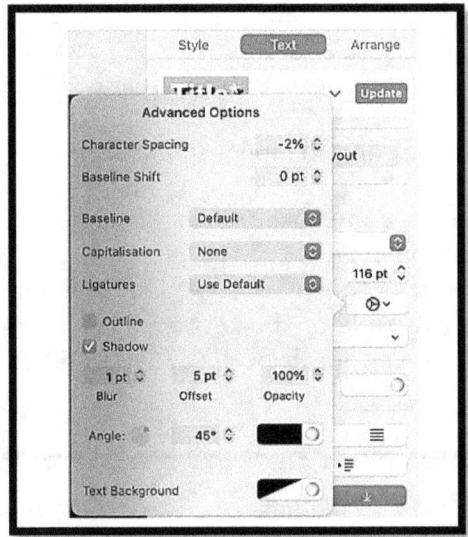

You've worked so hard to create a Keynote file that will serve as a fantastic foundation for creating your own titles. You should press the Command and S keys together to save the file before making any changes to the title. Next, choose a location and name that are simple to recall.

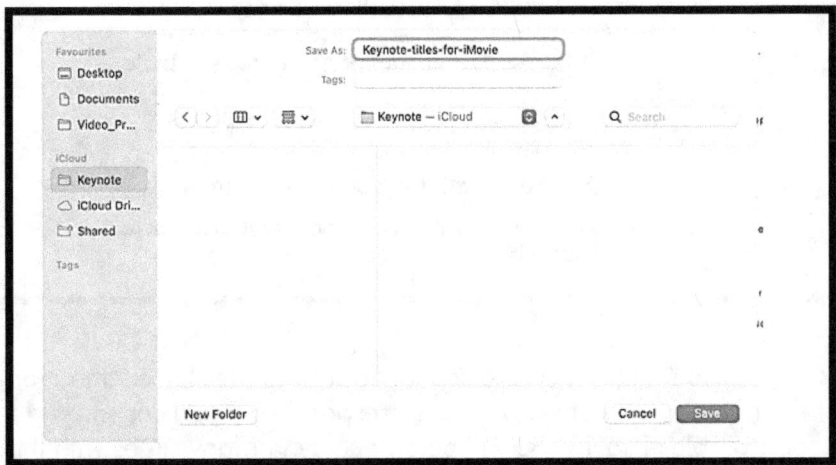

You should store your title documents in the iCloud folder that Keynote typically utilizes for saving files. iCloud Drive allows you to store your title documents so that you can access them from any internet Apple device. Keynote files (.Key) are compact and use up little space in iCloud.

Exporting Keynote titles

After you've had an opportunity to alter and style your well-selected stock title to your liking, you should try importing it into iMovie. If you adhere to the guidelines in the final line, you can accomplish this. The parameters you choose in the export menu will determine whether or not your title is compatible with iMovie.

Practice using your title by completing the following tasks:

- Once your title slide is complete and looks good, click it to confirm that the Background is still set to No Fill.
- To download images, choose File, export to, and then photos from the menu bar. There's no simple fix available on the keyboard for this.
- When you arrive, you'll see the Export Your Presentation options. Verify that you are currently on the Images tab.

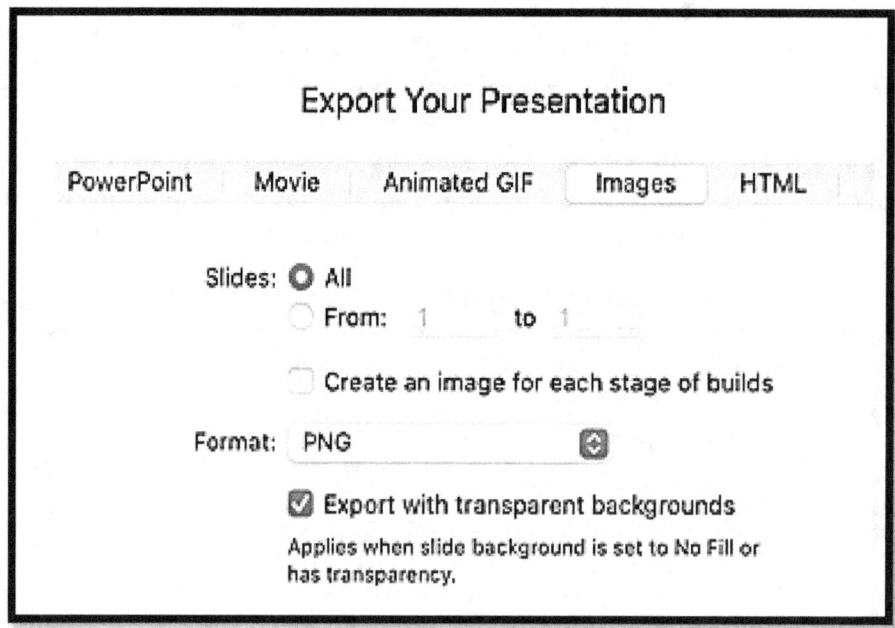

- In case you have many slides, typically with distinct titles, select the From circle and adjust the numbers in both boxes to correspond with the desired slide number to send, for example, 1 to 1. You will be able to send many slides with this.

- Verify that the file is either PNG or TIFF in the drop-down menu and that the "Export with transparent backgrounds" box is ticked. After that, press the Next button. Button located in the menu's lower right corner to select a suitable location for saving the title. The background image for a video should go in the folder you create in Finder specifically for videos.

Regarding Images and Transparency

One method to make sure the user gets a photo with a clear background instead of a white one is to search for images without backgrounds in PNG file format. This is so because search engines consider transparency to be white.

Although alpha channels are possible in images, the PNG format does not allow them. Remember this:

> *.JPEG files cannot carry transparency*
> *.PNG, .HEIC, and .TIFF files can carry transparency*
> *.PNG is often the best choice because it has great compatibility but cleverly compresses images to give you small files compared to others. TIFF, which is a lossless image format.*

Importing Keynote files into iMovie

After it has been made, you can import the Keynote.PNG file into iMovie. These title graphics have a see-through background, making them suitable for use as cutaways or PIP. This is the greatest way to use title photographs in a PiP style because it gives you the most alternatives. Once you've done this, you can use keyframe animations to enlarge the title to fill the screen and move the word about.

Your title will show up in the following sequence if you follow these steps:

- Open iMovie and double-click the project where you wish to utilize the title with the mouse.
- Select the Import Shortcut button after selecting the Project Media tab. Press the Command Key and "I" simultaneously.
- Once you have located the title photo, import it. Keynote allows for exporting. It will be saved in the folder you named it, and the filename of the first title photo will have .001 appended to it. Even if you don't send many images, this will still occur.

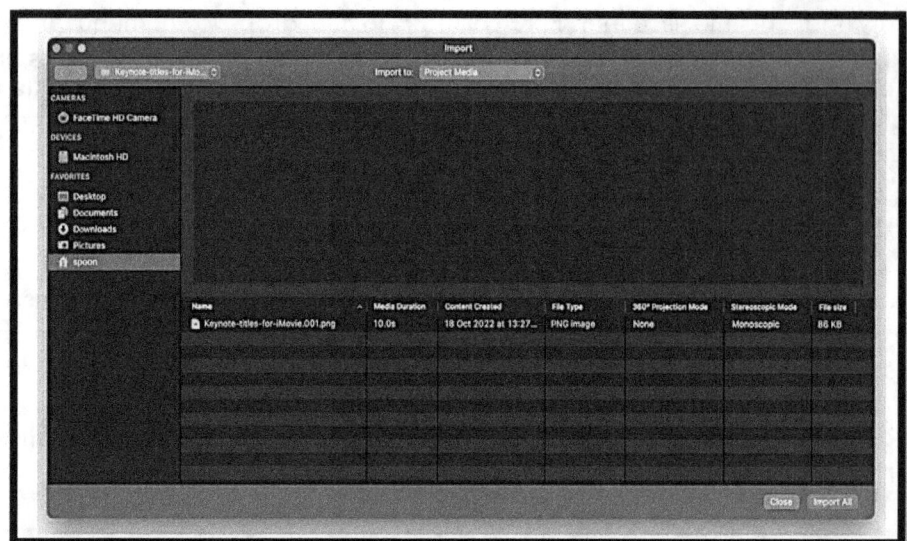

- Press Command + 4 to access the Backgrounds Media Browser tab, or select a clip. The title will take place in the footage. The playlist has to be updated with the video. Generally speaking, you want to make the title's backstory as straightforward as you can. To make the title easier to read on a background with lots of varied colors and patterns, you will need to add a stronger drop shadow or text outline.

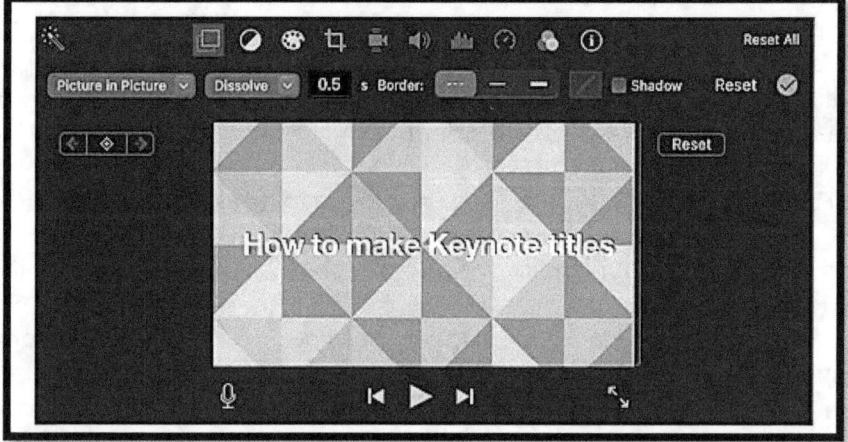

- Return to the Project Media tab, then hit Q to add the title file photo as a layer.
- Choose the picture that will serve as the title after selecting "Video overlay settings" from the toolbar. Next, utilize the drop-down menu to modify the overlay style to "PiP."

- To make the title appear immediately, move the fade handles to the timeline's edge of the clip. This will cause the title to appear immediately. The time editor box also offers the ability to set the transition's duration to zero.
- To enlarge the title and ensure that it fills the majority of the screen, press and hold the blue handles in the PiP's corner and move them outward.

Make sure the point of view aligns with the Viewer's yellow vertical and horizontal symmetry lines in order to create an appealing title. Although an ideal title doesn't have to be perfect or take up the entire screen, it's crucial to keep in mind that if you choose to stand out from the crowd, there's a good reason for it: people will notice. Everything pertaining to Keynote's custom set titles is now complete. Change your text's color and font style, as well as the shadow weight, blur and opacity, character and line spacing, and other parameters, by experimenting with Keynote's Advanced Options (the gear symbol). Regardless of the technique you employ to create your static title, it will function identically when saved and imported into iMovie. We will now examine the process of animating titles, which requires an altered export procedure in order to preserve the animation.

Animated title creation with Keynote

You know how to use iMovie's effects to make titles that move, grow, and fade. Using Keynote's built-in Build In, Action, and Build Out animations is another way to achieve this. This kind of PowerPoint animation—where text slides down, speeds up, and spins on the screen—may be familiar to some of you. These Keynote animations can still be used, and we can send just the title with an alpha channel.

When creating a title for an introduction, the following steps should be taken into consideration:

- Open the Keynote file you created for the iMovie titles first.
- Locate the text box around your material in Keynote and click on it in the menu's upper right corner. Click the Animate button after that.

- To make the "Build In" section stand out, click on that tab if it isn't already highlighted. The button allows you to add an effect. Click it.
- You may apply a plethora of different special effects to your title text. To accommodate various motion types, these effects are displayed in segments. You can preview how an animation will seem by moving your mouse over an effect and clicking the Preview button to the right of it.
- After selecting an effect and clicking on it, an option to make modifications will appear on the left side of the Animate window.

Depending on the animation you select, the options will vary, however most of them allow you to modify the following:

> - **Duration** of the animation
> - **Direction** of the animation (from the left or the right)
> - **Delivery** (allowing you to break up animations for larger bits of text, slow the start and end of animations, or add extra icons to the animation)
> - **Order** (ignore this for now unless it's not 1

- Once you've finished adjusting the animation settings, click the Preview button to verify that the text appears how you want it to. If not, continue adjusting the animation parameters little by little and testing them until you get the desired title animation.

Keynote animated title export

Once you're happy, hit "Send." We are unable to save the title as an image at this time because we are working on an animation that will take some time to finish. **To preserve the slide's clarity, we will need to export a movie and then adjust its parameters.**

- Choose File > Export To > Movie from the menu bar to save as a movie.
- If you're sending one moving title out of many, in this case, the slide range should be 3 to 3. After that, save the file.
- Look down at the menu to see the Resolution drop-down menu, and then select Custom...
- More options are displayed on the list. Make sure the Frame Rate corresponds to the one you're using for your project, and adjust it using the drop-down menu if needed.
- We need to adjust the Compression Type option so that we can send with an alpha channel. By clicking on that drop-down box, you can select HEVC.
- The last option in this menu will now be available for selection. If it hasn't already, make sure that the Export with clear backgrounds option is selected.

- Save the video file to the project folder after clicking the "Next" button.

Transparent video exporting

It has been observed that TIFF files are not see-through, but PNG files are. JPEG files, no way. Transparency in video is virtually eliminated in some formats. You have two options for compression types in the Keynote export menu: Apple ProRes 4444 and HEVC. These two choices both maintain transparency. The High-Efficiency Video Coding (HEVC) standard keeps the majority of the video's clarity and quality while reducing the size of the file. The output file will be almost same and raw if you select ProRes 4444. Because it's a TIFF file, it will be big.

ProRes 4444 offers more details, most of which you won't require. Adding your animated title to your timeline is basically the same process as adding photos, once you have created it in Keynote. Remember that the title does not start to animate until around midway into the clip when you add your title clip to the timeline. You shouldn't be concerned about this because it just means that we haven't changed the animation system's base build order parameters. That is what we are going to look at next.

Creating multi-stage animations with Build Order

We currently have a title that expands and shows an image. We'll supplement this with a second, differently-moving section of our title.

The following moves and adds this text box to our title slide:

- Open the title slide that you were working on in Keynote.
- After making one click in the title field, copy the content and paste it into the second box by pressing Command Keys C and V. Verify that the text in each boxes has the same style settings.
- To pick every word in the new text box, click three times. Next, type your updated title.
- Locate your second text box by going to the Animate tab. Verify that the Order is set to two.

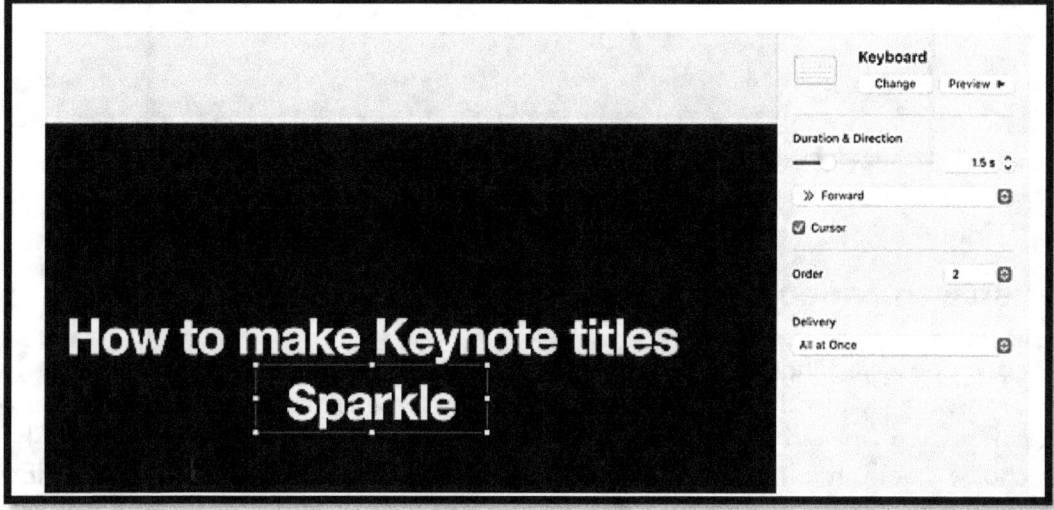

- Click Change at the top of the Animate page to select a different motion. To match the text, I went with Sparkle.
- It is now required that these images be connected. On the "Build Order" button located at the very bottom under "Animate," click.
- Click the second motion in the menu that appears. There, select With Build 1 from the Start drop-down menu.

Keynote won't need to pause in between animations when these construction events are used in place of click events. Rather, they will acquiesce to one another organically.

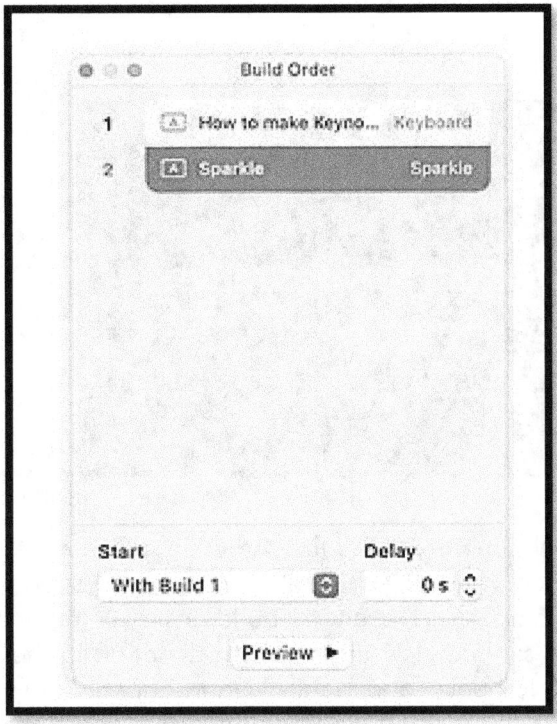

- At the bottom of the screen, select Preview. The two text boxes shouldn't wait for each other.
- **To alter the animation's appearance, modify the following settings:**
 - How long each changeover lasts
 - The second animation's delay

This is your moment to take command and alter the environment to suit your needs as an artist. Once you've made the small adjustments, see how they function. Repeat it after that. I'll walk you through the changes I would make to these images to better illustrate how the tools work. The keyboard movement appears excessively quick when I observe it for 1.5 seconds, at least compared to my own typing speed! I'm going to make it appear more like typing by slowing it down.

- Select the Build Order tab and click the first animation. The Duration tool is movable within the Animate tab. It takes 2.5 seconds, so that's about right. Consider your options first.

Now that the first animation is almost finished, I want the second title to appear. To do that, we require a wait time roughly equivalent to the first transition.

- In the Build Order menu, select the second transition and adjust the value in the Delay box. Examine and make a decision: a 1.8-second break is effective.

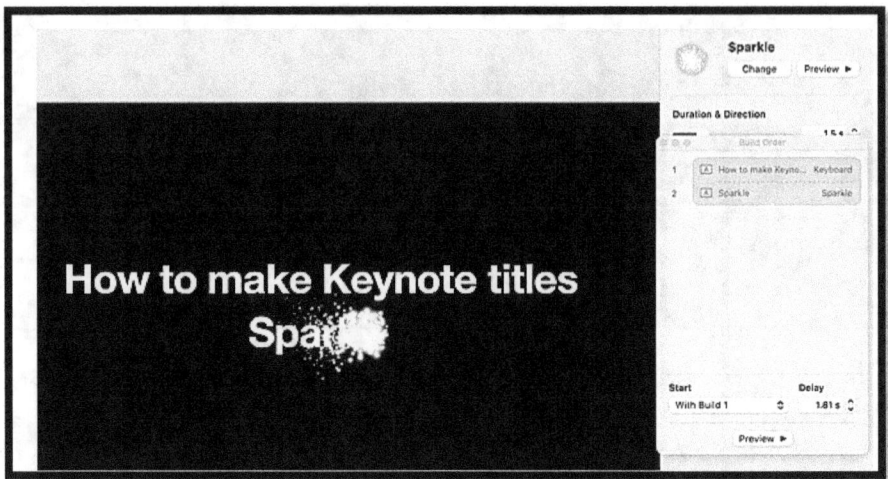

Once you're satisfied with the title, utilize the same file parameters to turn it into a movie. Keynote will utilize the delay we specify in between transitions rather than choosing its own delay after we move from click events to build order (With Build 1). To modify the On Click to After Transition setting, click on the first animation in the Build Order box. This will cause the animation to begin concurrently with the video. That concludes the matter at hand. The titles that fade off the screen will be added to our animation construction order.

About animations creations

These images correspond to our titles. Until the end of the clip, they are just sitting there. We could click and drag the fade handle at the conclusion of the clip on the timeline while holding down the Option key to fade them out. But what if we wish to keep the titles hidden as well?
- Again, click on the text box in the first row.
- Select Add an Effect from the Animate tab. Lastly, select "Build Out."

You are currently moving for a different text box. But don't worry; the integrated animation is still present. One Build In animation, one Action animation, and one Build Out animation can be added to anything in Keynote. They'll all be displayed in the Build Order box.
- Select an effect for Build Out. Repeat steps 1 through 3 for the other text box.

I once again used Keyboard as the Build Out motion for my first text box, which features the Keyboard animation. I modified the Keyboard animation's Build Out Direction in the Animation tab to be backward. The backspace key appears to be erasing the words. I decided to use Vanish as the Build Out motion for the second text box, which includes the Sparkle animation.
- Click "Build Order" to begin. If you're following along, the menu should look like the one below, but it varies depending on the moves you select.

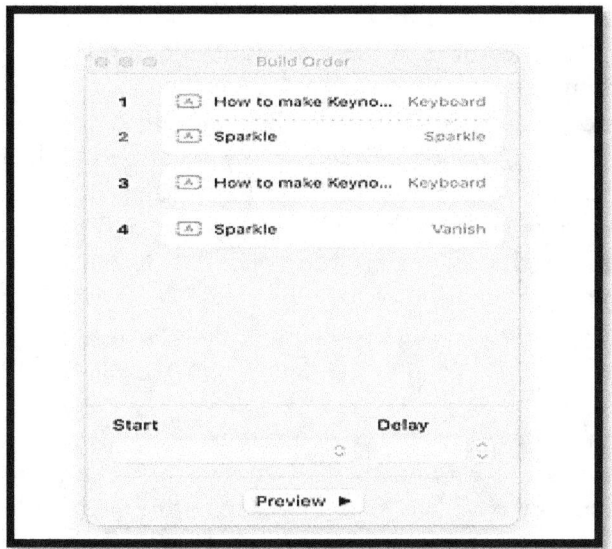

Now that the steps are all set up, we can utilize the Build Order menu to arrange them in the correct order. We must first ensure that every movement occurs on its own:

- Because Builds 3 and 4's names are spaced apart from the other builds on the screen, we can infer that they are configured to launch upon click.
- Select after Build 2 from the option that displays after clicking on Build 3.
- Select "With Build 3" from the selection that appears after clicking on Build 4. This is how the Create Order page should now appear.

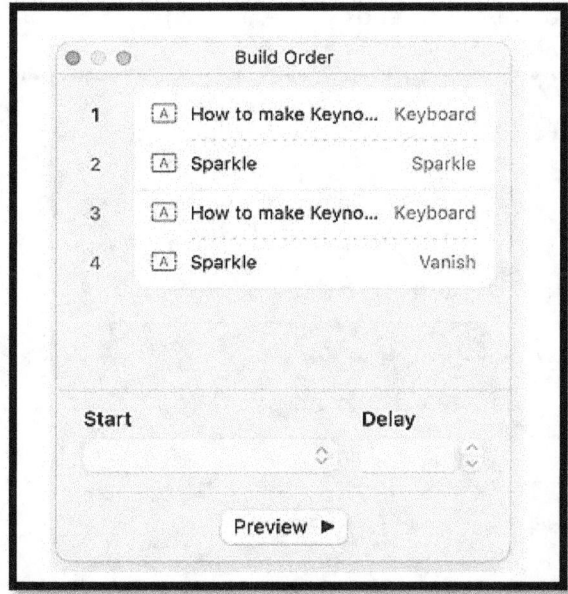

It's also useful to be able to immediately observe in Keynote what the builds are doing. **In the image, some of the constructions have straight lines connecting them, while others have partially dashed lines:**
- Two buildings occur simultaneously if a dashed line separates them.
- When two builds occur consecutively, they do so one after the other.

Examining these lines will make it easier to understand how your animations work together. When creating more intricate animations, this assists you in determining and modifying the appropriate delays and movements. The duration of the Build Out moves must then be determined. For the duration, the title will be visible on the screen before expanding, and the two text boxes will expand simultaneously.
- After entering a duration in the Delay field, select Build 3. To save the modifications, hit "Enter."

The duration for which the title appears on the screen is up to you. I chose a pause of two seconds. You can review the motion to see what went wrong and what you want to improve before making any modifications. The Vanish animation should start before the Keyboard animation, not the other way around. One animation needs to conclude faster, while its starting needs to be shifted back. In this manner, everyone will have to wait for the same amount of time plus the duration.
- From the Build Order menu, select Build 4. Add a 0.5-second wait after that. In order to save your edits, hit "Enter."
- In the Animate tab, click the "Build 3" button and adjust the Duration such that it is 0.5 seconds longer than Build 4. For instance, instead of two seconds, make it 2.5 seconds.

An animation example is playable, so we know the timing is OK, but Vanish causes the word to vanish before the animation finishes. This will be fixed by what I'm about to do:
- Add an extra second of delay to Build 4 (Vanish) so that the word Sparkle vanishes after the keyboard animation ends.

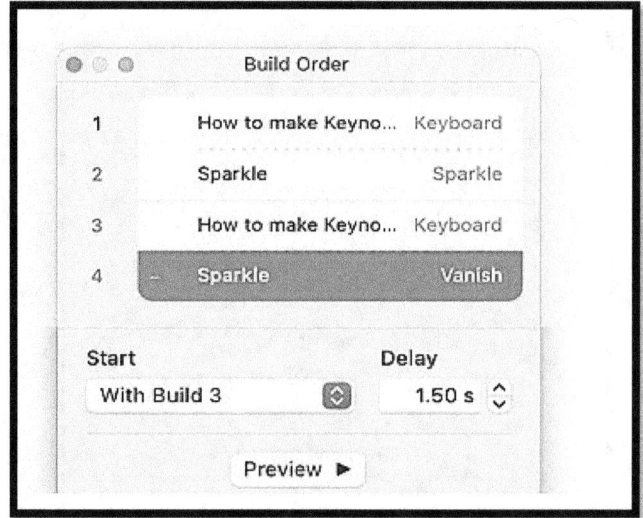

Importing, exporting, and changing multi-stage animations

Since we have previously stored an animated title clip, we'll utilize some timeline legerdemain to make adding new ones simple:

- Select File, Export To, and then Movie.
- Verify that the Export with clear backgrounds checkbox is ticked and that the codec is still HEVC.
- Once you've selected "Next," save the video file to the project folder.
- Locate the appropriate project in iMovie, and then use Command Key + I to add the file.
- To add the new title video to the playlist, use Command Key + C after copying the previous title clip.
- Select the new video from the Media Browser. Then, to remove it, click and drag it over the previous one.
- To transfer the overlay configurations from the old clip to the new one, select the new clip and then Alt+Command+U. This implies that you won't need to modify the PiP once again.

It is also possible to alter the title's style without having to reorganize the Build Order menu. Now that the sound has been added, this is achievable. Once the title film has been loaded into iMovie, you can easily adjust the shadows and modify the color of the titles without having to re-edit the animations. **I adjusted the following elements of the aforementioned image in Keynote's Format tab:**

- With the exception of Keynote, which had a fill that changed from yellow to blue, I applied a color fill to every word using the Text Color drop-down menu.
- I made the shadows less visible by moving them to the bottom of the lettering using the gear menu.
- For Sparkle, I made a picture with lots of polka dots.

However, I wouldn't enter a beauty competition with that title. It demonstrates your ability to use layout cleverly. Make sure your title has something helpful to do with it if you want to create something a little strange like the image above. In this way, it will be more noticeable against the background. It would be better to sprinkle shadows over the letters or give the lines more depth. A title that is unreadable is of no assistance. That concludes our discussion of keynote titles. However, the app is capable of more. In the Animate tab, the steps tab is located in between the Build-In and Build-Out stages. You can now move any object on the screen in any direction. You can create visually stunning animations using any of these options.

Keynote route animation generation

Why would you want to use Keynote for picture and video movement when you can accomplish it with keyframes in iMovie already? In three crucial areas, Keynote animation performs better than iMovie animation.

If any of the following are essential to the success of your project, use Keynote in their place:

- Animations that you send have a transparent background.
- More than one object can be moved simultaneously.
- You can rotate an object around a route and to within one degree.

As we've already shown, titles can benefit from exporting with openness. Let's now examine some additional benefits of creating a small-scale country road scenario. All of the objects in the following image were created using Keynote. You can see how the colors and tones were altered, pre-made shapes were used, and the Keynote Pen tool was used to create it. For now, though, it's only an image. In the event that you accept the shot, it must move.

It appears as though the car on the far left side of the image crossed the road on its own. You cannot use iMovie to accomplish this with a winding route. The best way to get a bent-looking form is to set tens of thousands of keyframes. The vehicle would follow the road, but it would not veer off course. It would appear to be rolling the entire distance.

To create the path in Keynote, do the following:

- Apply pressure to the vehicle. You can move all of the forms at once because they are grouped together.
- Click Action under the Animate tab. Click Add an Effect after that.
- We must click on the Move action in order to move the line. A fading replica of the car will be separated by a line.

The animation's course is indicated by the red line. Where the animation route terminates is indicated by the hazy automobile. Clicking the red diamond will allow you to add an animation. The route creator will reopen after you click the diamond to end the Move motion.

- To move the washed-away car to the end of the road, click and drag it. Like a real car, it should be facing the road in a logical manner.

The car's animation path is currently straight, but it is easy to bend it so that it follows the road:

- A keyframe is represented by the white circle that appears when the mouse is moved over the animation line. Rotate the circle until it arrives at the location where the road turns up the highest in the image.

- Now, the first white circle is at the desired location. When you move your mouse along the animation path, a fresh white circle will appear around the trio of trees.
- Drag the newly created white circle to the place where the road bends the tightest—the bottom. A square indicates the location that you should target.
- From now on, the car will smoothly navigate the road from the beginning to the end of the animation. On the Animate tab, check the box next to Align to Path. After then, the vehicle will follow the route and make the appropriate turn, just like a real car would.

The simple Align to Path option is really helpful most of the time. The direction of the animation is now straight. Nevertheless, we must ensure that the vehicle appears to be traveling in a certain direction and that its pace is appropriate. **The actions you need to take are as follows:**

- Once more, click the Animate box, and this time, adjust the Duration to a value greater than five seconds. After this, the car will drive more slowly. To save the updated length, type "Enter".

Now the car will speed along our road. However, it's currently stopping and beginning on the road. Do the following to make it appear as though the route the car was on was merely a small portion of a larger road:

- Click on the square in the center of the car and drag it off the slide to begin the animation. Press the Shift key, the Command key, then the "," key to exit the slide. It will be beneficial.
- With the faded car near the end of the animation path, repeat step 10 again.
- The car won't appear to be moving before it enters the photo if you choose "None" from the drop-down menu next to "Acceleration."

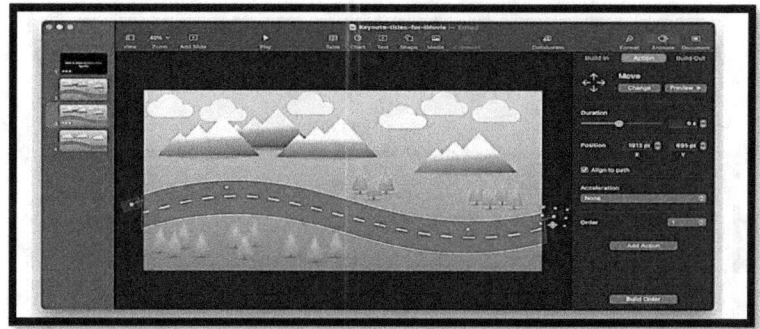

Click the Build Order button located at the bottom of the Animate window if you have disabled the animation path but are still unable to see the red diamond outside the frame slide. The road will reappear after you click Build for the car (Group). Take a look back and make a decision. Look for instances in the animation where the automobile leaves the road or stays on it for an extended period of time. **To improve the curve, take the following actions:**

- To add another white circle, place your mouse on the line of motion and click and drag it. Later on, you may want to repeat the same action to balance the turn. The white circle keyframes are easier to locate since they always appear in the center of the two keyframes that are adjacent to one another. These are movable as long as they stop before the next clip. But what about Keynote drawing's other benefit? It's simpler to add more moves now that we know how to use the ones

appropriately. **To relocate those clouds, let's send another car in the opposite direction:**
- Press Command Key + C to make a copy of the automobile. Press the Command Key and V keys in that order to move it to the other side of the road.
- Toggle between Format and Left. To rotate the car to face the other way, click and drag the Rotate tool's circle.

- In the Build Order menu, press the backspace key to remove the motion route of the second car. Now it's headed in the opposite direction.
- Return to steps 4–13 and choose Animate | Action | Add an Effect | Move to adjust the second car's motion. You're powerful!
- Modify the second car in the Build Order box so that it moves in tandem with Build 1. Allow for a delay at each crossing so that the vehicles arrive at various times.

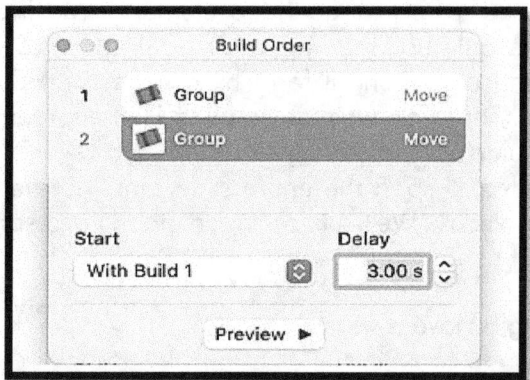

Not to mention, let's tidy up the sky. Since there are so many of them, we'll force them to move simultaneously:

- Holding down the Shift key, click on each cloud to select it. Select Action from the menu that appears, then select Add an Effect and Move.

- Set the Acceleration to "None" and set the Duration to at least 10 seconds.
- Go to the Build Order menu while the clouds are still selected. Select "Previous Build" from the menu next to "Start."

Take a look: The two vehicles should go in seemingly typical routes as the clouds pass slowly and hardly at all overhead. How lovely. The fact that you created it all in Keynote may make it even more exquisite. Recreate the motion route for the second automobile by going through each step, paying particular attention to steps 4 through 13. If there is a problem, address it. But in order to fit the other lane, the keyframes will need to be modified. The concept remains the same: place one at the top and one at the bottom of the bend. **Since the scene no longer contains any alpha channels, sending this animation is significantly simpler:**

- To create a movie, select File > Export To > Movie.
- Press "Next" and store it in a location you'll remember. And that's it!

We looked at how to animate multiple objects at once at the end of this procedure. We will examine the subsequent motion function that enables you to accomplish this, but with entire slides rather than fragments.

Using animations for Magic Moves

There is a distinction between Magic Move and Magic Movie. Using the slides as keyframes is one approach to accomplish seamless transitions between slides in Keynote. When you apply a Magic Move transition to Slide One, its status stays unaltered. It will look like slide number two. This tool is mainly used to add interest to slide transitions, though it can also be used to rearrange video elements. Moving every element on the screen at once is not the only use for Magic Move. It can also be used to get around certain laws. Here, scaling a very small form by a factor of 1,000 does not produce a significantly larger shape. The circle was too small to fill the screen and hide the cut to the following clip, so you couldn't complete the transition. However, if you had a small circle on one slide that expanded to span the entire slide, and vice versa, Magic Move would allow us to flip between slides. We'll utilize this method to create our transitions when moving shapes in this last assignment.

Let's first look at how Magic Move is used:

- You can click "Add Slide" from Keynote's menu or fast press "Shift Key + Command Key + N" to add a slide.
 - Command Key + N can be used to create a brand-new, simple presentation. You can begin on slide one and end on that slide in this manner.
- The text boxes on the slide should be removed.
- Select Shape from the menu. Click the circle next to Basic after that.
- The Format bar's color can be altered if desired.

- Holding down the Shift and Option keys, click on one of the locations around the circle. Then, drag the circle inside
 - The shape's lines remain straight when you simultaneously press the Shift and Option keys, preventing it from being crooked or off. Make sure you release the click before releasing the special keys as you make adjustments.
- Press the ".", Command, and Shift keys to move as near to the slide as you can. In this manner, the circle remains visible even as it gets smaller. The size of the shape is indicated by a moving icon. Reduce the shape's size till it is roughly 5 points.

- Click the slide in the Slide Navigator on the left, then use Shift + D to duplicate it.
- Click the circle on the duplicated slide while holding down the Option and Shift keys. Next, move it outward. This should fill the entire frame with the circle. To zoom out, pause in the middle of the slide and hit Shift + Command +.

- Return to the first slide and select the option labeled "Animate."
- Select Magic Move from the "Add an Effect" menu.

The first slide's little circle should enlarge during the Magic Move until it completely fills the slide. This concludes your first Magic Move. However, how is this related to the way you transition?

Customized overlay-based transitions

To indicate the transition, just say that it changes from clip one to clip two. Many transitions change the frame to show the change. For example, the previous clip may be slid off the screen or erased, and the new one could gradually lighten until it takes over. But in the meantime, we're working on something that will occupy the frame after this changeover. While viewers are viewing, the element in the middle of the screen may shift in the background, detracting from the video. When moving to unexpected material, it may seem unusual to take these efforts to hide the cut, but they are helpful. A live copy of a game frequently has these overlay transitions. This takes the audience back in time while presenting what they have already seen. During the transition, the TV makes this sound to let viewers know that it hasn't suddenly gone into repeat mode. That way, they'll be able to see the show live.

Using Magic Move to make transitions simple

How do animation transitions work? Let's make one utilizing the circle that we animated with Magic Move. We'll use another Magic Move to return the circle to its original position after it has blocked the screen. After that, the transition will be exported so iMovie may use it.

- If you haven't already, switch the backdrop of your slides from Color Fill to No Fill using the Format tab's backdrop drop-down box.
- Make a copy of the first slide and place it at Slide Navigator's bottom.
- It's the circle on the second slide's side. To modify it, select Animate, Add an Effect, and Magic Move.

Since Magic Moves aren't available in the Build Order menu, we'll need to link the builds using Slide Navigator and the Animate tab.

- Press the Command Key and A simultaneously to select every shot.
- Set the Start Transition drop-down button to automatically under the Animate tab. This transition is independent of the other parameters.

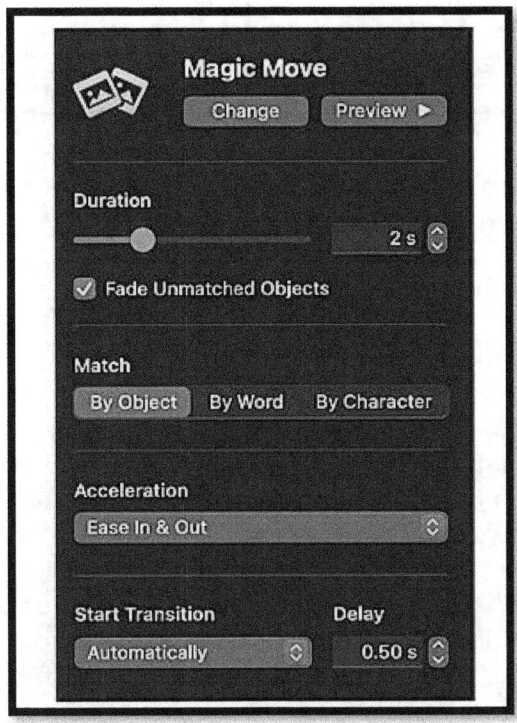

We linked the motion to multiple slides by configuring various Magic Moves. It is not necessary to create two different animation lines for the same thing on the same slide. This makes it easier for you to modify the animation and rapidly comprehend its meaning. However, Magic Moves lacks construction order parameters, so you can't move various objects at different periods. This means that if you want two animations to overlap and run out of time to add visual interest to the scene, you will have to use standard animation actions.

Multiple stage import and export of Magic Move animations

Since we use a lot of slides, the export process now involves several slides. To send your Magic Move transition out, take the following actions:

- Select File, Export To, and then Movie.
- Select the appropriate quantity of images. You can utilize Slides 1 through 3 or all in a new Keynote file.
- Select "Custom" using the list that pops up.
- Select the HEVC compression type and tick the box for Export with transparent backgrounds.
- Name the location; click "Next," and save it.

It's time to import your three-slide range into iMovie after creating a transparency-based movie. Follow these steps in iMovie:

- To access your previously stored transition, simply hit the Command Key and the letter "I."
 - From the drop-down option in the center of the Import menu, select the Event that you created for your animations.
- Add two clips to the timeline that contrast sharply with one another, such as a red background and a green background, to test the transition.
- The transition clip's center should be positioned over the edit point where the two clips converge. The clip will now be positioned above everything else.
- Press C after moving your mouse over the layer transition. Next, press the slash in front (/). This only plays the transition when the video has been selected.
- The clip on the main video layer shouldn't change color at that time because the circle should fill the frame. The transition will be successful if the circle becomes larger over it.

It may be necessary to adjust the top clip in order to ensure that this occurs. There won't be an interesting transition because it's only one circle. However, it's effective in bringing attention to itself. The extent of what we can learn more about is only beginning with what we have observed thus far. Having mastered the tools, you can now express your creativity by creating titles and images that reflect your identity as a creator or the subject matter of your video. The final type of animation is quite easy to create and requires very little effort.

Deadly basic animation with dynamic backgrounds

Keynote 12 introduced backdrops that were constantly changing. You can choose a group of colors that will change the background of your slide. Is there B-roll accessible to help a video make up the missing scenes? A picture with a changing background will look more interesting than one that has been stored for a long time. Making a high-quality video requires using relevant and entertaining video content. Still, it makes sense to have a busy background readily available.

You can create and send one by following these instructions:

- Use the Command Key and N to start a new Keynote presentation.
- Select Dynamic Rainbow (you may also choose Dynamic Dark for a darker background; both will allow you to alter every hue in the motion).

- The Format panel has a color bar that illustrates the color changes on the screen. By clicking on the marks, you may alter the colors.
- Move your mouse over the color bar and click on a space to add additional colors.

- **Additionally, you can modify the following in the Format panel:**
 - **Scale:** This figure indicates the degree of proximity between the colors on the slide.
 - **Speed:** The rate at which the screen's colors change
- Once you're satisfied with the motion background, save the video as a standard 1080p file. As long as you choose the duration for "Go to next slide after" in the export option, the movie will be that long.
- You might save these images by making an iMovie event for them.

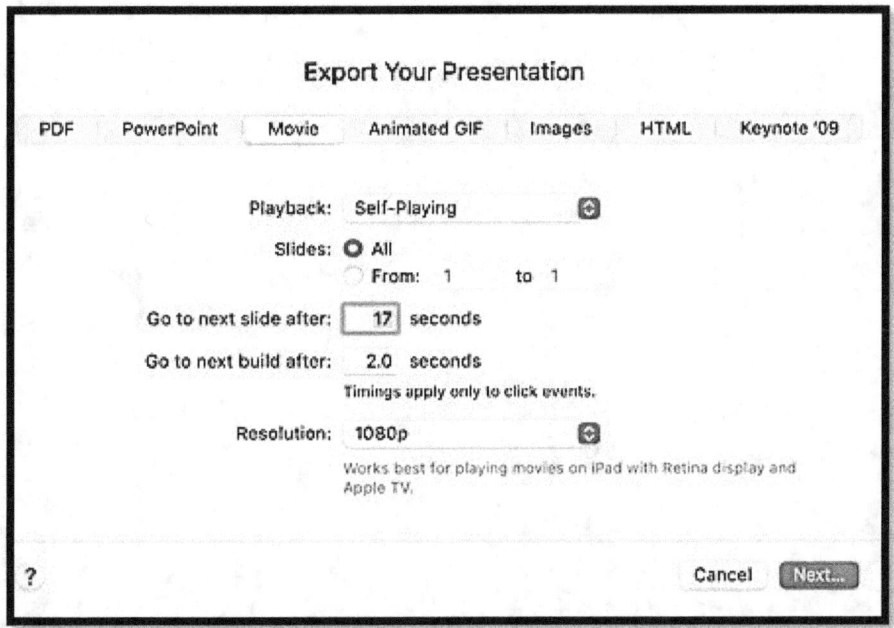

Furthermore, those backdrops are modifiable, so if you need to quickly edit a film, you may use them right away. But that shouldn't have to be your experience. Now that you are aware of all of this, you can create the video you like.

Assignments

1. Explain how to utilize Keynote to create unique titles
2. Explain how to use Keynote to create animated titles
3. Discuss the process of constructing animations
4. How will you personalize transitions with overlays
5. What do you understand by Magic Move animations?
6. Explain Importing and exporting Magic Move animations in multiple stages

CHAPTER 15

THE MOST COMMONLY ASKED QUESTIONS AND TROUBLESHOOTING TECHNIQUES

Adding Media Files

Issue: iMovie won't seem to accept media files

- Verify if iMovie is capable of reading the video files. iMovie can open a wide variety of file types, including MP4, MOV, M4V, and more. Your video files have to be in these file types.
- Verify that you are using the latest version of iMovie. Software versions can occasionally have compatibility issues with each other.
- Try restarting your computer after shutting it off, and then attempt to import the video files once more.
- If the issue persists, you may want to convert the media files to a format that iMovie can read before adding them using third-party tools.

iMovie randomly freezes or crashes while operating

- To create space for this program, shut down any other background apps.
- Be careful to install the most recent version of iMovie and frequently check for updates. Updates frequently include bug fixes, which increases stability.
- Restart your computer to make room for newly installed software and to reset the system.
- You might want to try restarting iMovie if the issues persist. This may assist in resolving any problems arising from corrupted files or configurations.

Issues with Audio Synchronization: The audio and video stop synchronizing after a change.

- Verify that the timeline's audio and video clips are perfectly aligned.
- Make sure to adjust or trim the clips to ensure proper sync between the music and video.
- Make sure all audio effects and enhancements are off in order to maintain the clips' timeliness.
- If the issue persists, you can attempt to export the project and then import it back into iMovie. This may assist in resolving the issue.

Exporting issue: I'm having issues trying to save the project from iMovie

- Verify the amount of space on your device. iMovie may not be able to save the project if your computer does not have enough space.
- Verify that all of the export parameters—including the desired file format, size, and compression—are configured appropriately.
- To determine whether certain settings are the cause of the issue, try relocating the project to a new location or file type.
- Try exporting the project in smaller portions or contact Apple Support for additional assistance if the issue persists.

Your video file is incompatible with iMovie

Occasionally, when you begin a project in iMovie, the files you've saved won't open or play properly. The most likely cause of these issues is the peculiarities in the import procedure. However, not every movie you intend to use with iMovie will function properly. First, let's examine the various file formats and sizes that iMovie supports.

iMovie has several ways of informing you which files it dislikes:

- When you drag and drop the video onto the timeline, it will not appear. There will be an indicator that reads "no entry"
- When attempting to import a video file, using Command Key + I will not allow you to select one. There will be a grayed-out file.

Most of the video files you use won't cause this, however some video instances (the letters at the end of the title) cause iMovie to act strangely. They work flawlessly with other programs, such as VLC Player and the majority of NLEs. **The following are the most typical kinds of iMovie issues:**

- .avi (Audio Video Interleave – the original Windows video file container)
- .mkv (Matroska video)
- .webm (web media – this can be video or audio)

Not just containers but other things are also significant. Certain codecs are compatible with specific file types, such as MKV and the VP8/VP9/AV1 formats. However, different codecs can be used with different structures. You can use M4V, MOV, and MP4 files with iMovie. It's possible that iMovie doesn't support the codec used to compress the video file. Then, the video won't play.

Transcoding the video that iMovie won't accept is the solution

It would be difficult to keep track of them all because there are so many of them. Adding movies to iMovie is not possible, so your only viable alternative is to convert the movies.

The handbrake is a useful instrument for this task because of its wide range of applications:

- Engage the handbrakes.
- Select your video in Finder and select "Open." The folder containing the converted file will be set to MP4 in the Format section of the Summary page. Because it integrates with other apps, this is acceptable as is.
- The handbrake will automatically transition to the quick 1080p30 mode. If your video is higher quality than 1080p, select a higher quality level from the Limit drop-down menu on the Dimensions page to make your video fit.
- If your video's frame rate isn't 30 frames per second, choose it from the drop-down menu next to Famerate (FPS) on the Video tab:
 - "Same as Source" seems to be the best option, based on my observations. But it's not particularly reliable, and using this option frequently results in encoding failures.
- To maintain the video quality, drag the Quality bar to one of the following Video tab settings:
- For 720p, 1080p, and 4K videos, use RF19, RF20, and RF22, respectively.
- In the Save As box located at the bottom of the Handbrake window, select the file's location and name.
- To start transcoding, press "Start".

This method can be useful as a backup or in the event that iMovie refuses to allow you to add a movie. You can use Handbrake to run your video files before editing them if you're unsure if the codec and folder will work with iMovie. In this instance, they would be if the video had been recorded with an iPad or iPhone. This usually eliminates any issues that weren't present at all but could cause major issues in later stages of the edit.

The videos don't play properly

Even movies that appear to have loaded properly can have issues. To be safe, you should import the videos in a different format after changing their format with a transcoder. If, however, movies you've already downloaded won't play, you can "remind" iMovie of the video it should be playing.

The technique of "reminding" iMovie of the project clips was effective

- Find the files that won't play by using Finder.
- As you drag the file in, hold it above the iMovie timeline. You don't have to dump it in. Giving iMovie the original file will fix it if it isn't playing a file because it "forgot" something about it.
- Alternatively, you can hit Command + I to open the import menu and attempt to load the same media again.

If that fails, transferring the blueprint to a fresh project could:

- Press Command Key + A and Command Key + C simultaneously to copy every clip on the timeline.
- Next, create a new project by using the Command Key + N. To return to the Projects page, press 2.
- Press Command Key + V to add every clip to the timeline of the newly created project.

If that stops working, the following common computer troubleshooting advice might be useful:

- Switch off and back on iMovie
- Do a computer restart.

You now understand why it's crucial to work on your source video files in Finder while they're open. It also demonstrates how beneficial encoding your video before loading it is. But many individuals have another problem with clips. The import begins, and the file and clip folder might be OK. However, for unknown reasons, it ends in the middle, and iMovie continues to attempt to download videos from iCloud.

When Audio and visuals become disconnected

You will need to sync the video and audio in the timeline if you recorded them separately—possibly using a different camera and microphone.

- Listen for a sudden, sharp sound in your video, such as a clap or the sound of drumming.
- An M should be placed there in the video. Next, locate the beginning of the sound on the audio track, click on it, and mark that location as well.
- Align the audio tags with one another. When the dots are near together, you can pull them together by pressing the "N" key.

The issue lies in the fact that the audio and video may have been precisely timed at the beginning of the film. However, by the conclusion, they can have switched places such that the audio now comes first or the video comes first. What is happening? If you record audio and video at various times, the speeds may not coincide. It is more likely to occur, and longer videos are better. The automated tools in NLEs like Final Cut Pro can help with this. These are also tools that IMovie, which is meant to be an NLE that "just works," need to have. You'll need to adjust the video's speed in iMovie to resolve this.

Solution: Adjust the audio clip's speed

One of the streams needs to be sped up or slowed down to match the other when they start to diverge during the video. Since the sound is smaller and can be altered more quickly and readily, it should be changed.

Here's how to resolve the shifting issue and restore the functionality of the sound and video:

- At the beginning of the video, make sure the sound and visuals are in sync.
- Near the end of the video, locate a sound that corresponds with a distinct visual cue. Mark the visual cue with an M.
- Note the audio file's start of the sound. At the beginning of the task, you synchronize the sound and video. By the end, the marks may be in a different location.
- Press the Command Key + R while the music is playing to launch the Speed Editor.
- Move the circle at the end of the sound clip so that the two dots line up. If you press the N key when the markings are near together, they will merge together.
- Press the Shift Key and Z simultaneously to exit the timeline. Next, determine whether the two sets of marks at the sync locations are still aligned.

There's no need to be concerned that the consumers' experience would be negatively impacted by the change in music pace. A speed adjustment of no more than 1% to 2% can correct video audio drift, which occurs around every 20 minutes. To help acclimate to the change, you may always tick the box next to Preserve Pitch in the Speed menu. You are now able to correct the audio shift. Close and reopen iMovie to resolve any additional issues you may be having with clips when editing. If the clips aren't performing as these methods instruct, then this is extremely crucial. Most of the problems ought to be resolved now. However, if you edit anything more complex, you may still run into problems even if your clips initially function properly.

Approaches for Improving Performance

a. **Update iMovie:** Make sure you have the most recent version of iMovie installed. Updates can improve the stability and effectiveness of the product by incorporating bug fixes, performance enhancements, and optimizations.
b. **Check System Requirements:** Make sure your Mac has the minimal hardware needed to run iMovie. Underspecified hardware may cause problems with performance. To enhance performance, think about updating the RAM, processor, or storage on your Mac, if at all possible.
c. **Shut down Other Apps:** When using iMovie, shut down any background processes and unneeded apps. Multiple programs open at once can strain the system's resources and compromise iMovie's functionality. To give iMovie more resources, only keep open programs that are absolutely necessary.
d. **Media File Optimization:** You should think about making your media files editing-ready before importing them into iMovie. Transcode high-bitrate video files to a lower-compression, more editable format, or to lower-resolution proxy files. This can lessen the amount of stress editing places on your system's resources.
e. **Use Proxy Media:** You can use iMovie to make lower-resolution copies of your original media files, known as proxy media files. Performance can be greatly increased while editing using proxy media, particularly when working with high-resolution video material. In the choices or settings of iMovie, enable proxy media.
f. **Control Project Size:** To lower the overall complexity and size of your projects, divide larger ones into smaller parts or utilize numerous project files. Performance can be enhanced in this way, especially on outdated or underpowered technology.
g. **Check Disk Space:** Make sure the internal storage drive of your Mac has enough free space. iMovie's performance can be affected by low disk space since it might find it difficult to write temporary files or cache data during editing.
h. **Optimize Preferences:** To get the best performance out of iMovie, modify its settings and preferences. You can change the audio sample rate, background rendering, rendering choices, and video quality, for instance. Try out several configurations to determine what strikes the optimum balance for your projects between output quality and performance.
i. **Update macOS:** Make sure you're running the most recent macOS version that works with your device. iMovie and other apps can benefit from performance enhancements and optimizations that are frequently included in macOS releases.
j. **Restart iMovie and Mac:** Attempt restarting iMovie or your Mac if you experience performance problems. By doing this, transient data and processes that might be interfering with performance can be cleared.

Frequently Asked Questions

An iMovie: what is it?

iMovie is a video editing software program created by Apple Inc. It is compatible with iOS, macOS, and iPadOS devices. iMovie is a popular among amateur and inexperienced video makers because it makes editing, organizing, and sharing videos easy.

Is iMovie free to use?

Yes, iMovie is free to use for all Apple users. It comes pre-installed on macOS, iOS, and iPadOS devices, so there's no need to download or purchase it separately.

Is Windows or Android compatible with iMovie?

iMovie is not compatible with Windows or Android devices; it is exclusively compatible with Apple platforms. There are substitute video editing software options for Windows and Android users.

What kind of system is required for iMovie?

The system requirements for iMovie vary according to the platform and version. Generally speaking, a compatible macOS, iOS, or iPadOS device has to have sufficient RAM and storage space in order for iMovie to run effectively.

How can I load videos into iMovie?

Videos can be imported into iMovie directly by dragging and dropping them in or by choosing the "Import Media" icon. MP4, MOV, and M4V are among the supported video formats.

Is audio editing possible with iMovie?

It's true that users can alter audio in iMovie by adjusting volume levels, adding music or sound effects, and adjusting the time of audio clips. iMovie's audio editing features are rather poor when compared to specialized programs.

Is it possible to add text and titles to my videos using iMovie?

Without a doubt, iMovie allows you to add titles and text to your videos. With so many different text styles, fonts, and animations to choose from, users may customize titles and captions to suit their tastes.

How can I export or share the edited videos that I created in iMovie?

iMovie allows you to export and share edited videos by clicking the "File" menu and choosing "Share." You can post your film to websites that share videos, share it on social media, or save it on your device, depending on your needs.

Does iMovie support extensions and plugins from third parties?

iMovie does not have an official plugin shop, just like a number of other video editing programs. Users may look into third-party extensions and plugins that are available from outside sources for additional features and effects.

Is iMovie capable of professional film editing?

iMovie can be used for professional projects even though its primary purpose is amateur and home movie editing. Experts in video editing may find that iMovie is deficient in a number of advanced features and tools found in more specialized professional editing software.

How do I add music to my iMovie project?

To add music to your project, you can import audio files from your computer or use the built-in iMovie music and sound effects library. Simply drag and drop the music file onto the timeline beneath your video segments to include it in your project.

Can I edit videos that I made with my iPhone or iPad using iMovie on my Mac?

It is true that iMovie offers seamless interoperability across iOS, iPadOS, and macOS devices. You may transfer videos from your iPhone or iPad to your Mac for iMovie editing via AirDrop, iCloud, or a USB cord.

Which are the basic iMovie editing techniques?

Some of the basic editing techniques in iMovie include splitting and trimming clips, adding transitions between clips, adjusting the speed of movies, and enhancing the visual appeal of your videos with color correction and filters.

How can I create a picture-in-picture effect with iMovie?

To create a picture-in-picture effect with iMovie, simply drag & drop one video clip onto another within the timeline. Resize, move, and adjust timing of the top video clip to achieve the desired picture-in-picture effect.

Can I create slow-motion or fast-motion effects in iMovie?

You may use iMovie to create slow-motion or fast-motion effects by changing the playback speed of your videos. Choose the clip you wish to edit, go to the Speed choices, and choose the appropriate speed change to create slow-motion or fast-motion effects.

How can I remove the background from a video clip in iMovie?

iMovie does not have an integrated feature that allows you to remove the backdrop from a video clip. However, to achieve a similar effect, you can utilize a green screen or chroma key approach. Use iMovie's green screen effect to replace the green background with a new image or video when filming a movie against a green screen.

Can I use iMovie to create videos on YouTube or social media?

Of course, you may utilize iMovie to create movies for other platforms, including social networking sites, YouTube, and personal websites. You can format, resize, and modify aspect ratios to ensure that your videos play on different platforms and for different audiences.

How can I use iMovie to edit my videos with filters and other visual effects?

Using iMovie, you may embellish your video clip with a variety of visual effects and filters. Simply select the footage to be altered, click the Video Effects tab, and choose from a variety of effects, including vignette, sepia, black and white, and more.

Can I collaborate with people on an iMovie project?

Unlike some other editing programs, iMovie does not come with a built-in real-time collaboration feature. Nonetheless, you can grant other people access to your iMovie project file so they can make their own edits. You can then manually integrate their modifications into your project after that.

How can I use iMovie to make my videos narrated or have voiceovers?

To add narration or voiceover to your videos with iMovie, just connect a microphone to your computer, choose the microphone icon in the toolbar, and start recording your voiceover while your video is playing back. You can adjust the loudness and timing of the narration using the timeline.

Is it feasible to import and edit video from external cameras or camcorders into iMovie?

Yes, you may import and edit video from external cameras or camcorders that are connected to your computer by USB or FireWire using iMovie. Importing videos from supported devices into iMovie allows them to be edited just like any other video clip.

How can I create titles and credits for my videos in iMovie?

iMovie includes built-in options for creating titles and credits for your videos. Simply click the Titles button in the toolbar, choose your favorite title style, and then adjust the text, font, color, and animation settings to create titles and credits for your movies.

Can I add closed captions or subtitles to my videos using iMovie?

iMovie does not have a built-in tool for creating closed captions or subtitles. You can manually apply text overlays or titles to your movies in order to add captions or subtitles. Alternatively, you can use third-party programs or the internet to create subtitles outside of iMovie and import them in.

How can I create a slideshow with music in iMovie?

To create a slideshow with music, import your photos into iMovie and arrange them in the timeline. Once the image transitions are added, import an audio file or choose tracks from the available library to add music. A visually captivating slideshow with music can be created by experimenting with the length and timing of each photo and transition.

Assignments

1. Troubleshoot the issue regarding importing and exporting Media Files
2. What are the approaches for improving performance in iMovie?
3. Discuss an answer to ten (10) frequently asked questions

CHAPTER 16
ANALYZING IMOVIE THIRD-PARTY EXTENSIONS AND PLUG-INS

The Best 10 Plugins & Add-ons for iMovie: Installation Tips

ASCII art

The primary benefit you will experience is the iMovie plugin's exceptional quality and ease of usage. Its price is reasonable as well, but you shouldn't go for extremely low-cost options as their quality will suffer greatly. By adding noteworthy artistic and experimental effects, ASCII & Art can help you improve the quality of your film. The quick conversion rate of this program for any kind of image or video is its most important feature.

Large and Audacious

The most noteworthy feature of Big & Bold is its user-friendly user interface, which has received favorable reviews from clients. These iMovie titles with strong visual elements in motion are incredible. Each title will include parameters that allow you to customize the overall design and word motion to your heart's content.

The BKMS All Images

Its documentation may not be what you're looking for, but it's always a smart choice to use it with iMovie. One of its most distinctive elements is the use of pixelated transitions known as washes and fades. Pixel fade, which can easily dissolve to black or from black, and Pixel wash, which can dissolve to white or from white, are other features you'll come across. Both of these elements have contributed to the improvement in the quality of films. It will be easy for you to see the images that are being entered and observe how, when it is being used, the photos change at an arbitrary rate.

BKMS Copy & Curl

You can use the two transitions in this package to give your iMovie movie a more professional look. There could be a page curl. It might come from the back of the page and display a pixelated picture of the photo that is being sent out from any corner. The copy machine, which will display a more vibrant version through an illuminated bar during the presentation, is the second transition. As this bar goes from one end of the screen to the other, it will obscure the scenes that came before, revealing the new

sequences. When the new scenes are all done being shown, the bar will return to where it was.

Crops & Zooms

You may obtain a range of magnification choices and incredibly smooth, blocky, square, and round peephole effects with this iMovie plugin. For your iMovie, you may select from yet another set of ramp effects. One of the most important characteristics of the Crops & Zooms plugin is its image modification capability, which allows for a variety of transformations like flipping, stretching, shrinking, and rotating. Each of them functions sufficiently when paired with iMovie and a deftly created camera shake effect.

Effects of Titles

This iMovie plugin can help you generate key effects that look good with traditional white-on-black titles. Among the numerous available effects, dropped shadows, color schemes, and title positions are a few of the most well-liked ones. All of these effects are included when necessary and in the proper context, along with the many more that are included with effects for titles.

DeDigitalEffects #1

With up to ninety more plugins, this is an incredibly complex plugin. When used with iMovie and many other video editing software packages, the plugin allows you to add specific visual effects to a movie. This utility is based on Apple's FixPlug program and makes use of the functionality of both Mac OS X 10.4 and Quartz Composer. Underwater, 3D titles, dots, comets, fire, video cubes, video feedback, explosions, oil painting, and 3D video walls are some of the most noteworthy effects included in deDigitalEffects#1. All of them are included in the package. You will always enjoy editing your videos with iMovie and this expert plugin. I will always be appreciative to you!

DeDigitalEffects #2

While this is essentially the same as deDigitalEffects#1, it stands out from the competition thanks to a unique combination of features. It would be a stupid mistake to combine any of them with the others or to mistakenly swap them out for one another. DeDigitalEffects#2 offers a wide range of effects, such as bouncing cows, flying toasters, roller coasters, fireworks, chess, pedals, mazes, tunnels, 3D bubbles, and fireflies. Fireflies and bouncing cows are two more effects you should search for. To find out which effect works best, you can download a free demo of each effect on deDigitalEffects#2, which is something you should do.

Gree Three Slick

This collection consists of ten volumes, each containing hundreds of titles, transitions, and effects. With all of the options that iMovie provides, you should attempt to refrain from choosing anything that you might come to regret. If you decide to use GreeThree Slick for iMovie, you might save a significant sum of money—up to forty percent. Enhancing iMovie's skills will be beneficial because all of its effects have won awards for excellence, ensuring that you get the finest experience and the highest caliber of movies. The main advantage of GreeThree Slick is its integration with the latest iterations of iMovie. This link makes it easy to include the best effects in your movie. If you want to make a movie with a Hollywood vibe, this is the iMovie plugin you should use.

iBubble

You will like using this iMovie plugin with iMovie because of its thirteen titles. Thought bubbles, arrow-pointing labels, voice bubbles, illuminating text, moving text, and plain text are all included in the plugin. These features are implemented as well. It will need wisdom to choose a choice that will benefit your iMovie project. iBubble is the perfect iMovie plugin because of its easy-to-use interface. It becomes an extraordinary plugin because of its remarkable characteristic. The user can add titles to any segment of the videos, regardless of where they are, thanks to the integrated graphics. You will therefore assess iBubble as a potential replacement for a few other options.

An overview of the marketplace for plugins

- **Mac App Store:** Although iMovie has a specific plugin marketplace, you may enhance your iMovie editing experience with a variety of third-party tools and utilities available in the Mac App Store. These programs can be used in conjunction with iMovie to offer further effects, transitions, or editing features.
- **Developer Websites:** A lot of developers use their websites to directly develop and share iMovie plugins and extensions. These plugins might provide special effects, transitions, or editing tools designed to meet particular requirements. You can find these plugins by searching for iMovie plugins online or by going to the websites of reliable software developers.
- **Online markets:** You may find extensions and plugins for a variety of software programs, including iMovie, on third-party software markets and platforms. Even though iMovie-specific plugins aren't as popular as they are for other video editing programs, these platforms nevertheless have some helpful tools and effects that you may utilize to improve your iMovie productions.
- **Community Recommendations:** One excellent way to find third-party plugins and extensions for iMovie is to participate in online groups and forums. Members frequently provide links, reviews, and suggestions for helpful plugins they've found, which can help you find new effects and tools for your editing tasks.

- **Tutorials and Reviews on YouTube:** A lot of YouTubers write guides and assessments of third-party iMovie plugins and extensions. You may determine whether plugins are worth attempting by watching these movies, which can provide you an understanding of the features and capabilities of various plugins.

The Indicators for Using External Tools to Increase Your Editing Capabilities

- **Select the Correct products:** Look into and purchase third-party products that meet your unique editing requirements and objectives. Pick editing tools that fit your style and workflow, whether it's motion graphics, color grading, audio editing, complex video effects, or workflow optimization.
- **Acquire Knowledge of the Tools:** Invest some time in learning the proper use of external tools. Examine the tool's developers' online resources, documentation, and tutorials. Gaining an understanding of the tools' capabilities and functions will enable you to take full advantage of them and get the outcomes you want.
- **Connect flawlessly:** Make sure that your primary editing program, such as iMovie, can connect flawlessly with the external tools you select. Seek for tools with export/import functions, extensions, or plugins that provide compatibility and interoperability. Your productivity will be streamlined by this integration, which also makes it possible for many products to collaborate effectively.
- **Try New Things and Be Innovative:** Don't be scared to try out novel approaches and workflows made possible by third-party tools. Experiment with different effects, be creative, and test the limits of your editing skills. Accept change and employ outside resources as editing project catalysts to inspire expressiveness and creativity.
- **Workflow Customization:** Adapt your editing processes to efficiently use outside tools. Determine whether areas—such as advanced color grading, audio upgrades, or specialty effects—can benefit from the use of outside technologies. Create specialized workflows that make the most of the capabilities of both your main editing program and add-on tools to effectively accomplish your editing goals.
- **Stay Up to Date:** Stay informed about any changes, additions, or modifications to your main editing program as well as any third-party tools. Check for software updates, patches, and new releases from your external tool's developers on a regular basis. Keeping up with the times will guarantee that you have access to the newest features and advancements that can boost your editing skills.
- **Seek Inspiration:** Examine the work of other filmmakers and editors who make innovative use of outside technologies. Learn from case studies, watch tutorials, and examine editing breakdowns to get ideas and motivation for using third-party tools in your work. Take advice from others' experiences and modify methods to fit your editing goals and style.

Options Criteria for External Tools

There are a number of factors to take into account when choosing external tools to work in tandem with iMovie in your video editing workflow in order to guarantee compatibility, effectiveness, and efficiency.

Here are some important factors to think about:

- **Compatibility with iMovie:** Verify that the functionality and file formats of iMovie are supported by the external tools you select. Seek for programs that allow you to easily import and export media files, effects, and projects to and from iMovie without experiencing any quality degradation or compatibility problems.
- **Process Integration:** Select iMovie tools that easily fit into your current process. Seek for technologies that provide alternatives for a smooth integration experience, such as plugins, direct import/export capabilities, or connectivity with iCloud and Photos, among other services inside the Apple ecosystem.
- **Feature Set:** Think about the features and functions that the external tools provide and how they enhance the possibilities of iMovie. Seek for tools that offer more editing capabilities than iMovie, including as effects, transitions, audio enhancements, and advanced editing options.
- **Ease of Use:** If you're working in a team or interacting with others, use products that are easy to use and intuitive. Selecting tools with an easy-to-use interface, well-written documentation, and readily available support services can help reduce learning curves and increase output.
- **Performance and Stability:** Select tools that can efficiently handle your editing jobs and are stable and dependable. To make sure a tool is compatible with the most recent versions of both your operating system and iMovie, look for ones with strong performance metrics, few crashes or glitches, and frequent updates.
- **Cost and Value:** Take into account the external tools' value proposition and cost-effectiveness in relation to your editing requirements and budget. Search for products that strike a decent mix between features, performance, and pricing, and take into account any supplemental expenses like in-app purchases, subscriptions, or licensing.
- **Customer Support and Community:** Assess the community resources, including tutorials, forums, and specialized support channels, as well as the customer assistance choices offered for external tools. Seek for products with helpful customer service and a vibrant user base that can offer advice and support when required.

You can guarantee compatibility, efficacy, and effectiveness when choosing external tools to supplement iMovie in your video editing process by taking these factors into account. This will eventually improve your editing capabilities and productivity.

Methods for Workflow Integration

Especially if you use other Apple hardware or applications, integrating iMovie into your workflow can improve cooperation and expedite the video editing process.

The following are some methods for incorporating iMovie into your daily routine:

- **Use iCloud for Seamless Access:** iCloud allows you to synchronize your iMovie projects across all of your Apple devices, including a Mac, iPhone, and iPad. This eliminates the need for manual file transfers and enables you to begin working on one device and finish on another without interruption.
- **Take Advantage of the Apple Photos Integration:** iMovie and Apple Photos work together flawlessly to let you access your photo and video libraries right from within the program. This makes it easy to import media files into your projects without having to go between various applications.
- **Contribute with iMovie Theater:** iMovie Theater allows you to share your projects with others and contribute in real time. You may invite colleagues to see and edit your projects, provide input, and make changes jointly. This can be very handy for team projects or collaborative editing sessions.
- **Export to Final Cut Pro:** If you need more advanced editing features beyond what iMovie offers, you can export your work to Final Cut Pro, Apple's professional video editing program. This allows you to take benefit of Final Cut Pro's advanced editing capabilities while still starting your projects in iMovie.
- **Combine with Keynote and GarageBand:** If you're making presentations or adding music to your films, you may combine iMovie with Keynote and GarageBand, Apple's presentation and music creation apps, respectively. This makes it simple to add sound and visual effects to your videos by enabling you to import Keynote presentations and GarageBand recordings straight into your iMovie projects.
- **Use Shortcuts to Automate processes:** If you use iMovie on iOS devices, you can automate repetitive processes and improve workflow by using Shortcuts. To save time and effort, you can, for instance, build shortcuts to import media files, apply effects, or export projects with particular parameters.
- **Version control and backups:** To avoid losing any material, make sure you periodically back up your iMovie projects. To automatically backup your projects, utilize Time Machine on macOS or iCloud Backup on iOS devices. In order to better work with others and monitor changes, think about utilizing version control systems like Git.

Summary in general

As we come to the end of our iMovie course, we've covered all you need to know to start making incredible videos. We talked about how anyone can use iMovie to edit videos

easily, no matter what their level of experience. You may do a lot of various things, including as cutting clips, adding music, and making visually striking transitions, to make your videos seem fantastic. We also looked at how you could improve the audio quality and watchability of your videos. We also looked at a number of other tricks and approaches to make your videos better, such using programs other than iMovie and applying special effects. Remember that the best ways to enhance your abilities in video creation are to practice and try new things. iMovie is a fun and practical application that may help you share your stories and artistic achievements with the world. So go ahead, have fun, and make some amazing movies!

INDEX

4

4K Ultra HD using iMovie, 30

A

A Jump Cut, 90
AAC, 30, 31, 71, 128
ability to import photographs in two different resolutions, 31
ability to modify the length of your clips, 40
Accept change and employ outside resources, 178
access preferences, 16
access the "Camera" button, 22
access the "Camera" button on your iPhone, 22
access the App Store, 20
access your photo and video libraries, 180
Acquire Knowledge of the Tools, 178
Adapt your editing processes to efficiently use outside tools, 178
Add a Title, 111
Add a Transition, 6, 110
Add Animation, 114
add any image or video captured with your iPad or iPhone, 22
add audio effects, 118
Add dialogue to the film, 63
add effects and filters, 12, 13
add images and videos, 22
Add Keyframe pointer, 78
ADD MEDIA, 71
Add Music to the Slideshow, 5, 104
Add photos, movies, and music, 5, 102
add PiP effects with zoom, 89
Add some of your collection's tracks, 4, 72
add sound effects, 12, 116
Add the video to your collection of photos, 7, 132
Add Titles and Text, 5, 104
add videos on top of one other in Mac iMovie, 83
Add Videos overlay to iMovie for Additional Features, 83
adding audio files, 73, 81
Adding both subtitles and captions, 3, 66
ADDING CAPTIONS, 7, 139

ADDING CAPTIONS AND ILLUSTRATIONS TO THE KEYNOTE, 7, 139
adding clips,, 26, 28
Adding Color Effects, 98
Adding Media Files, 8, 165
adding music, 180
Adding Pictures and Graphics, 5, 100
Adding Tags, 33
Additional background data, 4, 83
Additional Remarks, 1, 20
add-on tools, 178
Adjust a section of the clip's loudness, 4, 76
Adjust the audio clip's speed, 169
Adjust the audio level in Mac iMovie, 75
adjust the distance between text lines, 60
Adjust the Pictures in the Timeline, 5, 102
adjust the second car's motion, 157
Adjust the Tempo of a Sound clip, 75
Adjust the volume of a timeline clip, 76
Adjusting a clip's length and speed, 43
Adjusting Exposure and Contrast, 97
adjusting the project settings, 16
adjusting the project settings and parameters, 16
Adjusting the start and end points, 2, 40
Adjusting the start and end points and make split adjustments using the precision editor., 2, 40
adjustments for exposure,, 97
Adjustments panel., 97
Advanced Audio Coding, 71
advanced editing features, 180
advanced editing options, 179
Advanced Styles for Fonts, 65
advise adding a drop shadow, 141
affordable option, 13
alter the animation's appearance, 149
An Examination of Noise Reduction Techniques for Videos, 6, 115
An iMovie, 8, 171
An overview of the marketplace for plugins, 9, 177
ANALYZING IMOVIE THIRD-PARTY EXTENSIONS AND PLUG-INS, 9, 175
Animate page, 148
Animate tab, 148, 149, 150, 152, 153, 154, 155, 160
Animate window, 146, 156
Animated title creation with Keynote, 7, 145

Animating and Adding Motion Effects to Still Images, 6, 113
Animations, 64, 114, 154
Apple created the CAF, 71
Apple devices, 180
Apple Lossless, 71
Apple M1 Max, 123
Apple produced a user-friendly movie editing program called iMovie, 12
Apple users, 130
Apple's presentation, 180
Apple's professional video, 180
Apple's professional video editing program, 180
apply effects, 17, 180
Apply Extra Motion Effects, 114
Apply Text Effects in iMovie, 62
Apply the Animation, 114
Applying Advanced Color Correction and Grading, 5, 97
Applying Ken Burns' effect to visual animations, 3, 50
Appropriately formatting and editing, 6, 116
ASCII art, 9, 175
aspect ratio, 17
Aspect Ratios, 31
Aspects of Resolution and Quality to Consider, 7, 128
Aspiring Filmmakers, 14
Aspiring Filmmakers and Independent Artists, 14
Assess the community resources, 179
Assignments, 1, 2, 3, 4, 5, 6, 7, 8, 9, 17, 31, 38, 51, 58, 70, 81, 90, 99, 114, 122, 132, 138, 164, 174
Astute Assortments, 32
Attaching tags, 33
audio and video import, 16
Audio and Video Splitting, 46
Audio and visuals become disconnected, 168
Audio Detachment, 115
audio editing, 71, 178
Audio Editing, 13
audio effects and enhancements, 165
audio enhancements, 179
audio files, 4, 12, 13, 31, 71, 72, 73, 74, 104, 128, 172
Audio Format, 71, 128
audio or video recording, 115
audio output, 16
audio quality, 71, 128, 129
audio upgrades, 178
automatic content identification, 16
Automatic Metadata, 33

automatic project backups, 16
automatic version history feature, 137
automatically backup your projects, 180
available Options, 3, 60, 70
avoid losing any material, 180

B

backdrop color, 16
backdrops, 15, 164
background, 13, 15, 55, 60, 61, 62, 65, 74, 79, 94, 112, 115, 118, 122, 128, 129, 141, 143, 144, 153, 154, 162, 163, 165, 170
Background, 60, 81, 95, 122, 142
background music, 4, 12, 13, 74, 77, 104
background noise, 6, 13, 115, 116, 117
balance the color of your movie, 16
Basic Templates, 1, 24
Becoming familiarized with the iMovie program, 1, 12
begin a new project in iMovie, 16
Begin and end the voiceover recording, 81
benefit of Final Cut Pro's advanced editing capabilities, 180
better work with others and monitor changes, 180
birthdays, 12
Bitrate, 128
Bitrates and Sample Rates, 31
BKMS Copy & Curl, 9, 175
Blade Tool, 46
BMP, 31, 100
Bold, Italic, and Underline, 60
Bring In All, 28
Bring in files from your Mac., 23
Bringing in and Organizing Audio Files, 71, 81
broad spectrum of users, 12
Build Order menu, 149, 151, 152, 153, 157, 158, 160
build shortcuts to import media files, 180

C

cache data, 170
Can an SRT file be imported into iMovie?, 3, 66
Can I collaborate with people on an iMovie project?, 8, 173
Can I create slow-motion or fast-motion effects in iMovie?, 8, 173
Can I use iMovie to create videos on YouTube or social media?, 8, 173

Captions or subtitles, 3, 68
Captions or subtitles can be added with an iPhone or iPad running iMovie, 3, 68
Carry out the Configuration of an iCloud to Enable Collaborative Editing, 138
car's animation path, 155
change a clip's length in your movie, 39
Change Animation Settings, 114
change the audio's speed and level, 13
change the volume to enhance the sound, 12
Changing the audio levels and gain, 6, 116
Changing the Color Balance, 5, 97
Changing the Colors, 64
Changing the Project's Parameters, 1, 16
Changing the Volume and Audio Levels, 75
Chat capability, 137
Check Disk Space, 170
Check for software updates, 178
Check System Requirements, 170
Choose a movie, 22, 23
choose a project theme or template, 16
choose File from the menu, 91
choose Oldest to Newest., 35
Choose the ideal location, 6, 115
Choosing Fonts, 65
choosing the import option, 17
click the Animate box, 156
Click the iMovie window, 23
Codecs, 30, 31
Collaborating in Real Time, 7, 137
Collaboration is more adaptable and user-friendly, 133
Collaborative Editing, 7, 134, 138
collaborative editing sessions., 180
Color Balance, 97, 99
Color Correction, 15, 98, 99
color grading, 55, 98, 178
Color Grading, 55, 98
Color Ratings and Labels, 32
Combine or Divide Events, 37
Combine with Keynote and GarageBand, 180
Comments and Annotations, 137
Common Issues with iMovie Sound Out of Tune, 6, 119
common picture file types that iMovie supports., 31
COMMONLY ASKED QUESTIONS, 8, 165
Communicate Clearly, 134
Community Recommendations, 177

compatibility problems, 179
Compatibility with iMovie, 179
compatibility with the macOS version, 20
completed video creation, 17
complex video effects, 178
Comprehending Team Projects in iMovie, 7, 136
comprehensive, 117
Compression, 128, 146
CONCERNING OVERLAYS AND KEYFRAMES, 4, 82
Configuring choices, 1, 16
Connect flawlessly, 178
connectivity with iCloud and Photos, 179
Consistency, 34, 99
Constructing animations, 150
Content Creation, 12
content creators, 12, 13
Content Creators, 13
Content Creators and Social Media Influencers, 13
Contrast Adjustment, 98
contribute in real time., 180
Contribute with iMovie Theater, 180
Control Project Size, 170
Conventions for Naming Files, 32
Cost and Value, 179
Create a dramatic effect, 4, 83
create a FireWire link, 29
Create a green screen effect on Mac iMovie, 5, 93
create a Keynote file, 141
create a movie, 158
Create a new event, 26
Create a new project in iMovie, 5, 101
Create a picture collage, 6, 107
Create a split-screen effect in Mac iMovie, 5, 95
create a video, 59, 81
create fundraising campaigns, 13
create interesting movies, 12
Create or Open a Project, 100
Create or Open Project, 52
create outstanding videos, 12
Create specialized workflows, 178
create split edits, 51
create the path in Keynote, 154
create the PiP effect, 89
create tutorials, 24
creating a new project, 16
creating a title for an introduction, 145
Creating an Account on iCloud, 7, 133
Creating Custom Color Effects, 98

Creating Events, 2, 35
Creating Green Screen in iMovie, 99
Creating multi-stage animations with Build Order, 7, 148
Creating Projects, 1, 17
creating the animation with iMovie, 60
Crops & Zooms, 9, 176
Cross Zoom, 53
Current Fill, 140
customer assistance choices, 179
Customer Support and Community, 179
Customization of Export Settings, 132
Customization Options, 1, 15
Customized overlay-based transitions, 8, 160
Customized Templates, 1, 24
Cut or Expand Audio Clips, 75
Cut the video short, 45
Cutaway, 82

D

Deadly basic animation with dynamic backgrounds, 8, 162
Deciding on the alignment of your comments., 69
DeDigitalEffects #1, 9, 176
DeDigitalEffects #2, 9, 176
desired appearance and feel, 17
destructive editing technique, 128
Developer Websites, 177
Device compatibility, 21
Device Compatibility, 1, 20
Different Formats, 6, 123
different strategies, 2, 46
direct import/export capabilities, 179
Directly record into iMovie, 22
Discuss an answer to ten (10) commonly asked questions, 174
Discuss on how to Apply Green Screen Effects, 99
Discuss the means of Adding Motion Effects, 114
Discuss the process of constructing animations, 164
Discuss three built-in options, 122
display several images, 15
Dissolve, 52, 53, 110
Divide a single event, 37
Do a computer restart., 168
documentation, 178

Does iMovie support extensions and plugins from third parties?, 8, 172
Download and install iMovie, 20
drop-down menu, 61, 62, 119, 124, 140, 143, 144, 146, 148, 153, 156, 167
Duplicate Clips, 37
DVCAM, 29
DVCPRO, 29
DVD player, 27

E

Ease of Use, 179
easily import and export media files, 179
Easy to Use layout, 13
Edit and Enhance, 17
edit and style subtitles, 70
editing features, 177
Editing Metadata, 33
Editing photos in the Movie mode, 3, 49
editing process, 16, 116, 130, 134, 138, 179
editing project catalysts, 178
editing requirements and budget., 179
editing subtitles, 69
editing tools, 13, 15, 17, 177, 178
Editing Tools, 13, 15
Editing without Loss, 128
educational films, 24
Educational Goals, 12
Educational templates, 24
Educational Templates, 1, 24
educational themes, 12
effectively accomplish your editing goals, 178
effectively search and filter your media library thanks to metadata., 33
effectiveness, 170, 179
Effects and filters, 15
Effects of Titles, 9, 176
efficiency, 179
Eliminate the Background Sounds, 6, 116
Embed External Audio into Video with iMovie, 121
Employing Audio Effects, 6, 118
Employing Audio Effects and EQ Modifiers, 6, 118
enabled iCloud collaboration, 134
enabled iCloud Photos, 130, 132
Engage the handbrakes., 167
enhance learning and engagement, 24
Enhance the branding and messaging, 4, 83

enhance the possibilities of iMovie, 179
ENHANCE VIDEO QUALITY, 5, 91
ENHANCE VIDEO QUALITY USING ADVANCED TECHNIQUES TO EDIT, 5, 91
enhance your video's dynamic range, 98
Enhancements to Changeovers, 89
Enhancements to Changeovers Using Picture-in-Picture (PiP) Effects, 89
enjoy yourself, and create some incredible films!, 195
ensure the security of your work, 16
Equalizer Tool, 115
Establishing a New Project, 22
Establishing the Suitable Roles and Objectives, 135
Event Library, 100
examine editing breakdowns, 178
Examine the work of other filmmakers and editors, 178
Examining Fonts in Advance, 65
existing project in iMovie, 133
Expected Levels of Response, 136
experience performance problems, 170
experiencing any quality degradation, 179
Explain how to use Keynote to create animated titles, 164
Explain how to use transition effects, 58
Explain how to utilize Keynote to create unique titles, 164
Explain the iMovie set up, 31
Explain the steps in bringing in Images and Graphics, 114
Explain the steps in Managing and Organizing of Images, 114
EXPLORING THE WORLD OF CLOUD CO-EDITING, 7, 133
Exploring Transitions, 3, 52
Export a picture from iMovie on the Mac, 6, 125
Export iMovie's Slideshow Video, 6, 106
Export or share your iMovie work using an iPhone or iPad, 7, 130
export projects with particular parameters., 180
Export Settings, 129
Export to Final Cut Pro, 180
export your video project to social media, 17
export/import functions, 178
exporting, 7, 114, 120, 123, 125, 126, 127, 128, 129, 143, 153, 154, 164, 166, 174
Exporting issue, 166

Exporting Keynote titles, 7, 142
Exporting Projects, 6, 123, 132
Exporting Projects in Different Formats and Resolutions, 6, 123
exporting videos from iMovie, 128
Exposure Correction, 98
extensions, 177, 178
extensive editing capabilities, 13
external storage, 16, 17, 33, 130
external tools, 98, 178, 179

F

Fade to Black, 53, 111
Fade to Black/White, 53
Famerate (FPS), 167
Feature Set, 179
Features, 13, 135
few crashes or glitches, 179
few useful applications, 48
File Types, 30, 31
film's editing, 12
Filtering by Tags, 34
find particular media files fast., 33
Find the files that won't play by using Finder., 168
fine-tune the start, 51
fine-tune the start and stop places., 51
finished creating a video, 23
First, import pictures from the iPhoto Collection, 6, 105
Flash, 53
Font, 60, 64, 65
Font Color, 60
Font Size, 60, 64
Formats, 30, 71, 81, 132
Formats for Audio, 30
Formats for Videos, 30
Formats Supported, 30
forums, 177, 179
Four Easy Steps for Audio and Video Synchronization in iMovie, 6, 120
frame rate, 16, 128, 138
frequent updates, 135, 179
Frequently Asked Questions, 8, 171
frequently employ fades, 79
From Finder, 100
functionality found in professional editing software, 14

G

GAINING EXPERTISE IN AUDIO EDITING, 6, 115
GarageBand recordings, 180
gear icon, 16
general compatibility rules, 21
general rules of compatibility, 21
get ideas and motivation, 178
Get your movie ready to be uploaded to popular video-sharing platforms, 6, 124
GETTING STARTED WITH IMOVIE, 1, 18
Getting things started, 7, 136
GIF are among the common picture file types, 31
Give tasks and responsibilities, 134
Gree Three Slick, 9, 177
Green/Blue Screen, 62, 82, 92, 94, 95
guarantee compatibility, 179

H

handbrake is a useful instrument, 167
HD, 17, 30, 131
HEVC, 30, 146, 153, 161
high definition, 30
high-definition video (HDV)., 29
highlights brighter,, 98
home screen on iOS, 17
How can I create a picture-in-picture effect with iMovie?, 8, 173
How can I create a slideshow with music in iMovie?, 9, 174
How can I create titles and credits for my videos in iMovie?, 8, 174
How can I export or share the edited videos that I created in iMovie?, 8, 172
How can I load videos into iMovie?, 8, 171
How can I remove the background from a video clip in iMovie?, 8, 173
How can I use iMovie to edit my videos with filters and other visual effects?, 8, 173
How can I use iMovie to make my videos narrated or have voiceovers?, 8, 174
How can you add Sound Effects and Background Music?, 81
How collaborative projects are distributed, 7, 136
How do I add music to my iMovie project?, 8, 172
How do you Include Text Effects in a Mac iMovie?, 70
How long each changeover lasts, 149
How to Add Videos Overlay to iMovie for Additional Features and Picture-in-Picture Effects, 4, 83
How to Build Your Own Speed Ramps, 43
How to collaborate via channels of communication, 7, 135
How to edit and design subtitles in iMovie, 3, 69
How to Include Text Effects in a Mac iMovie, 62
How to launch a fresh iMovie project on a Mac, 1, 23
How to make the most of PiP's switch transitions and zoom, 5, 87
How to Proceed with AirDrop Sharing, 7, 129
How to set Up a Green Screen in iMovie, 5, 91
How to Use It, 5, 84
How will you Set Up an iCloud Account, 138

I

iBubble, 9, 177
iCloud and tick, 133
iCloud Backup on iOS devices, 180
iCloud collaboration function operates, 133
iCloud Drive, 17, 73, 130, 133, 142
ILLUSTRATIONS, 7, 139
I'm having issues trying to save the project from iMovie., 166
IMOVIE 2024, 11
iMovie also has options for controlling backup and storage configurations, 16
iMovie and Apple Photos work together flawlessly, 180
iMovie and other apps, 170
iMovie application, 19, 20, 35, 36, 41, 43, 57, 97
iMovie Configuration, 1, 18
IMOVIE MEDIA ORGANIZATION, 2, 32
iMovie offers, 13, 89, 180
iMovie offers a wide range of editing tools, 15
iMovie presents you with several sharing options, 12
iMovie project, 22, 62, 75, 83, 87, 100, 101, 113, 118, 131, 132
iMovie Project Templates, 1, 24
iMovie projects, 180
iMovie project's timeline., 4, 74
iMovie randomly freezes, 165
iMovie randomly freezes or crashes while operating, 165
iMovie software, 27, 37, 42, 43, 76, 79

iMovie Theater allows you to share your projects with others, 180
iMovie timeline, 23, 135, 168
iMovie titles, 145
iMovie Video Overlays, 4, 82, 90
iMovie won't seem to accept media files, 8, 165
iMovie works with Mac systems running macOS, 21
iMovie's advantages, 137
iMovie's editing features, 12
iMovie's educational templates, 24
iMovie's media search, 73
IMOVIE'S OVERVIEW, 1, 12
iMovie's performance, 170
iMovie's pre-built themes and styles, 17
iMovie's project options and preferences, 16
iMovie's sharing features, 135
iMovie's user-friendly interface, 12
Import button, 25, 27, 29, 30, 91, 100, 113
Import chosen clips, 26, 28
import Keynote presentations, 180
import media files into your projects, 180
import procedure, 26, 28, 30, 166
Import Your Still Image, 113
imported files, 28
Importing, 1, 4, 7, 25, 71, 100, 143, 153, 164, 174
Importing Images, 100
Importing Keynote files into iMovie, 7, 143
Importing Media Files, 1, 25
Importing, exporting, and changing multi-stage animations, 7, 153
improve cooperation, 180
improve cooperation and expedite the video editing process, 180
improve the curve, 156
Improve the Slideshow Project in iMovie Utilizing Project Music, 6, 106
improve workflow by using Shortcuts, 180
In iMovie, record a voiceover and add it, 80
in-app purchases, 179
Include any media, 63
Include more audio files, 73
Including Communication Channels Accessible to the Public, 135
including MP4, 30, 165
INCLUDING SOUND, 71
Including the soundtrack in the backdrop, 4, 77
including tutorials, 179

Incorporating sound effects, 4, 74
information about compatibility, 21
inspire expressiveness and creativity, 178
Installation Tips, 9, 175
Installing iOS, 20
instantaneous communication, 137
instruct the computer, 26
integrated chat feature, 137
integrating iMovie into your workflow, 180
INTEGRATION OF GRAPHICS AND PHOTOGRAPHY, 5, 100
interacting with others, 179
interfering with performance, 170
iOS, 1, 12, 13, 17, 20, 21, 52, 68, 69, 115, 129, 133, 171, 172, 180
iOS and macOS devices, 12
iOS device, 12, 13, 17, 20, 52, 68, 69, 133
iOS devices, 17, 21
iOS version, 20, 21
iPhone models, 21
Is audio editing possible with iMovie?, 8, 171
Is iMovie capable of professional film editing?, 8, 172
Is iMovie free to use?, 8, 171
Is it feasible to import and edit video from external cameras or camcorders into iMovie?, 8, 174
Is it possible for iMovie to sync movie subtitles automatically?, 3, 66
Is Windows or Android compatible with iMovie?, 8, 171
Issue, 8, 165
Issues with Audio Synchronization, 165

J

JPEG, 30, 31, 61, 100

K

Keep in mind to add audio, 112
Ken Burns, 15, 51, 53, 109, 113, 114
Keyboard shortcuts, 16
keyframe animations, 143
keyframes in iMovie, 87
Keyframing is a crucial technique for video editing, 84
Keynote animated title export, 7, 146
Keynote route animation generation, 7, 154
Keyword Tags, 33

Keywording, 100

L

Large and Audacious, 9, 175
last-minute rewrites, 17
launch a new video project, 18
Launch iMovie, 68, 91, 108, 113, 131
launch Keynote, 139
Launching a Novel Initiative, 1, 16
Launchpad, 17, 20
Launchpad or the Applications folder, 17, 20
Learn from case studies, 178
Learn the Differences between Zoom and Swap Transitions, 5, 88
Letter Spacing, 60
licensing, 179
limited funding, 13
Line Spacing, 60
location of the music play area, 74
lower background noise, 12
lower the overall complexity and size of your projects, 170
lowercase and capital letters, 69
lower-compression, 170

M

M1 Ultra, 123
M2 Max, 123
M2 Ultra, 123
M3 Max., 123
M4A, 30, 71, 73
M4V, 30, 165, 166
Mac App Store, 20, 21, 177
Mac Configuration, 1, 20
Mac using the included USB connection., 25
macOS, 1, 6, 12, 19, 20, 21, 105, 116, 120, 123, 170, 171, 172
macOS Catalina, 21
macOS Catalina and later, 21
Magic Move, 160, 164
main clip using the Green/Blue Screen option, 82
main editing program, 178
main responsibilities, 12
Make a clip for split screens, 96
Make brightness adjustments, 97
make changes jointly, 180

Make Events and Change Their Names, 35
make innovative use of outside technologies, 178
Make Movie, 22
make split adjustments, 2, 40
make sure a tool is compatible with the most recent versions, 179
make sure you periodically back up your iMovie projects., 180
Make Sure Your Presentation Has a Transition, 5, 103
make the most of the capabilities, 178
Make time lapse and stop motion in iMovie, 6, 113
make transitions, 8, 12, 160
make tutorials, 12
Make use of the shortcut menu to eliminate extraneous frames, 2, 42
making presentations, 180
Management and Organization, 5, 100, 114
Management and Organization of Images, 100
manual file transfers, 180
Manual Metadata, 33
Map, 53
material button in the menu, 19
Media, 13, 14, 15, 17, 22, 25, 27, 29, 30, 34, 52, 63, 67, 72, 73, 74, 100, 120, 143, 144, 153, 170, 174
Media File Optimization, 170
Media Import, 13
Mention some Audio File Formats That Are Compatible, 81
Merge events, 37
Messaging systems, 135
Messenger or WhatsApp, 69
Metadata, 33
Methods for creating opacity effects, 5, 86
methods for incorporating iMovie, 180
methods for incorporating iMovie into your daily routine, 180
Methods for Library Organization, 2, 32
Methods for Transition, 55
Methods for Using the User Interface, 1, 14
modifications to your main editing program, 178
Modify a video split-screen, 97
Modify as Needed, 100
Modify Duration, 113
modify methods to fit your editing goals and style, 178
Modify the green or blue screen effect, 95
Modify the overlay's length, 87
Modify the second car, 157

Modify the voiceover recording parameters, 80
Modify Transition Duration, 52
Modifying Acceleration, 43
Modifying Edits, 3, 49
Monitoring, 129
more editable format, 170
Motion a Still Picture, 5, 102
Motion blur, 55
MOV, 30, 165, 166
Move or copy clips between events, 2, 36
Movie to QuickTime movie, 128
Movie Trailer Templates, 1, 24
MP3, 30, 31, 71, 73, 128
MP4 files with iMovie, 166
MPEG Audio Layer III, 71
MPEG-4 Audio, 71
multimedia container format MP4, 71
multimedia producers may add text overlays, 13
Multiple stage import and export of Magic Move animations, 8, 161
music creation apps,, 180
music files, 73
Muting the Audio, 115

N

Navigate through your photo library with iMovie on a Mac, 1, 19
necessary adjustments, 87, 89, 99
New Document button, 139
new Keynote file, 161
new project, 14, 17, 19, 22, 23, 62, 168
new project default parameters, 16
new releases from your external tool's developers, 178
new scenes, 15
newest features and advancements that can boost your editing skills., 178
Note the audio file's start of the sound, 169
Notes and Explanations, 135
Novices and Casual Users, 13
number of factors to take into account, 179
number of formats, 13

O

Objective, 17
Objective and Abilities, 17

Objectives and Capabilities, 1, 12
offer advice and support, 179
Older macOS versions, 21
On an iPad or iPhone, how do you modify subtitles in iMovie?, 3, 69
Online markets, 177
on-screen directions, 17
Open iMovie, 17, 52, 62, 88, 100, 126, 143
Open Mac iMovie and import files from file-based cameras, 1, 26
open the "Adjustments" panel., 97
open the Import window, 29, 30
Open the Photos app, 6, 108
open the Precision Editor, 46
Open your project in iMovie, 22
Open your project in iMovie and drag the playhead to the location, 22
optimize disk space consumption, 16
Optimize Preferences, 170
Options for Text Formatting, 60, 70
Organizations, 13
Organizing Backup and Storage, 1, 16
Organizing Folders, 2, 32
original media files, 170
other metadata fields in iMovie, 33
other services inside the Apple ecosystem., 179
Out of sync audio when making a video, 119
Outline, 60, 69

P

particular requirements, 177
patches, 41, 178
paying specialized personnel, 14
performance and features, 21
Performance and Stability, 179
Performance can be greatly increased while editing using proxy media, 170
performance, and pricing, 179
Periodically save and back up your work, 134
Personal Projects, 12
Personalization of Export Parameters, 7, 127
picture files, 13
Picture Formats, 31
Picture in Picture, 57, 82
picture library, 18
Picture-in-Picture (PiP) effects, 89
Pinching the Viewer, 50

PiP style, 143
PiP's corner, 145
Place the Images in the Timeline, 6, 109
Play Around and Have Fun, 52
Playback in reverse, 44
plugins, 177, 178, 179
PNG, 31, 100, 143
point of satisfaction., 119
Pointers for Using External Tools to Increase Your Editing Capabilities, 178
polished and professional, 12
polished appearance, 61
pop-up option, 28, 30, 94
possibility of misconceptions, 136
powerful editing tools, 12
PowerPoint animation, 145
precision editor, 41, 42, 46, 51
Precision Editor, 3, 41, 46, 47, 48, 49
Preferences contain options for sharing settings, 16
pre-made project templates, 24
Prepare the Images in Photos, 5, 101
presentations, 12, 13, 24, 101, 136
Pre-Setup, 20
Press the Command Key, 143, 157, 160, 169
Preview and Adjust, 52
Preview and Complete, 17
Preview and fine-tune, 114
Preview and Fine-Tune, 99
preview of the equalization changes, 119
primary editing program, 178
primary objective, 12
primary picture-editing options, 139
Procedure for AirDrop Sharing, 132
Process Integration, 179
Professional Projects, 13
professional-looking movies, 13
professional-looking videos, 13
Project Configuration and Preferences, 1, 16
Project Export and Sharing, 7, 137
Project Exporting, 101
Project Properties, 16
PROJECT SHARING AND EXPORTING, 6, 123
project theme or template, 17
promotional movies, 13
ProRes 4444, 61
Protection from Wind and Interference, 6, 116
provide alternatives for a smooth integration experience, 179

provide input,, 180
Providing Evidence of Decisions, 136
proxy media files, 170
purchase third-party products, 178
Push, 53
Putting your video online, 45

Q

quickly produce high-quality videos, 16
QuickTime is the format most users, 128

R

Raising the level of audience participation, 4, 82
range of styles and layouts, 12
readily available support services, 179
realize your creative ambitions, 12
Real-Time Sync, 137
rearrange footage, 12
Receive Easy Content Updates, 4, 83
recent macOS version, 170
Record a voiceover, 4, 80
Record video with your Mac straight into iMovie, 23
Record Voiceover icon, 80
Recording Quality, 128
reduce learning curves and increase output, 179
Regarding Images and Transparency, 7, 143
Regular Maintenance, 33, 34
regular resolution and high resolution., 31
Relevance, 34
Reminder, 38
Remove Videos and Events, 38
Reposition the timeline's clips., 43
resolution for your project, 16
Resolutions, 30, 132
Respect version control, 134
Restart iMovie and Mac, 170
resulting window, 18

S

Sample Rate, 128
saturation and vibrance, 98
Saturation and Vibrance, 98
Save a video, 7, 126
Save and Export, 52

Save and export the slide presentation, 5, 105
save time and effort, 33, 180
school projects with iMovie's educational, 24
SD, 27, 30
Search and Filtering, 33
Search for products, 179
searching for iMovie plugins online, 177
Seek for products with helpful customer service, 179
Seek for programs, 179
Seek for technologies, 179
Seek for tools that offer more editing capabilities, 179
Seek Inspiration, 178
select "Create New" or "New Project"., 17
Select "Custom" using the list that pops up., 161
select a range of frames, 42
Select an Animation, 114
Select an existing event, 30
Select Duplicate Movie under Edit., 37
Select File,, 126, 153, 161
Select iMovie tools that easily fit into your current process, 179
Select Italic (I),, 69
Select Split Clip after selecting Change., 43
Select the Correct products, 178
Select the preferred export format, 17
Select the video, 45, 89, 97, 130
Select the VTR or VCR mode, 29
Select tools that can efficiently handle your editing jobs, 179
Select your video in Finder, 167
Selecting tools with an easy-to-use interface, 179
Selection Criteria for External Tools, 179
Send a movie email, 7, 131
Setting Up iCloud to Allow Cooperative Editing, 7, 133
Shadow, 60, 141
Share and Export, 17
Share your iMovie work on social media with a Mac, 6, 124
shared on social media, 13
Sharing and Collaboration, 135
Sharing Options, 13, 16
shortcut menu, 2, 42
Should a song not be available in iMovie, 4, 74
Show Clip Trimmer, 39
Show Precision Editor, 41, 46
Shut down Other Apps, 170

Slide, 43, 53, 67, 75, 139, 158, 159, 160
slideshows, 61
small businesses and NGOs, 13
Small Businesses and NGOs, 13
Smart Collections, 34
social media influencers, 12, 13
Software versions, 165
Solution, 169
Some Additional Remarks, 31
some important factors to think about, 179
Sort events by name, 35
Sort events from newest to oldest, 35
Sorting and Filtering, 34, 38
sound and visual effects, 180
Sound Design, 55
sound effects, 13, 15, 55, 73, 74
Soundtracks, 15
specialized support channels, 179
specialty effects, 178
specific version of macOS, 21
specify the location for the receiving files' storage, 30
Speed controls, 15
Split a video clip, 43
Split Screen, 15, 82, 96
Split Techniques, 42, 51
Splitting Clips during Playback, 46
Splitting in iMovie 2024, 2, 46
Splitting Videos, 46
spread your fingers apart., 50
standard arrow, 47
standard definition, 30
Start a New Initiative, 17
Starting off, 5, 88
starting scenes, 12
starting your projects in iMovie, 180
Stay Up to Date, 178
still and motion pictures, 18
Storage and Backup, 33
Storyboard View, 101
Strategies for Improving Performance, 170
Strategies for Organizing Libraries, 38
Strategies for Workflow Integration, 180
strike a decent mix between features, 179
strong performance metrics, 179
style your text, 60
subscriptions, 179
Summary in general, 9, 180

summary of the project settings and preferences in iMovie, 16
supplemental expenses, 179
Supplemental Remarks, 21
Switch off and back on iMovie, 168
Switch off iMovie's audio on the Mac, 4, 79

T

Tags and Keywords, 32
Tags and Metadata, 33
Take Advantage of the Apple Photos Integration, 180
Take advice from others' experiences, 178
Teachers and Students, 13
team projects, 180
technical difficulties, 134
Templates for the Project, 31
temporary files, 170
test the limits of your editing skills, 178
Text alignment options, 60
text and titles, 3, 8, 12, 59, 70, 104, 171
Text Animation Effects, 60
Text Effects Application, 3, 62
text overlays, 12, 13, 17, 24, 55, 64, 174
Text style Shadows of the text, 69
The audio and video stop synchronizing after a change., 165
The Audio File Formats That Are Compatible, 71
The Best 10 Plugins & Add-ons for iMovie, 9, 175
The Best Methods, 7, 138
The Best Techniques for iMovie Collaborative Editing, 138
The BKMS All Images, 9, 175
The clips trimming, 2, 39
The EQ Modifications, 119
The Greatest Methods for Collaborative Editing in iMovie, 7, 134
The incorporation of collaborators, 7, 137
The Jump Cut tool in iMovie, 5, 84
The Last Actions, 112
The method of "reminding" iMovie of the project clips was effective, 168
The methods used for the Installation, 1, 20
THE MOST COMMONLY ASKED QUESTIONS AND TROUBLESHOOTING TECHNIQUES, 8, 165
the primary clip., 82
the search results, 20

The second animation's delay, 149
The suitable measures, 3, 66
The videos don't play properly, 167
Theater, 14, 180
theme music, 74
Theme templates, 1, 24
Themes, 15, 33, 62
Think about the features and functions, 179
third-party tools, 165, 177, 178
Through the App Store, 20
Thunderbolt Display, 29
Thunderbolt port, 29
TIFF, 31, 100, 143
Time and Speed, 55
Timeline, 15, 44, 45, 46, 52, 85, 100, 101
Tips for adding fade transitions to overlays, 5, 87
Title inspector, 64, 65
Titles, 13, 15, 61, 63, 67, 70, 111
Top Techniques, 34
Trackpad, 85
Transcode high-bitrate video files, 170
Transcoding the video, 167
Transcoding the video that iMovie won't accept is the solution, 167
Transfer your video to an alternative device, 7, 130
Transform Your Images into Digital Formats, 6, 107
Transitional Effects, 55
Transitional Shots, 55
transitions, 12, 13, 15, 17, 46, 52, 53, 55, 62, 79, 84, 87, 88, 89, 90, 100, 110, 111, 113, 150, 164, 177, 179
Transitions, 15, 52, 55, 87, 88, 89, 90, 100, 111
TRANSITIONS AND EFFECTS INCORPORATED, 3, 52
Transparent video exporting, 7, 147
Trimming the clips, 51
Troubleshoot the issue regarding Bringing in Media Files, 174
Try New Things and Be Innovative, 178
Turn down the volume, 77
Tutorials and Reviews on YouTube, 178
Typeface Choice and Design, 65

U

uncompressed audio format, 71
UNDERSTANDING FUNDAMENTAL EDITING, 2, 39
Understanding Tags, 2, 33
Update iMovie, 170

Update macOS, 170
Updates frequently include bug fixes, 165
upload video to your library in iMovie, 34
Upload your film to the internet, 7, 131, 132
USAGE OF TITLES, 3, 59
Use cutaways to conceal jump cuts, 4, 84
Use iCloud for Seamless Access, 180
use iMovie, 12, 20, 21, 34, 44, 46, 70, 71, 80, 86, 89, 100, 120, 154, 170, 180
use iMovie on iOS devices, 180
Use iMovie on Mac to import files, 31
Use iMovie on Mac to import files from your photo library, 31
Use iMovie to email a Mac movie, 6, 123
Use iMovie to email a Mac movie, trailer, or clip, 6, 123
Use keyframes to gradually change the audio, 4, 78
Use Mac iMovie to import video from tape-based cameras., 1, 29
use of outside technologies, 178
use other Apple hardware or applications, 180
use products that are easy to use and intuitive, 179
Use Proxy Media, 170
Use Shortcuts to Automate processes, 180
useful tool for visual communication and storytelling, 12
users can produce videos, 12
Using animations for Magic Moves, 7, 158
Using External Tools, 98, 178
Using Green Screen Effects, 5, 91
using iMovie, 2, 3, 7, 8, 9, 12, 15, 44, 59, 61, 62, 66, 70, 94, 106, 126, 129, 134, 170, 171, 172, 174
using iMovie on your Mac, 2, 44, 94
Using iMovie on your Mac, split videos, 44
Using iMovie to add text and titles, 59
Using iMovie to Add Typewriter Effect, 61
Using Keynote to generate original titles, 7, 139
Using Photos to Create Slideshows and Montages, 5, 101
Using Picture-in-Picture, 89
Using software, 59
Using the clip trimmer, add or remove frames, 39
using the latest version of iMovie, 165
using the libraries list on the sidebar, 18
using third-party tools in your work, 178
Using Transitional Effects, 53
utilize AirDrop, 130
Utilize the dropdown menu, 69

utilize Time Machine on macOS, 180
Utilizing filters and effects, 55
Utilizing the clip trimmer, 2, 39
UTILIZING TITLES AND TEXT, 59
utilizing version control systems like Git., 180

V

vacations, 12
value proposition and cost-effectiveness, 179
variety of applications, 12
variety of file types, 165
various applications., 180
various distinct communication platforms., 135
Verify that the functionality and file formats of iMovie, 179
Verify that the timeline's audio and video clips are perfectly aligned, 165
Verify that your device satisfies the system requirements, 21
Version control and backups, 180
Version History, 137
vibrant user base, 179
video clips, 12, 13, 15, 16, 17, 23, 24, 25, 27, 42, 52, 74, 75, 77, 88, 98, 129, 130, 165
Video Conferencing, 135
video footage, 12
video overlay options, 94
Video Overlay options button, 94
video quality, 16, 128, 129, 167, 170
video's frame rate, 167
video-sharing services,, 17
viewer's curiosity, 61
viewing experience, 55
Visit the website for recording voiceover, 80
visual appeal and shareability, 13
vloggers, 12, 13
Voiceover Option button, 80

W

watch tutorials,, 178
Waveform Audio File Format, 71
well-written documentation, 179
What are some crucial points to remember in Resolution and Quality Aspects, 132
What are the methods of transition?, 58

What are the process of using iMovie to add text and titles?, 70
What are the strategies for improving performance in iMovie?, 174
What are the techniques for iMovie installation, 31
What are the types of transition?, 58
What are the ways to carry out EQ MODIFICATIONS?, 122
What do you understand by iMovie?, 17
What do you understand by tagging and metadata?, 38
What exactly is a jump cut?, 4, 84
What kind of system is required for iMovie?, 8, 171
What Makes a Video Overlay Necessary?, 90
When exporting an altered movie, the audio is out of sync, 120
When importing camera video into iMovie, the audio is not in sync, 120
Which are the basic iMovie editing techniques?, 8, 172
Which circumstances and techniques may you use a Jump Cut for?, 4, 84
White Balance Adjustment, 98
white circle keyframes, 156
Who This Is Meant For, 1, 13
Why Is a Video Overlay Required?, 4, 82
wide range of media file formats, 12
widescreen, 16, 17

Wipe, 53
work in tandem with iMovie in your video editing workflow, 179
Workflow Customization, 178
workflow optimization, 178
working in a team, 179
working on one device, 180
Write a Custom Text, 63

Y

You can adjust the clip's loudness, 79
you can automate repetitive processes, 180
you can export your work to Final Cut Pro, 180
You can share or export your Mac iMovie project, 7, 131
You can specify an external storage device, 16
you may combine iMovie with Keynote and GarageBand,, 180
You may invite colleagues to see and edit your projects,, 180
your iMovie version and device, 17
your level of editing experience, 12
Your video file is incompatible with iMovie, 166
YouTube, 17, 113, 131, 132, 137
YouTubers, 12, 13, 178
YouTubers write guides and assessments, 178

www.ingramcontent.com/pod-product-compliance
Lightning Source LLC
Chambersburg PA
CBHW082233220526
45479CB00005B/1221